KENTUCKY'S
LAST GREAT PLACES

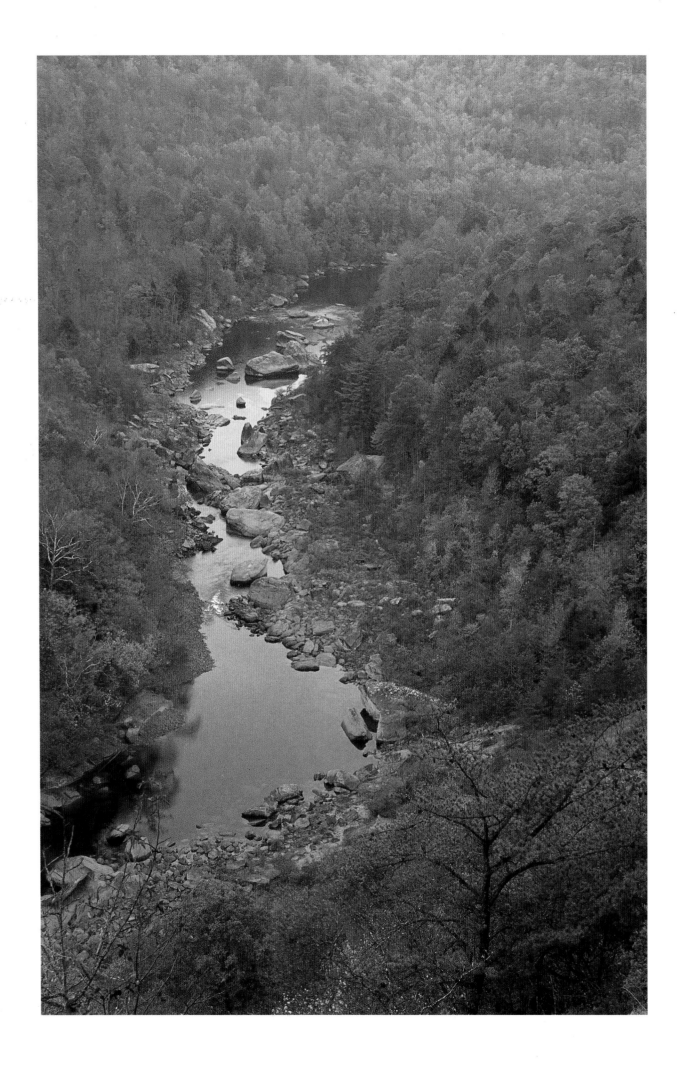

KENTUCKY'S
LAST GREAT PLACES

Thomas G. Barnes

THE UNIVERSITY PRESS OF KENTUCKY

Publication of this volume was made possible in part by a grant from
the National Endowment for the Humanities.

Scholarly publisher for the Commonwealth,
serving Bellarmine University, Berea College, Centre
College of Kentucky, Eastern Kentucky University,
The Filson Historical Society, Georgetown College,
Kentucky Historical Society, Kentucky State University,
Morehead State University, Murray State University,
Northern Kentucky University, Transylvania University,
University of Kentucky, University of Louisville,
and Western Kentucky University.
All rights reserved.

Editorial and Sales Offices: The University Press of Kentucky
663 South Limestone Street, Lexington, Kentucky 40508-4008

06 05 04 03 5 4 3 2

Frontispiece: The Big South Fork of the Cumberland River.

Library of Congress Cataloging-in-Publication Data

Barnes, Thomas G., 1957–
Kentucky's last great places / Thomas G. Barnes.
p. cm.
ISBN 0-8131-2230-9 (cloth : alk. paper)
1. Landscape photography—Kentucky. 2. Nature photography—Kentucky.
3. Kentucky—Pictorial works. I. Title.
TR660.5 .B3723 2002
508.769—dc21 2001007142

508.769
Barn

This book is printed on acid-free paper meeting
the requirements of the American National Standard
for Permanence of Paper for Printed Library Materials.

Manufactured in Hong Kong.

Text Design : Glenda King

For my children, Jeremiah and Michaela. I hope you inherit a world as biologically rich as the world I inherited. I further hope it is not your generation that has to choose which species continue to exist and which ones cease to exist.

CONTENTS

ACKNOWLEDGMENTS

Completion of this book has been a tremendous undertaking, requiring more than three years. This project would not have been possible without the assistance of numerous individuals and organizations. First and foremost, I am indebted to Don Graves, chair of the Department of Forestry at the University of Kentucky, for believing in the project and finding funding to help defray publication costs. These funds came from our federal Extension dollars received through the Renewable Resources Extension Act. Thank you, Congress, for keeping that source of funding alive and well.

Foremost among the many other individuals and organizations that assisted with the project are the staff of the Kentucky State Nature Preserves Commission. I cannot thank you enough. You provided me with access to locations and site-specific information for locating plants, and in some cases even helped me find them. You all are a true inspiration. I especially want to acknowledge the contributions of Rick Remington, Kyle Napier, David Skinner, Joyce Bender, Mark Evans, Ron Cicerello, Ellis Laudermilk, Deborah White, and Bryce Fields for putting up with me on our little field excursions. Other staff members, including Don Dott, director, and former directors Bob McCance and acting director Barry Howard, were also helpful by supporting their staff and allowing me to monopolize some of their time and talent.

The other important biologist to whom I am indebted is Julian Campbell of the Nature Conservancy. Much like the biologists with Nature Preserves, Julian made special efforts to get me information about preserves and plants and accompanied me on several field trips. I will never forget the times when we discussed the natural world and came away with a better respect for and understanding of one another. Thanks to Richie Kessler for his information about accessing areas around the Green River, and Jim Hays, who provided information about special locations in the Horse Lick Creek area of Jackson County. I would also like to thank Jim Aldrich, director of the Kentucky Chapter of the Nature Conservancy, for allowing Julian, Richie, and Jim to take time from their busy schedules to help me.

I cannot say thank you enough to the folks at Murphy's Camera, Don, Annette, and Richie, nor to Phyllis, Vicki, Heather, Sally, Josh, and Mark at the University of Kentucky photo processing lab, who have taken very good care of me over the years; I truly appreciate your dedication to quality and your humor. Finally, thanks to the director of the lab, Scott McDonald. Over the past several years Scott has become a dear friend and trusted colleague. He runs the photo lab with great professionalism. More important, he has often provided the boat and vehicle for Kentucky river runs. Without him I would not have had many great adventures.

Others who have helped include Bill Bryant, Don Harker, and Hugh Archer, who provided much of the historical information. Jeff Hohman, Dan Duorson, and Jayd Raines were wonderful in helping me photograph various herptofauna. Cary Tichenor and John Tierney helped with getting images at Blue Licks and Carter Caves State Parks.

The assistance of a good editor can either make or break any project. Georgiana Strickland saved this manuscript with her insight and helpful edits.

Finally, I need to say thank you to my wife, Linda, and our kids for putting up with me. They deserve a great deal of credit for understanding the life of an Extension Specialist, especially one trying to do a book. I love you all very much. Thanks for the support.

PREFACE

We love what we know and care about. We can only know and care about something if we can begin to understand it, and we can only understand something if we are aware of its existence. During the past thirteen years, as I have traveled across the Commonwealth of Kentucky, I have sensed that a large majority of our population has little awareness of Kentucky's unique biological heritage. Perhaps that is to be expected. Growing up, I never traveled through much of my native South Dakota. I was aware of the natural world and appreciated being able to walk across the street into the prairie to snare gophers or catch bullheads in the pond or chase ring-necked pheasants. But I never truly appreciated the prairie until I was no longer there. And it is only now, when I return with a little knowledge and information, that I truly appreciate my heritage.

When I present programs, give show slides, and talk with audiences and mention the two million acres of prairie that existed in Kentucky before European settlement, I am often greeted by amazement. When I give a wildflower lecture and mention that prickly pear cactus and Virginia agave are pretty common in Kentucky, I often hear, "I didn't know that." I have become convinced that the majority of people in Kentucky have little concept of the biological richness that exists in our old-growth forests, prairies, wetlands, glades, and other unique biological habitats. I hope this book changes that. My intention is to create an awareness that will begin the cycle of understanding and, ultimately, of caring for our natural world.

The purpose of my photographic essay is to bring this biological heritage into your living room. I hope that after reading this book you will see for yourself the spectacular, the rare, and even the common organisms that make Kentucky a unique state. Many of the nature preserves I visited and photographed are not open to the public, however, so it is my hope that you experience these natural areas through the viewfinder of my camera and that the images will speak for themselves. The text that accompanies the photographs, by taking you through some of my travels and photographic adventures, is an effort to provide you

with a written interpretation of our natural world. But first and foremost this book is my attempt to capture the natural beauty of Kentucky on film.

I am often asked about my photography. What type of equipment do I use? What type of film? Let me begin by stating that I am a self-taught photographer. I have been photographing nature for more than twenty-five years and have more than thirty thousand slides on file. In some sense photography is like marriage: once you select a camera system, you pretty much have to stick with it. In the early years the only professional camera I could afford was a Nikon FM2, a totally manual camera. And so this marriage was created and I have used Nikon equipment, exclusively, for the past twenty years. For most of the work in this book, I used a Nikon F100 or N90S camera body and Nikkor lenses ranging from a 16-millimeter fisheye to a 400-millimeter telephoto. My film of choice was Fuji Velvia, with Kodak E100VS or E100SW as secondary films. I shot more than 100 rolls of film to get the images you see in this book. You can learn more about my photography by visiting the following website: agpix.com/photographer/prime/A0213360.html.

PRESERVATION IN KENTUCKY

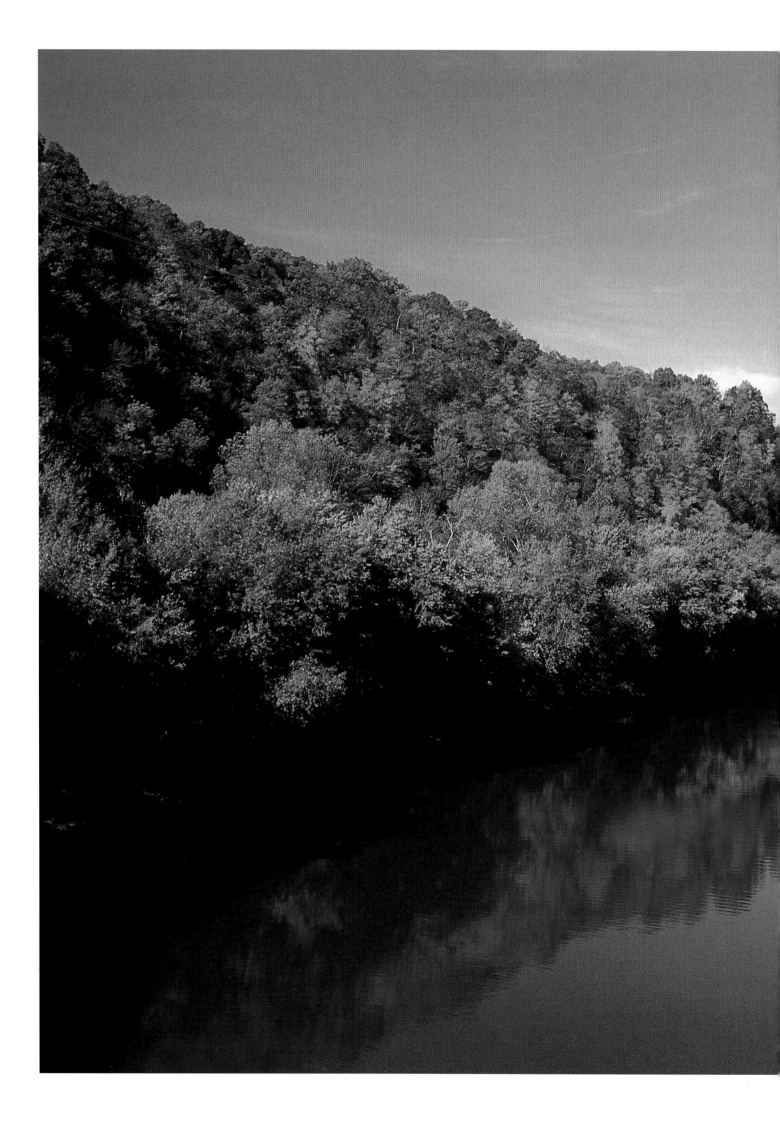

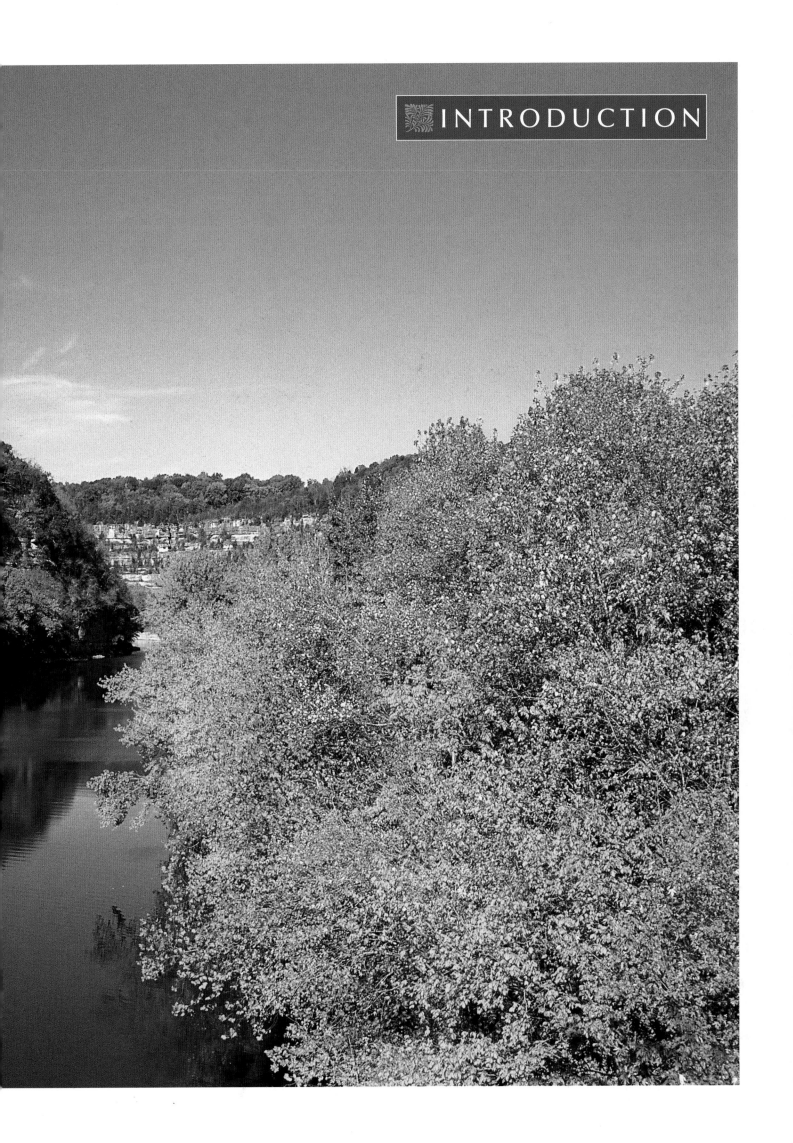

INTRODUCTION

Lloyd Woods, located in Grant County, was the state's first protected natural area. It has some of the finest old-growth trees in the commonwealth. This photo reveals some of the characteristics of an old-growth forest canopy dominated by several different species, including black walnut, sugar maple, American beech, and red ash.

Kentucky's natural biological wealth and beauty have drawn the attention of people for centuries. The state is home to eleven rare ecological communities, two of which are rare globally. The bluegrass savanna, unique to central Kentucky, is now functionally extinct, having succumbed to horse farms, agriculture, and urban development. All that remains are a few groves of the old bur or chinquapin oaks, blue ash, and shellbark hickory. The best remnant savanna is a two-hundred-acre tract in Harrison County, but it has been heavily grazed, and the understory is dominated almost completely by exotic plants, that is, plants not native to Kentucky.

More than 80 percent of the state's wetlands have been destroyed, and two wetland types—the bottomland hardwood forest and the stream-head seeps—are highly threatened. The Kentucky State Nature Preserves Commission (hereafter called Nature Preserves) estimates that only 1 percent of our state's bottomland hardwoods remain. Unfortunately, most of these forests have been heavily logged or adversely affected by agriculture or development that results in hydrological changes. These communities, once dominated by oaks, are now dominated by early-successional species such as red maple and tulip poplar, and their understories are usually dominated by exotic plants, including bedstraw, Japanese stilt grass, multiflora rose, and common chickweed.

Seeps occur where groundwater more or less permanently percolates through sandy or gravelly soil to the surface. Both acid and calcareous seeps are found in the state; each is characterized by the pH of the water that moves through it. There are probably fewer than two dozen high-quality seeps left in the state, mostly in the Cumberland Plateau and Mountains.

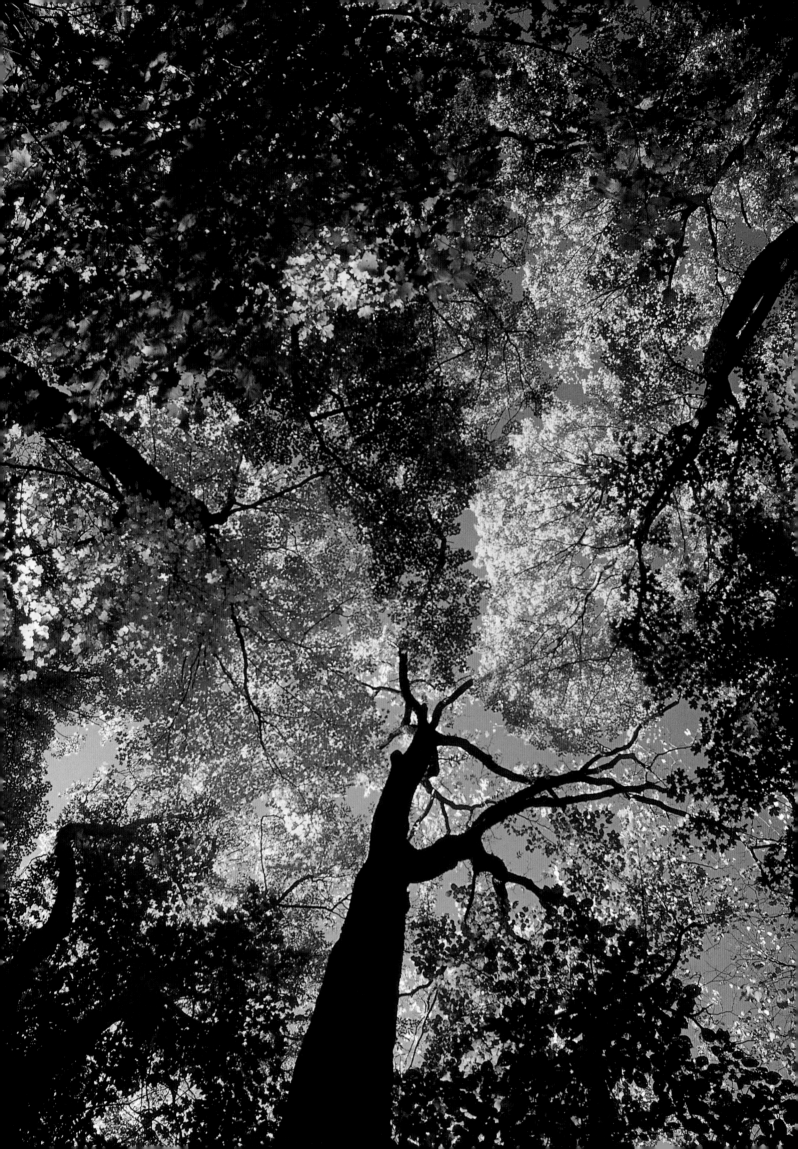

A small cypress swamp in western Kentucky, Murphy's Pond was the natural area that galvanized conservation efforts in the state. As a result, the Kentucky Chapter of the Nature Conservancy was born in 1975.

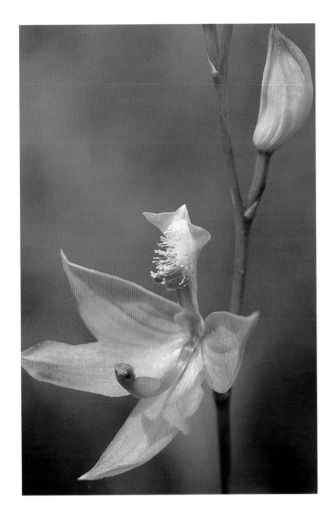

Sites located by aerial reconnaissance are identified on topographic maps and field-checked. The grass pink orchid (left) was "rediscovered" in the mid-1990s growing in marginal habitat and was not seen again in subsequent years. But field-checking a small, boglike wetland, Martina Hines and Aissa Feldman recently discovered a healthy population of this delicate orchid. Once an area has been protected, ecologists begin fieldwork to document the flora and fauna. Sometimes these inventories reveal new species records for the state. This was the case at Crooked Creek Barrens, where the false foxglove (above) was discovered after the site was protected.

More than two million acres of tallgrass prairies and barrens have been reduced to less than twelve hundred acres (about .05 percent) in scattered remnants. Those that remain are usually found on land that is unsuitable for either agriculture or development, often on steep slopes, rock outcrops, or poor soils.

The flora and fauna of Kentucky's forests, though diverse, are in conditions ranging from almost pristine to pitiful. Less than fifteen thousand acres of older growth or unmanaged forests remain in the state, about .1 percent of Kentucky's thirteen million forested acres.

In the state's natural areas, Nature Preserves thus far has discovered about 20,700 acres (approximately .08 percent of the state's land area) of high quality land that could be classified ecologically as in a "pre-European" condition that deserves significant protection. Of this, only about 2,600 acres (or about .01 percent of the state) are actually protected.

Disturbances by humans have fragmented naturally occurring ecosystems, resulting in increased edge (where two different ecological communities come together), and this in turn has created significant problems for various wildlife and plant species. Increased edge and habitat destruction have resulted, for example, in serious population declines among forest and grassland-interior neo-tropical birds (birds that spend the summer in North America

and winter in the tropics), though they have certainly benefitted other species, such as white-tailed deer and wild turkey, of which there is almost an overabundance in some areas.

Various human activities in natural areas also have resulted in declining reptile, amphibian, and bat populations throughout the state. Furthermore, invasive exotic organisms continue to degrade natural communities. Often referred to as "biological pollution," these invasions, which to this day continue almost unabated, are a real threat to the health of numerous rare communities and organisms.

Time is of the essence in protecting Kentucky's remaining natural areas. More than one-third of the state still needs to be inventoried for rare species and communities. In the most recent inventory efforts, Nature Preserves did not find even one tract of older-growth forest in the ten counties they surveyed. Several barrens and glades were found, but most of these were too small to justify protection efforts. During this same period, two mature, diverse forest tracts on Pine Mountain and a near-old-growth tract in Jackson County became victims of the chain saw. And in the period between finding and actually purchasing Blanton Forest in Harlan County, approximately fifteen acres of the forest's old growth succumbed to an unethical timber company. The message is quite clear: the time to protect our remaining high-quality natural areas is now.

The focus of this book is the beauty of our precious natural heritage and how two organizations, the Kentucky Chapter of the Nature Conservancy (hereafter called the Kentucky Chapter) and Nature Preserves, have worked and are continuing to work to protect it. It is not meant to be a scientific treatise, nor an authoritative reference on all aspects of Kentucky's biodiversity. I have avoided using scientific names, except in quotations from other sources. If you are interested in scientific names and Kentucky's rare biota, Nature Preserves provides a list of rare species along with their scientific names on their Internet website, www.kynaturepreserves.org.

Why speak of Kentucky's Last Great Places? I borrowed this title from a program, "The Last Great Places," initiated by the Nature Conservancy (hereafter called the Conservancy) several years ago in an effort to protect the best of the best remaining ecosystems. Many may argue with my selection of which areas and species to include and which ones to exclude and may suggest additional areas that should have been considered, such as Bernheim Forest or Thousand Acre Woods (Latourneau Woods) in Fulton County. Unfortunately, I could not include everything and have focused primarily on lands owned or managed by the Kentucky Chapter and Nature Preserves (see table 1 and map). Other areas, such as the national parks or the Daniel Boone National Forest, I have added because of their overall significance to protection of the state's biodiversity and the work that both organizations have conducted on those properties.

Finally, this book is also a celebration of the twenty-fifth anniversary of the Kentucky Chapter, the twenty-fifth anniversary of Nature Preserves, and the fiftieth anniversary of

Overleaf: Often natural areas are located by aerial reconnaissance. The large tree canopies, like this maple on the crest of Blanton Forest, were the characteristics that led Marc Evans to field-check the site. Several thousand acres of old-growth forest were subsequently "discovered" and became a Kentucky state nature preserve.

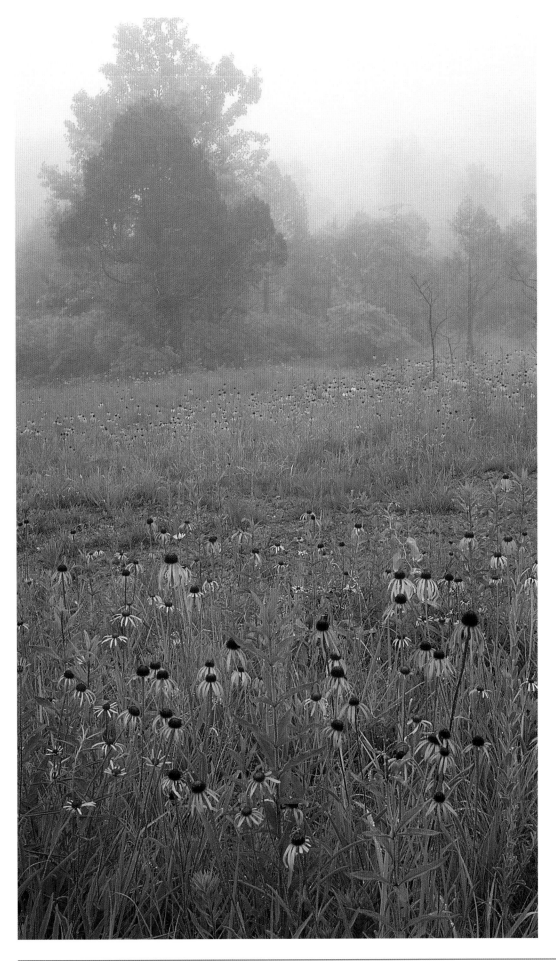

One of the first steps in an inventory of state natural areas is to examine aerial photographs. Marc Evans, senior ecologist with the Kentucky Nature Preserves Commission, thought he had found the prairie barrens "mother lode." Unfortunately, the aerial photograph was dated, and when the site was field-checked, much of it had been developed into a subdivision. Because of the quick action of the Conservancy, a large percentage of the remaining Pine Creek Barrens has been protected.

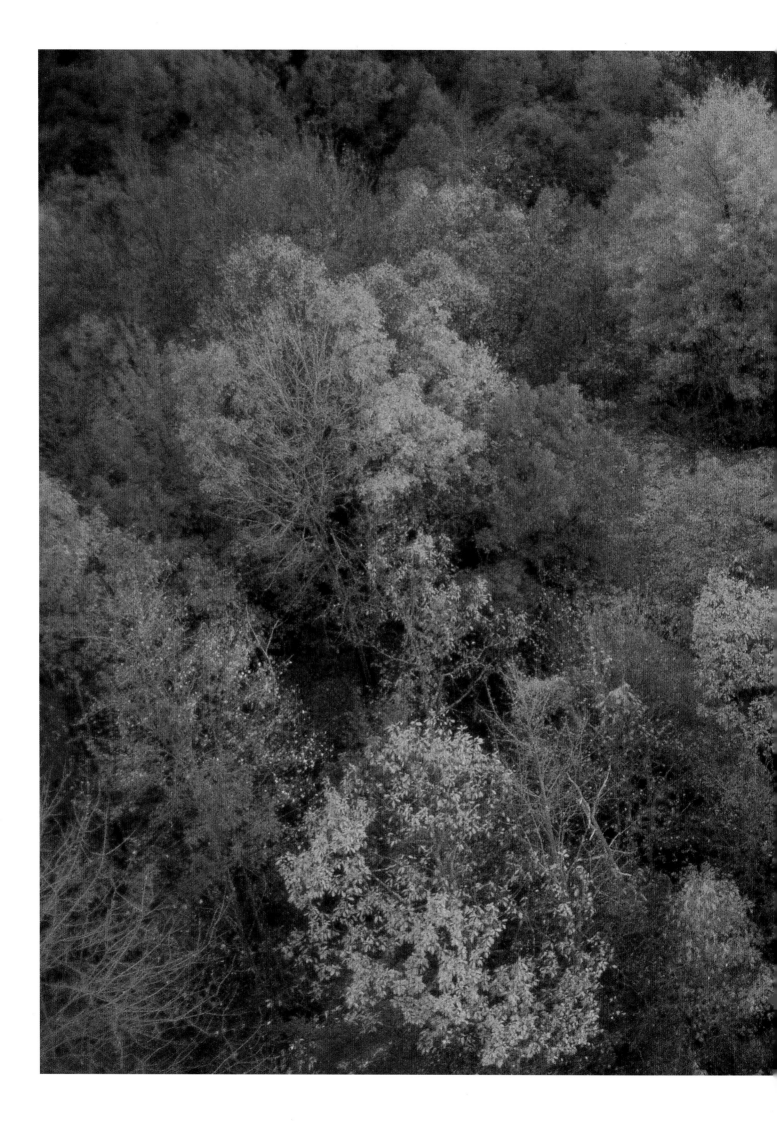

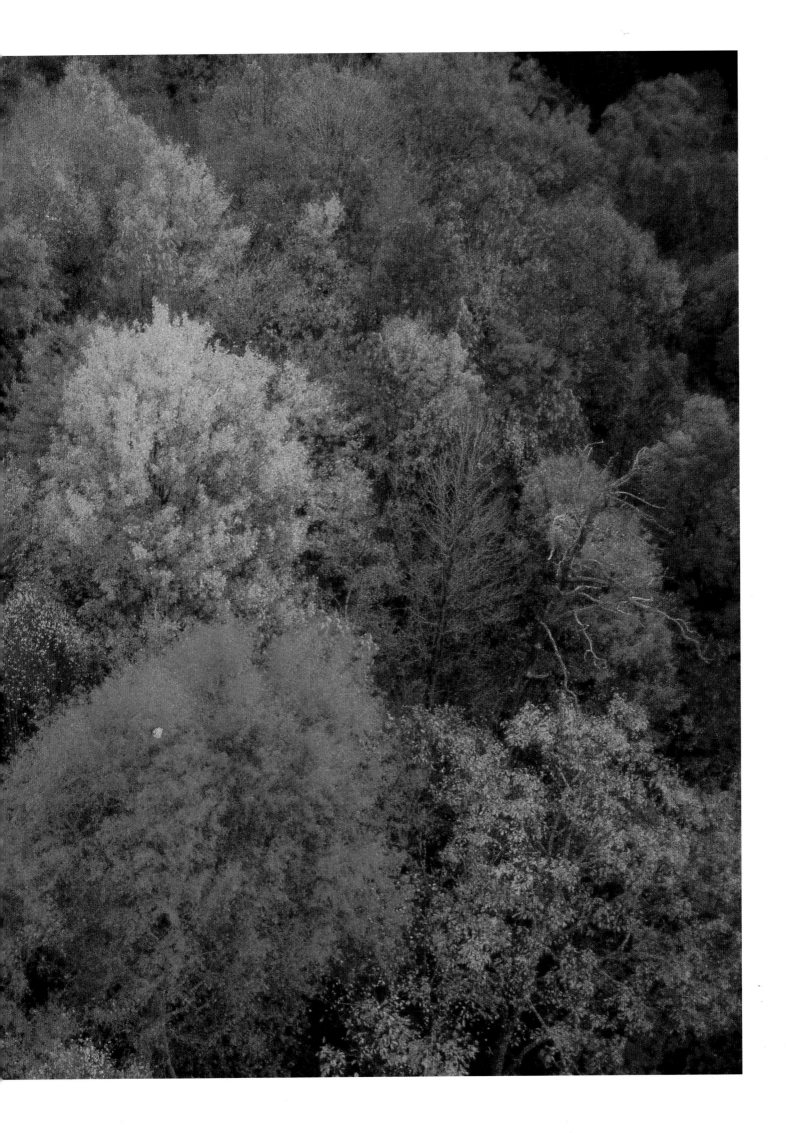

TABLE 1. Protected Nature Preserves by Physiographic Region

PRESERVE	COUNTY	PUBLIC ACCESS
BLUEGRASS		
Beargrass Creek	Jefferson	Open
Blackacre	Jefferson	Open
Blue Licks Battlefield	Robertson	Open
Boone County Cliffs	Boone	Open
Buffalo Trace	Fleming	By guided hike only
Crutcher	Garrard	Open
Dinsmore Woods	Boone	Open
Floracliff	Fayette	By appointment only
Jessamine Creek	Jessamine	By guided hike only
Jim Beam	Jessamine	Open
Kirwan	Woodford	By guided hike only
Lower Howard's Creek	Clark	By guided hike only
Pine Creek Barrens	Bullitt	By guided hike only
Quiet Trails	Harrison	Open
Sally Brown	Garrard	Open
Six Mile Island	Jefferson	Open via boat only
Tom Dorman	Jessamine and Garrard	Open
White Oak Creek	Garrard	By guided hike only
EASTERN KENTUCKY		
Bad Branch	Letcher	Open
Bat Cave/Cascade Caverns	Carter	Open
Blanton Forest	Harlan	Open
Crooked Creek Barrens	Lewis	By written permission only
Hi-Lewis Barrens	Harlan	By written permission only
Horse Lick Creek Bioreserve	Jackson	By guided hike only
Jesse Stuart	Greenup	Open
John B. Stephenson	Rockcastle	Open
Kingdom Come	Letcher	Open
Mary Breckinridge	Leslie	By guided hike only
Mrs. Baylor O. Hickman	Pulaski	By guided hike only
Natural Bridge	Powell	Open
Pilot Knob	Powell	Open
Pine Mountain	Bell	Open
Pine Mountain-Mullins	Letcher	By guided hike only
Primroy Creek	Whitley	By guided hike only

PRESERVE	COUNTY	PUBLIC ACCESS
PENNYROYAL		
Aimee Rosenfield	Livingston	By guided hike only
Baumberger Barrens	Grayson	By guided hike only
Buck Creek Bioreserve	Several	By guided hike only
Brigadoon	Barren	By written permission only
Chaney Lake	Warren	By written permission only
Eastview Barrens	Hardin	By guided hike only
Flat Rock Glade	Simpson	By written permission only
Goodrum Cave	Allen	By written permission only
Green River Bioreserve	Several	By guided hike only
Hazeldell Meadow	Pulaski	By guided hike only
Jim Scudder	Hardin	By written permission only
Knights Barrens	Hardin	By guided hike only
Logan County Glade	Logan	Open
Raymond Athey Barrens	Logan	By written permission only
Sunset Barrens	Warren	By guided hike only
Thompson Creek Glades	LaRue	By written permission only
Vernon-Douglas	Hardin	Open
Woodburn Glade	Warren	By written permission only
SHAWNEE HILLS		
Canoe Creek	Henderson	By guided hike only
Crittenden Springs Glade	Crittenden	By guided hike only
Cypress Creek	Muhlenberg	By written permission only
Hunter Bluff	Caldwell	By guided hike only
John James Audubon	Henderson	Open
Mantle Rock	Livingston	Open
EAST GULF COASTAL PLAIN		
Axe Lake Swamp	Ballard	By written permission only
Cypress Creek Swamp	Marshall	By guided hike only
Metropolis Lake	McCracken	Open
Murphy's Pond	Hickman	Open
Obion Creek	Hickman	By written permission only
Terrapin Creek	Graves	By written permission only

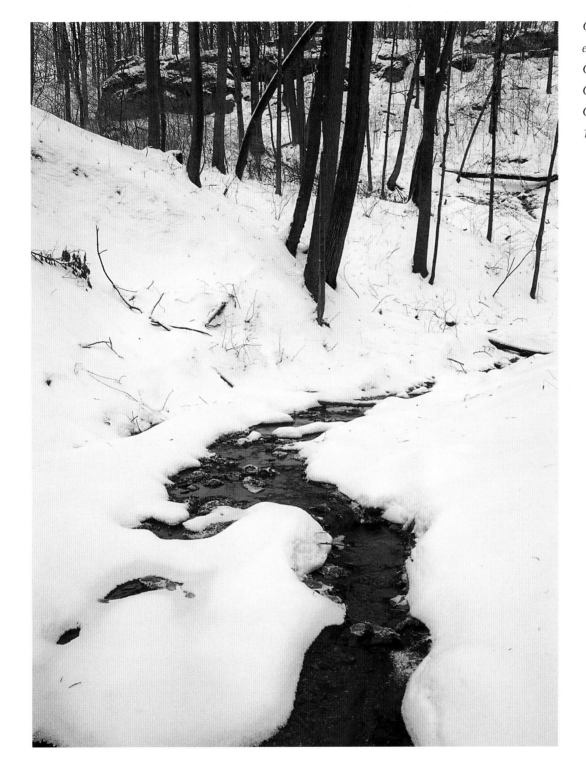

One of the first preserves established by the Kentucky Chapter of the Nature Conservancy, Boone County Cliffs was dedicated in 1987.

the founding of the national parent organization, the Nature Conservancy. It is also a celebration of life. Every time I step into the natural world beyond the asphalt jungle, road-raging traffic congestion, and people, people, people, I am reminded of how special it is to live in such a beautiful state, to still have places to roam the woods, to smell the fragrance of sweet wildflowers, to see my children touch a snake, to ride the rapids or canoe the still waters, and to be reinvigorated by the sights and sounds of nature. Such times refresh my soul, regenerate my batteries, and renew my sense of awe and wonder.

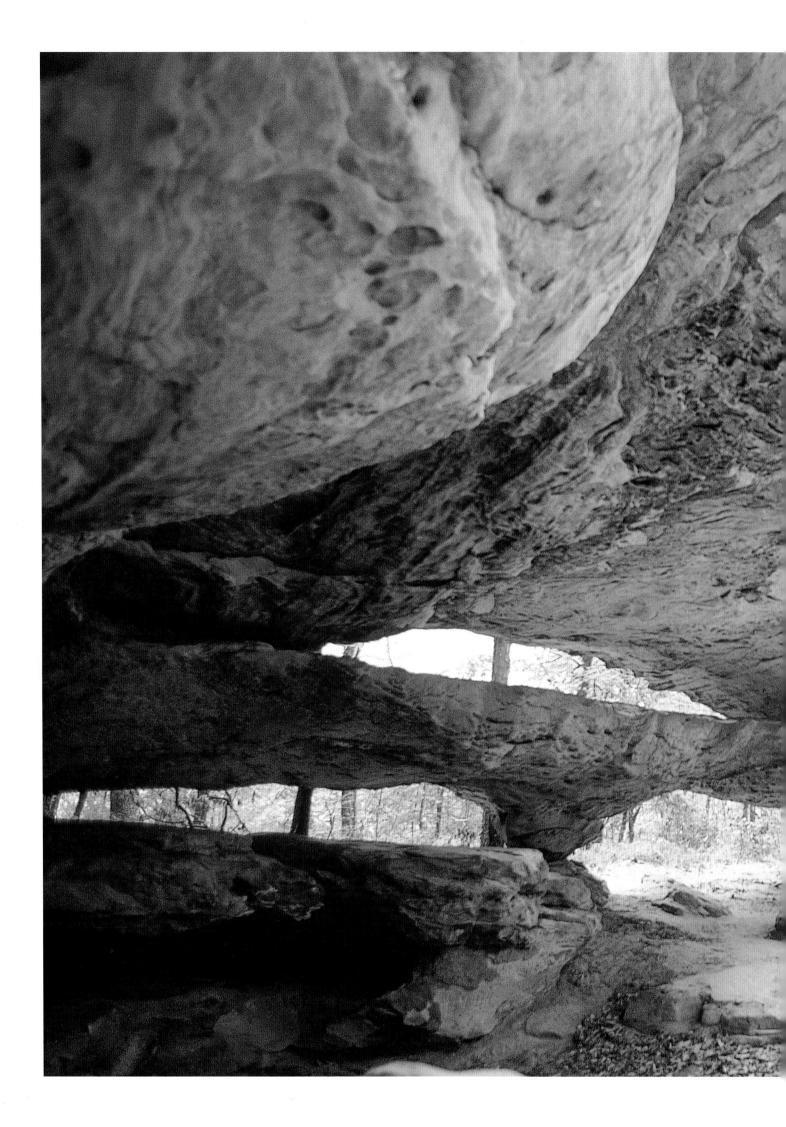

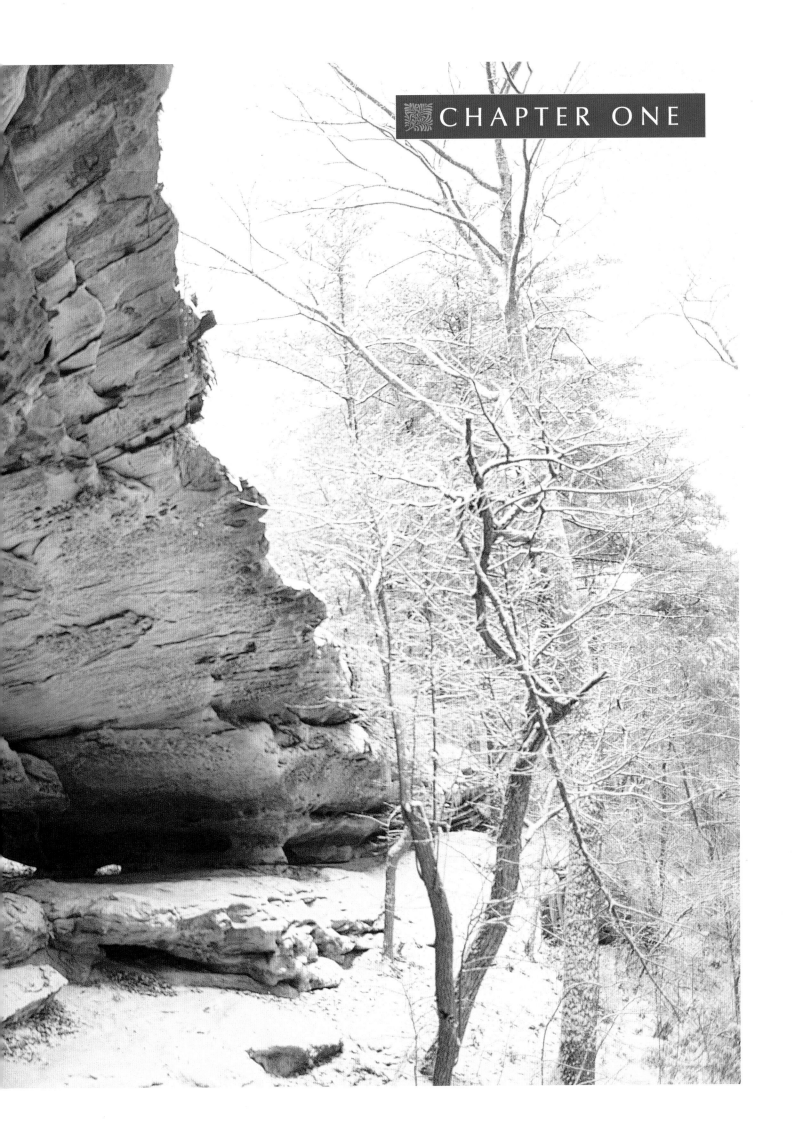

1

PRESERVATION EFFORTS
A History

Nature conservation has never been a priority in Kentucky. Although the common-wealth has done an admirable job of protecting our cultural and historical heritage, the same cannot be said for protecting our biological heritage. Nature Preserves reports that .08 percent of Kentucky is in excellent ecological condition. Bill Bryant, ecology professor at Thomas More College in Crestview Hills, Kentucky, verified that statement was accurate with a response of "It is certainly much less than 1 percent."

Sadly, others also have recognized the state's lack of natural-area protection. Thomas D. Clark, Kentucky's laureate historian, notes in his 1988 revision of his 1937 History of Kentucky, "This wooded Eden was penetrated by game and Indian trails, and these were followed by early long hunters and land scouts. The journals of travel noted the existence of the towering woods. . . . Sawmill owners cut-out and got-out with complete disregard to the future of the woods, or even elementary rules of conservation. . . . The profligate decades of shameful waste and unforgivable rape of the virgin forest . . . all but screamed condemnation at Kentuckians and Tennesseeans for the wanton destruction of their precious forest resource. . . . There still prevails . . . a wasteful process of harvesting forest resources" (4–6).

In a 1917 issue of the journal Ecology, A.R. Middleton, W.R. Jillson, F.T. McFarland, and W.A. Anderson Jr. wrote, "There are no large regions in Kentucky remaining today in which the fauna and flora are in their natural condition. . . . The greatest change . . . has been the removal of the larger native forest trees and the extinction of certain species in the local fauna. . . . Unpolluted waters really do not occur in Kentucky due to the fact that the

Overleaf: *Bridge Rock in Jackson County.*

state is almost entirely inhabited" (349–54). Even at this early date, Middleton and his colleagues noted that Kentucky lacked protected natural areas. "At the present time," they continued, "Kentucky has no completed state parks, but tracts of land for State Park purposes have been given . . . and will be considered by the State Legislature in 1926. . . . The Mammoth Cave in Edmondson County is being proposed as a national park."

The authors identified a number of areas they believed deserved protection. They described Natural Bridge as an "area of virgin forest, mixed deciduous and evergreen; very beautiful" and the Lloyd Library Forest Reservation in Crittenden and Grant Counties as "two tracts of about 20 acres each that have never been touched with an ax." The third area in need of protection was the University of Kentucky zoological experiment station, now known as University of Kentucky Robinson Forest, and the fourth, the Berea College Forest Reserve and Adjacent Territory. Two additional areas in northern Kentucky were identified: Woolper Creek Glacial Moraine (Split Rock) and the Middle Creek Glacial Moraine (Boone County Cliffs). Finally, the authors listed the Hillman Land and Iron Company Reservation (Land Between the Lakes), "Tight Holler" Forest on the Middle Fork of the Red River, and Torrent Falls. Their vision at the turn of the century of what was ecologically significant was truly remarkable. Today only two of these areas have not been protected: Split Rock in northern Kentucky and Torrent Falls.

Even with respect to formation of the Kentucky Chapter and its state counterpart, Nature Preserves, Kentucky has lagged behind most of the country. The year 2001 marks the fiftieth anniversary of the Conservancy, which was formed in 1951 by a group of professional ecologists. The Kentucky Chapter celebrated its twenty-fifth anniversary in 2000, and Nature Preserves celebrated its twenty-fifth anniversary in 2001. In a sense, we started twenty-five years behind many of our state counterparts.

Yet much has been accomplished since the formation of these two groups within the borders of Kentucky. They work together, and each organization compliments the other. Nature Preserves, for example, provides a great deal of inventory and rare-organism information to the Kentucky Chapter to help the latter's staff make informed decisions about protecting particular properties. For its part, the Conservancy can provide an immediate source of cash for areas Nature Preserves might be interested in protecting. Each organization has its own modus operandi. The Conservancy is a private, nonprofit corporation that seeks to conserve the natural world through private action using nonconfrontational, market-based economic solutions to protecting biological diversity. Its goal is to preserve plants, animals, and natural communities that represent the diversity of life on Earth by protecting the lands and waters they need to survive. In one sense, the Conservancy is the up-front money component. The Nature Preserves, on the other hand, is a state agency that has the same goal but is mandated by state law to "secure for the people of present and future generations the benefits of an enduring resource of natural areas by establishing a

system of nature preserves . . . and otherwise encouraging and assisting in the preservation of natural areas and features" (KRS sec. 146.410[2]). The agency is the holder and manager of the land for all of us.

How did it all start in Kentucky? Like most volunteer organizations, the Kentucky Chapter began slowly. There have been good times and successes, but there have also been difficult times. The first conservation effort, when Thunderstruck Shoals was purchased by the Conservancy in 1964 and transferred to the U.S. Forest Service in 1967, was conducted without the guidance of an official state chapter. For once we actually provided the lead for some form of conservation in this country: Thunderstruck Shoals was the Conservancy's first cooperative project with a federal agency in the entire United States. This 379-acre site in Whitley County lies within the Cumberland River Wild River Corridor and is important because it harbors globally rare plant communities along its rocky banks. Unique species that occur here are the riverbank goldenrod and riverbank ragwood.

The purchase of Thunderstruck Shoals was followed shortly by the protection of Lilley Cornett Woods. In 1969, the Conservancy, in cooperation with U.S. Department of the Interior and the Commonwealth of Kentucky, obtained sufficient funding to purchase this 554-acre forest, which includes several hundred acres of old growth, in Letcher County. Eastern Kentucky University manages the forest to honor Lilley Cornett's wishes: "As long as I live, I aim to be able to look out and see them big trees a-growin."

Another significant forest tract, Rock Bridge Fork, was purchased and transferred to the Daniel Boone National Forest in 1970. This 860-acre tract located in Menifee and Wolfe Counties has geological as well as ecological significance, as it includes the only known arch or bridge that actually spans a stream in the Red River Gorge geological area. The U.S. Forest Service added this parcel to the Clifty Wilderness Area in 1985.

By the early to mid-1970s a core group of dedicated Conservancy volunteers had formed. Pat Noonan, president of the Nature Concervancy, contacted Roger Barbour, a biologist at the University of Kentucky, about the possibility of starting a local chapter of the Conservancy. A group of university biologists and botanists, including Barbour, Bill Bryant, Wayne Davis, Bill Martin, Hunter Hancock, and Mary Wharton, assembled with the intention of creating a state chapter. Barbour headed up this small group and suggested that two sites deserved protection: Black Mountain and Murphy's Pond. Unfortunately, Barbour's strong personality came into conflict with personnel at U.S. Steel, which owned Black Mountain at the time, creating an impasse in negotiations.

In far western Kentucky, however, at a place known as Murphy's Pond, conservation forces began to coalesce. This unique, undisturbed cypress swamp was threatened by developers who wanted to drain, log, and destroy the pond for additional land that could be farmed and planted with corn or soybeans. Barbour and his associates received a charter from the national organization, and Barbour became the first director of the Kentucky

Chapter. This loosely bound group of academics knew a great deal about the importance of this ecological gem, and their first order of business was to approach the national organization for funding. The Conservancy loaned sixty-five thousand dollars to the newly formed Kentucky Chapter to purchase Murphy's Pond, which it did in 1973. The property was transferred in 1975 to Murray State University.

Like most scientists, these dedicated individuals understood the importance of protecting ecologically sensitive areas, but they lacked the organizational, fund-raising, and people-oriented skills necessary to create a thriving entity that could protect Kentucky's treasures. The Kentucky Chapter began to work on other projects but did not raise any money to repay the national organization for the purchase of Murphy's Pond. Ultimately, the group's charter was revoked and Kentucky was again without a local Conservancy chapter (only Alabama, Georgia, and Mississippi also lacked chapters).

After several years a small core of folks led by Richard Durrell and his wife, Lucie, from the University of Cincinnati, emerged to resurrect the Kentucky Chapter. Durrell and his wife were the heart and soul of the group because they provided important contacts and were closely linked to the national organization. "Dr. Durrell was a student of [author] Dr. E. Lucy Braun and he became our mentor," recalled Bill Bryant. "We knew Kentucky was fairly diverse, and we didn't want to lose the last prairie or the last swamp because we didn't know much about it. So one of our first goals was to identify as much of the state and the potential projects we might have in the future. We began meeting in basements and any cubbyhole we could find." Durrell called upon Mary Wharton and Bruce Poundstone, a retired agriculture professor from the University of Kentucky, to help resurrect the Kentucky Chapter. They recruited other notable individuals, including Sally Brown, Mrs. Dot Clay, Oscar Geralds, Carl Wedekind, and Cathy Wilson. The core group of academicians still provided the scientific expertise, while the others provided financial, organizational, fund-raising, and volunteer support.

From the beginning the group determined that it was important to gather in the field at various locations across Kentucky to ensure that people with a diversity of backgrounds—scientists, lawyers, bankers, homemakers—interested in the natural world would feel welcome to join the new organization. By the time an official chapter was organized in the mid-1970s, the group had worked to identify the first projects of the Kentucky Chapter.

With a few success stories behind them, including Murphy's Pond, Thunderstruck Shoals, and Rock Bridge, there was enough momentum in the conservation movement to further the group's mission of protecting ecologically significant communities and species, not just receiving gifts of historically or geologically significant sites. At this time the group began working on a set of bylaws, a constitution, and a code. Now all it needed was a project. That project arrived in the form of a For Sale sign on a forty-six-acre tract of land

Overleaf: *Red River Gorge.*

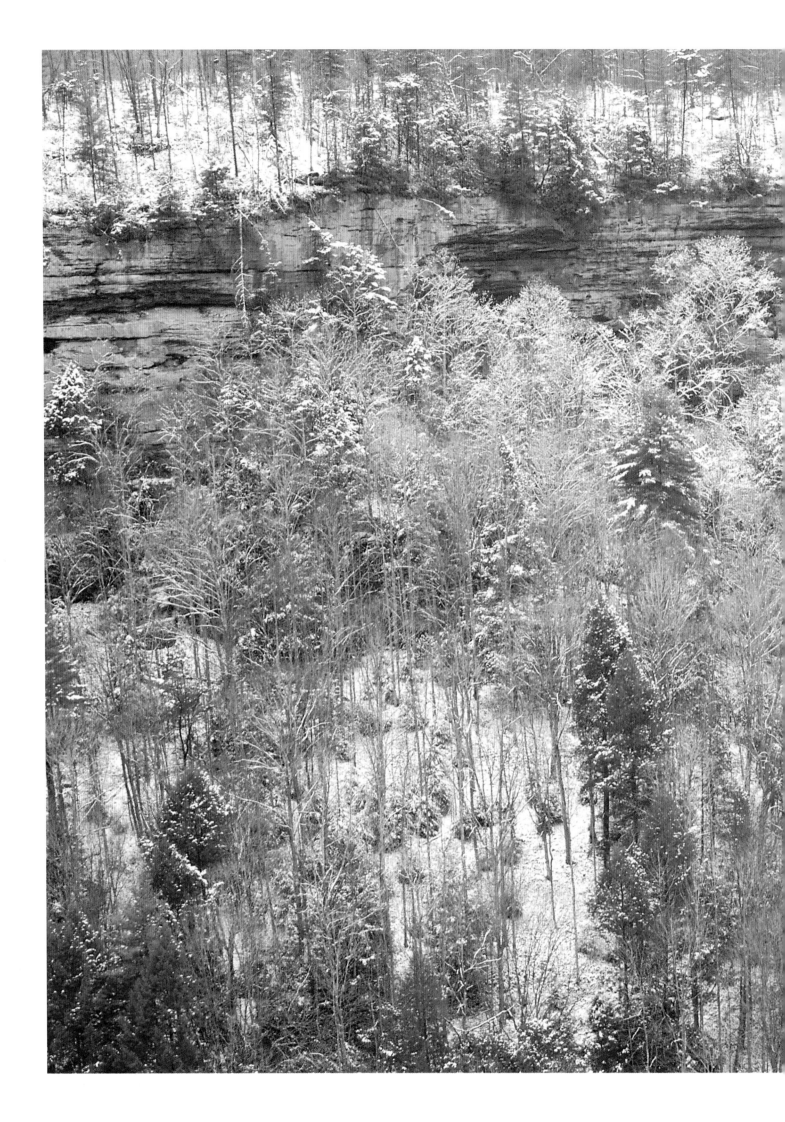

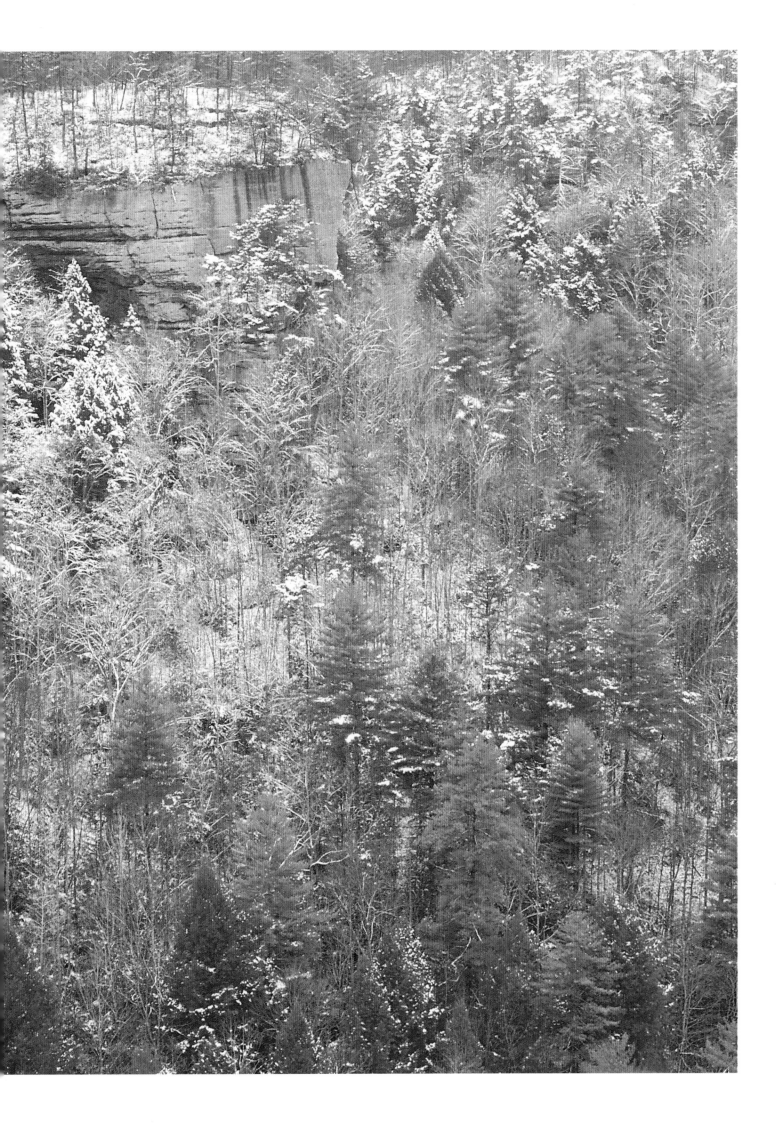

known to the local community as Boone County Cliffs, or the Enchanted Valley, near Burleson. Bryant was familiar with the property because his students had been known to roam the area in search of a good grade in his ecology course. All they needed to raise was twenty-five thousand dollars. Although Bryant believed that every good conservation organization should be in debt because it makes them raise money, he later admitted that the funding for this project was the hardest money he ever hustled. In the end, he felt that the property was worth every penny. The chapter raised the money, and the first "official" Kentucky Chapter nature preserve was hatched, so to speak.

In 1975 the Conservancy granted an interim charter for a Kentucky Chapter to Bruce Poundstone, who was serving as the organization's first chairman. Other first board members included Bryant, vice chairman, and Lois Troyer, treasurer. The chapter's modest beginnings included a budget of thirty-five thousand dollars, 108 members, and six nature preserves. Poundstone served as chair for two and a half years before Bryant took over the reins for a short time. He was followed by Cathy Wilson, who was followed by Letty Hair. Throughout this period, Poundstone was still a driving force, and it was at this time that several volunteers traveled to the national headquarters and came home with the idea that the organization could actually hire an individual to serve as director. Carl Wedekind was instrumental in the efforts to hire the first director; his impact on the creation of a professional organization cannot be understated.

The early years, Bryant noted, were a "most satisfying time period." Chapter members would make lists of important projects and branch out into other areas of the state. They had a vehicle with which to purchase and protect those significant sites known by the scientific community. "There were other areas that were known," Bryant remembers. "Prairie areas, sinkholes, sinkhole swamps, bottomland hardwoods—we spread out over the state. We had meetings and would go to those areas in need of protection, areas that the public could go out and see." Thus began the tradition (one that remains today) of having the annual meeting of the Kentucky Chapter at different locations across the commonwealth.

The next project that required fund raising was the Spencer-Morton tract in Powell County. Part of the preserve was donated to the Kentucky Chapter as a gift from the Spencer estate. As Bryant stated, "Pilot Knob was an easy one to raise money for because of the historical significance and its ties to Daniel Boone." And so in 1976 Pilot Knob was acquired and ultimately transferred to Nature Preserves and dedicated as a state nature preserve in 1985. Nature Preserves and the Division of Natural Areas at Eastern Kentucky University jointly manage the property today.

Still, with all these successes, something was lacking in the effort to systematically find and protect the best of the best natural areas that remained. That something was an organized protocol. What should be protected first? How do you prioritize the importance of any particular species or community? The answer to these questions would arrive in 1976

with the formation of the Kentucky State Nature Preserves Commission and the adoption of the Natural Heritage Program.

It was during the mid-1970s that Bob Jenkins, a scientist working for the Nature Concervancy, developed an innovative system for cataloguing species and communities at the national level. Called the Natural Heritage Program, this system's goal was to assemble an inventory of biological organisms and communities in a computer database for easy retrieval. Jenkins hoped to establish one of these programs in each state, thereby assisting the Conservancy in developing protection priorities and, by providing detailed information about the location of species, in avoiding conflicts with development. Illinois and Ohio already had the Natural Heritage Program in place, and it was thought that Kentucky should have it as well. The program would be initiated by the Conservancy, which would guide the establishment effort, but ultimately the program was to be handed over to a state agency. That was problematic in Kentucky because there were no natural-area programs in place before 1976.

It quickly became apparent that a state agency counterpart to the Kentucky Chapter was needed in Kentucky. A letter was written to Secretary John Stanley Hoffman of the Cabinet for Natural Resources suggesting that the state get involved with nature conservation by creating a natural-areas program similar to those already in place in adjoining states. It was here that fate stepped in and provided a strong supporter of this concept. Jon Rickert, a former state legislator, avid bird watcher, and personal friend of Gov. Julian M. Carroll, looked closely at the Illinois model and drafted the legislation that would be submitted to the legislature. As with most pieces of legislation, it was a tough sell the first time around. The agricultural community was largely suspicious of a state agency that would preserve land in perpetuity. This did not discourage those first ecologists and conservation supporters. Rickert knew that Governor Carroll supported the legislation, and it was rewritten to satisfy the concerns of the agricultural community by including members of the National Farm Organization, Soil Conservation Districts, and the Farm Bureau on the commission board. The bill, KRS 146.410, the Kentucky Nature Preserves Act (see Box 1), was introduced a second time, passed, and was signed by the governor. The Kentucky Nature Preserves Commission was born. Carroll then appointed the first five commissioners on September 17, 1976, and to no one's surprise, Jon Rickert became the commission's first chair. Donald Harker was appointed as its first director on August 1, 1977.

Times can be tough when you are a one-man operation. Harker, sharing an office with one part-time administrative assistant and other Natural Resources Cabinet officials, began the daunting task of organizing a state agency. With a budget of just thirty thousand dollars, which included both his and the administrative assistant's salary, he spent the first year playing the administrative game. It is easy to imagine the bureaucratic nightmares involved in creating new employee positions that fit Nature Preserves' needs, not the needs of the

foresters or wildlife biologists employed by the Division of Forestry or the Department of Fish and Wildlife Resources. Much of the first year was spent figuring out state government.

Within that time frame, however, Harker began to visualize how the agency would catalog the information that was generated by their biologists. Harker knew this methodology would be critical to the future success of the agency because his office needed to locate and map rare species and communities. He contacted the Conservancy and paid them thirty thousand dollars for Bob Jenkins's Natural Heritage Program methodology. Kentucky was the twelfth state to adopt this program. Once again, we were at the leading edge of some aspect of the conservation movement.

The Conservancy was impressed by this quick action and volunteered to pay half the salary if the Kentucky Chapter would hire a permanent director. In 1981, at an annual meeting at Natural Bridge, a twelve-person committee selected Hugh Archer as the chapter's first paid director. Thus began the coalescing of the Kentucky Chapter and Nature Preserves.

Archer and a part-time secretary set up an office in Lexington. His primary job was to raise money to protect land, and to that end he lived on the road. He dictated notes into a tape recorder and traveled the highways and byways of Kentucky in search of a buck. One year alone he put more than seventy-two thousand miles on his Renault, turning the car into a shambles. He remained director until 1983, when he tired of life on the road. After all, he was a lawyer who liked to broker land deals, not raise money. It was at this point that Archer decided to hire and train a new boss. In 1983 Mike Andrews took over as director and moved the chapter's office to Covington. Archer was then hired as director of land-owner contact. He subsequently moved to Frankfort and shared space with Nature Preserves until he was rehired as the chapter's director in 1985.

Like the Conservancy, Nature Preserves had a modest beginning with four permanent employees: a director, a botanist, a zoologist, and an executive secretary. The early days were dominated by gathering information from the literature and from various biologists, naturalists, and conservation activists throughout the state. This also meant visiting museums, herbariums, and various other scholarly institutions in search of information that could be added to the growing database. Don Harker loved being in the field, and he visited every single county during his tenure as director. He accompanied biologists on their trips to validate information collected from the literature. Once the database had sufficient information, Nature Preserves took the lead with the Kentucky Academy of Sciences and created the first rare and endangered species list for the state.

With Harker heading up Nature Preserves, Hugh Archer was able to work with his friend in developing and implementing the National Heritage Program. The results of this collaboration allowed both organizations to concentrate on protecting the most biologically significant lands based on information contained in the database. Theoretically, the

146.410 PURPOSE OF SYSTEM OF NATURE PRESERVES.

(1) All areas within the borders of the Commonwealth, except those which are expressly dedicated by law for preservation and protection in their natural condition, are subject to alteration by human activity. As part of the continuing growth of the population and the economic development of the Commonwealth, it is necessary and desirable that the overall impact on the natural ecology be considered when major alterations are proposed affecting same, and that certain areas of unusual natural significance be set aside and preserved for the benefit of present and future generations. Such unique areas are valuable as laboratories for scientific research, as reservoirs of natural materials not all of the uses of which are now known, as habitats for plant and animal species and biotic communities, as living museums of the native landscape where people may observe nature's web of life and our natural heritage, as places of historic and natural interest and scenic beauty, and as reminders of the vital human dependence upon fresh air, clean water, and unspoiled natural areas.

(2) It is therefore the public policy of the Commonwealth of Kentucky to secure for the people of present and future generations the benefits of an enduring resource of natural areas by establishing a system of nature preserves, protecting these areas and gathering and disseminating information regarding them, establishing and maintaining a registry of natural areas and otherwise encouraging and assisting in the preservation of natural areas and features.

146.415 DEFINITIONS.

As used in KRS 146.410 to 146.530

(1) "Natural area" means any area of land or water, or of both land and water, in public or private ownership, which either retains, or has reestablished to some degree in the judgment of the commission its natural character, though it need not be completely natural or undisturbed, or which has natural flora, fauna, biological, ecological, geological, scenic or archaeological features of scientific, aesthetic, cultural or educational interest;

(2) "Nature preserve" means a natural area, and land necessary for its protection . . . to be maintained as

nearly as possible in its natural condition and to be used in a manner and under limitations consistent with its continued preservation, without impairment, disturbance or artificial development, for the public purposes of present and future scientific research, education, aesthetic enjoyment and habitat for plant and animal species and other natural objects;

146.440 USES AND PURPOSES OF NATURE PRESERVES.

In order to secure for the people of the Commonwealth of Kentucky of present and future generations the benefits of an environment having one or more of the characteristics of a natural area, the commission is hereby empowered to acquire in the name of the Commonwealth of Kentucky and to hold in trust for the benefit of the general public an adequate system of nature preserves in the manner herein set forth, and for the following uses and purposes:

(1) For scientific research . . . natural sciences;

(2) For the teaching of biology, natural history, geology, conservation and other related subjects;

(3) As habitats for plant and animal species and other natural objects;

(4) As reservoirs of natural materials;

(5) As places of natural interest and beauty;

(6) As living illustrations of our natural heritage . . .

(7) To promote understanding and appreciation . . . of our unpolluted and unspoiled environment;

(8) For the preservation and protection of nature preserves against modification or encroachment [that might] . . . destroy their natural or aesthetic conditions;

(9) As places where people may observe nature's web of life and our natural heritage, and as reminders of the vital human dependence upon unspoiled natural areas.

146.475 NATURE PRESERVES TO BE HELD IN TRUST.

The fee simple estates . . . held as nature preserves are hereby declared held in trust . . . for the benefit of the people of the Commonwealth of Kentucky of present and future generations and are declared to be put to their highest, best and most important use for the public benefit.

program is the most important method in ranking protection priorities; in practice, many other factors enter into the equation.

Archer and Harker's original philosophy was to protect the tough preserves first, "tough" meaning properties that were high on the priority protection list but for which getting clear titles were a problem. Most such tracts had multiple landowners from whom property had to be purchased. For example, more than forty landowners in sixteen states and Madrid, Spain, needed to be included in negotiations to purchase Bad Branch in Letcher County. But the strategy worked, and several additional preserves were added to the system including Brigadoon Woods in Barren County.

The big break for Nature Preserves came when they received a $250,000 grant from the U.S. Environmental Protection Agency (EPA) to survey both the Eastern and Western Coal Field regions of Kentucky. This large chunk of money allowed Harker to hire several full-time staff members, including aquatic biologists Mel Warren, Ron Cicerello, and Keith Camburn, botanist Max Medley, and zoologist Floyd Scott. Additional personnel were hired, including summer interns, and the staff ultimately grew to about ten permanent employees. The EPA project provided funding to purchase vehicles, set up mapping operations, and develop the infrastructure of the Nature Preserves. With this initial seed money, Harker was able to build a budget incrementally that would convert part-time employees to full-time, permanent staff. Fortunately, he had friends in both the governor's office and the legislature who helped build Nature Preserves financial stability. The Natural Resources Cabinet budget liaisons, Nancy Osborne and Paula Moore-Carson, helped carry the cause of Nature Preserves as well.

The commission's initial priorities for selecting parcels as Nature Preserves were for (1) conservation, (2) interpretive education, (3) scientific research, and (4) passive recreation. In 1979, Judge Macauley Smith and his wife, Emilie, offered to donate 170 acres of land in Jefferson County to the Kentucky Chapter. The chapter declined the offer because the land simply was not ecologically significant. But Nature Preserves was approached, and because the Smith land certainly met the last three selection criteria, it became the first state nature preserve in Kentucky. It was named Blackacre State Nature Preserve and today serves as the environmental education "heart and soul" of Jefferson County.

In the beginning, like the Kentucky Chapter, Nature Preserves accepted several tracts that may not have had great ecological significance. Some of the early preserves did have historical significance, however, or met criteria other than the need for conservation. Three additional preserves were added in 1979: Six Mile Island, an 81-acre Ohio River island, and Jesse Stuart, 715 acres, in Greenup County; and 325 acres within John James Audubon State Park in Henderson County. The Audubon State Park Preserve was the first state-owned park property included in the preserve system. Other state park properties added in 1981 included portions of Carter Caves, Blue Licks Battlefield, and Natural Bridge. In

1983, portions of Pine Mountain and Cumberland Falls State Parks were added to the nature preserve system. The final park that was added was a cave located at Kingdom Come State Park in 1992. These efforts created a unique partnership between the Department of Parks and Nature Preserves, which worked to balance the protection of the resource with various recreational activities.

The early 1980s were a period of growth that led to remarkable achievements for both the Kentucky Chapter and Nature Preserves. By 1979, Kirwan Preserve in Woodford County and Dinsmore Woods in Boone County had joined the Conservancy's preserve system. It was during this period that Hugh Archer was able to solidify the foundation of the Kentucky Chapter. Perhaps the event that would most determine the future of the Kentucky Chapter happened in early 1985: the Atlantic Richfield Company donated $300,000 to the newly created Land Preservation Fund (an endowment that allows the Conservancy to acquire land). This gift provided the first permanent capital, and the interest from this fund gave financial security to the young chapter. At the same time, the Kentucky Conservator ("Acorn") Program, another capital-raising mechanism, was announced. This much-needed infusion of money allowed Archer to hire a staff that included a full-time secretary, a membership services coordinator, a development director, and a landowner-contact land steward. With a staff in place, Archer could now focus on developing a strategy for protecting land.

During this period there was substantial cooperation with Nature Preserves to re-rank endangered species, prepare natural diversity scorecards, and rank and prioritize potential preserve sites. The 1980 Kentucky General Assembly passed legislation creating a state income tax "checkoff." Under this program, Nature Preserves received 50 percent of the proceeds, but its staff was experiencing growing pains. The number of full-time employees increased to four, and there were sixteen soft-money employees. In 1982 the agency released its first publication in its scientific and technical series, identified 350 natural areas, and hired a new director, Richard R. Hannan. Six additional preserves were acquired from 1980 through 1983.

By the mid-1980s both organizations were now firmly established, and the growth experienced in the early part of the decade continued unabated. By the end of the decade, the Kentucky Chapter had established twenty preserves. Many projects were initiated and several were transferred to Nature Preserves or another land-management agency. Archer was a magician at working out deals to purchase preserves. He knew the system and he knew how to work it to the advantage of land protection. Additional tracts to the Daniel Boone National Forest (Cave Hollow, Gladie Creek, Baylor O. Hickman Memorial Preserve) were closed at this time as well as several sites that the Kentucky Chapter would manage themselves, including Jessamine Creek Gorge and Buffalo Trace, and several joint projects with Nature Preserves, including Woodburn Glade.

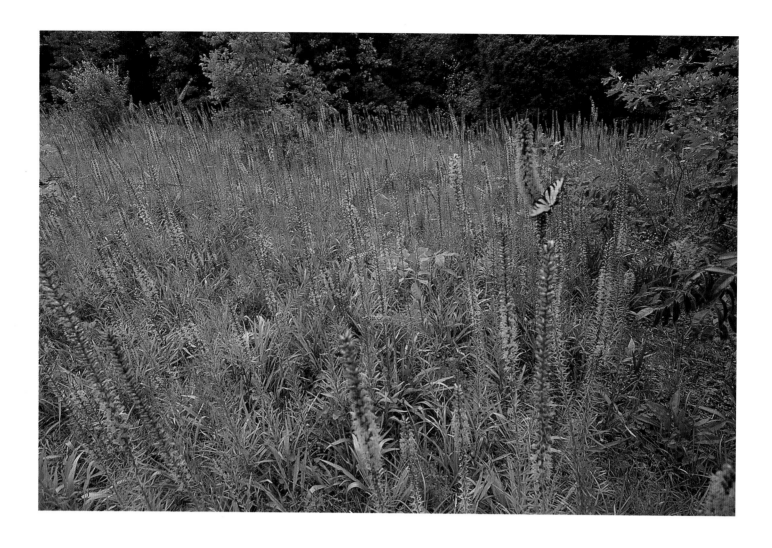

Dense blazing star and a tiger swallowtail at Log House Prairie.

Another extremely important project in cooperation with Nature Preserves was initiated in the mid-1980s. The Natural Areas Registry Program was developed in an effort to provide some level of protection to unique sites that private landowners were not interested in selling. In 1984, thirty-one such areas were added to the registry. By now Nature Preserves had acquired sixteen preserves encompassing 5,708 acres and natural-areas registries covering an additional 5,638 acres. Something had to give, and in November 1986 the first full-time stewardship coordinator was hired.

Other significant activities occurred during this period, including completion of a recovery plan for Short's goldenrod, publication of five scientific and technical series reports, the accumulation of more than sixty-three hundred records in the Natural Heritage database, the monitoring of more than 260 animal and 300 vascular plant species, and, most important, development of the county natural areas inventory in 1988. This inventory, which continues today, is an attempt to identify the most significant natural areas left in each Kentucky county. Forty-six counties remain to be inventoried.

Bold new changes in national conservation policy were beginning to emerge in the early 1990s that would ultimately shape how the Conservancy would operate in the future.

The Conservancy works under the premise that saving individual species requires protecting the ecological communities in which these organisms exist. This model has worked well. The Conservancy has protected more than eleven million acres in the United States alone and has estimated that 85 percent of our biodiversity can be protected using this "community" approach. But what about aquatic species, or migratory species that winter in the tropics? Although a great deal of attention was being devoted to protecting North American species and communities, little was being done to protect organisms or habitats in other countries. The Conservancy thus began an active international conservation program. At the domestic level, it was a leader in a new paradigm called "ecosystem management," a fundamental shift in conservation philosophy. It meant not just purchasing land that contained rare organisms or communities but working with local communities to create sustainable landscapes where all organisms, including people, can coexist.

The objective of this approach is to conserve and protect biodiversity. Because ecosystems range in size from a drop of water to the North American continent and are highly variable across a wide range of spatial scales based upon the geographic context of local stands, sites, watersheds, or regions, what happens at one scale is going to determine what happens at other scales. If we examine and manage an individual site that is embedded in a larger landscape, what happens in that landscape is going to affect the individual site. Furthermore, ecosystems do not respect human, political, or social boundaries. This means moving from a focus on purchasing one parcel of land that contains rare species to developing and working with larger landscape units, in particular watersheds, to provide for the sustainable use of resources within that region. Perhaps the best way of looking at the change in philosophy is to think big! Big ideas, big goals, big preserves—in fact, preserves embedded into larger management units called "bioreserves."

Under new management in 1988, Jim Aldrich took charge of the Kentucky Chapter. The chapter now had a strong financial backbone, and he directed it into new and different directions. With a $150,000 grant from the Steele-Reese Foundation in 1992, the chapter began planning for the Horse Lick Creek Bioreserve in Jackson and Rockcastle Counties. The significance of this site had been identified by Nature Preserves. This sixty-two-square mile watershed was designated one of the Last Great Places by the Conservancy the same year. In the spirit of a bioreserve and the concept of ecosystem management, the Kentucky Chapter entered into a memorandum of understanding with the U.S. Forest Service and Nature Preserves to upgrade the quality of life for everyone, or everything, in the watershed: the plants, wildlife, residents, and those who use the area for aesthetic enjoyment. But, as with any ecosystem project, one agency or organization cannot take all the credit, nor can great things be accomplished without creating enduring partnerships. Horse Lick Creek is certainly no exception to that rule. Other partners include the Kentucky Department of Fish and Wildlife Resources, the U.S. Fish and Wildlife

Service, the U.S. Natural Resources Conservation Service, the Cooperative Extension Service, the Environmental Protection Agency, the Kentucky Divisions of Water, Forestry, and Waste Management, and other state and private organizations. They all work within their own capacity to address the stresses on this ecosystem in order to provide for the long-term health of the aquatic, cave, and terrestrial communities within it.

In addition to the work at Horse Lick Creek, the Kentucky Chapter in concert with Nature Preserves and the Kentucky River Authority began a concentrated effort to protect habitat along the Kentucky River. Many preserves were created in the Palisades region, including Crossen, Jim Beam, Tom Dorman, White Oak Creek, and Sally Brown. With the addition of Jessamine Creek and the Shakertown property, which contains substantial palisades habitat in addition to the historic settlement, a large amount of palisades habitat has been permanently secured. The chapter copublished with Westcliffe Publishers The Palisades of the Kentucky River to celebrate its successes in protecting that region.

The day-to-day business of using Natural Heritage Program information to protect biodiversity has remained constant. Several other preserves were added during this period, including the highly significant Hazeldell Meadow and Eastview Barrens. Mantle Rock, with the assistance of Nature Preserves, Baumberger Barrens, and Indian Creek Cave rounded out the preserves acquired during this decade.

Development pressures on rural lands continued to escalate in the 1990s with rural rebound (urban folk moving back to the country on their one- to ten-acre "mini-farms"), continued urban sprawl, and ever-increasing population. The world was moving at a faster and faster pace. All this meant more pressure to protect Kentucky's significant natural areas. Unfortunately, state budgets did not allow for the rapid expansion of Nature Preserves efforts to complete the county natural areas inventory. By 1996 only 60 percent of the state had any type of natural area survey, and the comprehensive county natural areas inventory had been completed in only one-third of the counties.

With the first appropriation of general funds since the agency's inception in 1976, numerous individual sites were added to the Nature Preserves system during the 1990s. Sixteen additional preserves, representing a variety of rare communities, were dedicated. Half of Kentucky's largest old-growth forest, Blanton Forest, became the commission's thirty-second nature preserve in 1995. Other forested preserves added during this decade include a highly significant pine barrens (Hi-Lewis) in Harlan County; Quiet Trails, donated by a private landowner in Harrison County; Floracliff, the first private organization's land to be dedicated as a state nature preserve in Fayette County; Tom Dorman in Garrard County; and Vernon-Douglas, which was transferred from the National Audubon Society in Hardin County. Prairie or glade preserves added include Flat Rock Glade in Simpson County, Athey Barrens and Logan County Glade (the second county-owned preserve dedicated as a state nature preserve) in Logan County, Woodburn Glade in Warren

County, and Thompson Creek Glade in Larue County. Added wetland preserves include Axe Lake Swamp in Ballard County, Chaney Lake in Warren County, and Terrapin Creek in Graves County.

In September 1992, Richard Hannan resigned as director to take a position with the U.S. Fish and Wildlife Service. The following year, Robert McCance Jr. became Nature Preserves' third director. The mid-1990s were an active period of preserve dedications, but one critical miscalculation in dedicating a new tract of land at Bad Branch led to political turmoil that almost resulted in tragedy.

On September 17, 1997, a commission meeting, which Bob McCance described as "one of the longest and probably one of the most interesting in recent memory," was held at Western Kentucky University in Bowling Green. A significant amount of time was spent discussing the proposed route of U.S. 119 over Pine Mountain. The following determination was announced after much agonizing discussion: "There being an imperative and unavoidable public necessity for another public use of this property, which is the improvement of US 119 over Pine Mountain, the Commission hereby removes dedication from that portion of the Caudill tract necessary for the construction of Alternative 2 of the proposed US 119 project." In the end, as Kentucky conservationists have seen all too often, nature lost to the powerful Transportation Cabinet. The historical significance of this event was that a precedent had now been set that allowed for the undedication of a state nature preserve.

Because of the tremendous growth in the number of preserves, it became fairly obvious that one stewardship manager could not handle all these preserves. From 1986 to 1996, only one full-time staff person, with additional seasonal help, managed all the preserves. In 1996 funds were appropriated to hire two full-time regional managers. A third full-time manager position was created in 1998. With a much larger work force, management activities were increased. More frequent fires were ignited on prairies and barrens, caves were gated to keep people out, boundaries were cruised, exotic plants were removed, and a whole host of associated management activities were initiated.

Several additional technical reports were also published during the 1990s, including the Kentucky Breeding Bird Atlas and Butterflies and Moths of Kentucky. By 1994 the inventory of the Daniel Boone National Forest had been completed, with both the Kentucky Chapter and Nature Preserves staff providing recommendations for protecting biodiversity in the forest. Commission botanists began the arduous task of completing two recovery plans (on Eggert's sunflower and Braun's rock cress) mandated by the Endangered Species Act. Nature Preserves aquatic staff began monitoring mussels in the Green River.

Although conservationists and activists, being the pessimists they are, bemoaned the fact that the state was losing natural areas left and right, some good things were happening. The 1994 Kentucky General Assembly passed the Rare Plant Recognition Act, which

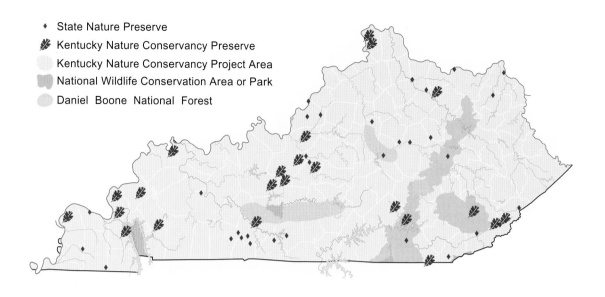

authorized Nature Preserves to create an official state list of endangered and threatened plants. Unfortunately, the law lacked any teeth because there were no criminal or civil penalties associated with destruction of the species or their habitat. At least it was a movement in the right direction. The most significant piece of legislation that passed created and appropriated monies for the Kentucky Heritage Land Conservation Fund.

It would be difficult to overstate the importance of KRS 146.55, the Kentucky Heritage Land Conservation Act. The act created the Kentucky Heritage Land Conservation Fund, which disperses grant monies for (1) natural areas that possess unique features such as habitat for rare and endangered species, (2) areas important to migratory birds, (3) areas that perform important natural functions that are subject to alteration or loss, or (4) areas to be preserved in their natural state for public use, outdoor recreation, and education. The act specifies that 50 percent of the monies are to be allocated equally among five state agencies. This means that Nature Preserves, Fish and Wildlife, the Division of Forestry, the Department of Parks, and the Wild Rivers Program each gets 10 percent of the funding. The remaining 50 percent is allocated to other state agencies, local and county governments, or state colleges and universities on a competitive basis.

The Kentucky Heritage Land Conservation Fund Board, comprised of members from five state agencies plus seven members appointed by the governor, determines how the monies are allocated. By the end of 1998, more than $17 million had been deposited into this fund. The source of this funding included $8.1 million from the state portion of the tax applied to unmined minerals, $6.3 million from fines collected by the Natural Resources and Environmental Protection Cabinet, and $1 million from the sale of environmental license plates.

Since its inception in 1995 the board has approved eighty-nine applications in forty-three counties across the state. In fiscal year 2000, an additional twenty-three projects in eighteen counties were approved. The properties that have been protected range from the eighty-acre Perkins Creek parcel in Paducah to a thirteen-hundred-acre tract in Harlan County that encompasses more than two and a half miles of a Kentucky Wild River Corridor. With the aid of this funding, Nature Preserves has purchased additions to Brigadoon, Flat Rock Glade, Axe Lake Swamp, Terrapin Creek, Eastview Barrens, and Hi-Lewis Barrens. It has also allowed the commission to purchase several additional significant sites, including Crooked Creek Barrens (Hymes Knob) in Lewis County and Blanton Forest in Harlan County.

Other state agencies have also benefitted from this important source of income. The Kentucky Department of Parks has purchased additional properties adjacent to Natural Bridge and Audubon State Parks. The Kentucky Department of Fish and Wildlife Resources has purchased Latourneau Woods and additions to the Barlow Bottoms, Hardin Bottoms, Central Kentucky, and Kentucky River Wildlife Management Areas. The Division of Forestry has obtained additions to the Green River, Pennyrile, and Kentucky Ridge State Forests. Finally, several county fiscal courts have purchased outstanding tracts, including parts of Laurel Creek Gorge in Elliott County, Stone Mountain in Harlan County, and the Lost River Cave in Warren County.

CHAPTER TWO

2

BIODIVERSITY OF KENTUCKY

As a society we may have always had a fascination with rare things. We like collecting, and in some cases this collecting has caused problems for both Nature Preserves and the Kentucky Chapter because unscrupulous folks will remove rare orchids or moths from their preserves. This issue aside, as a society we became concerned about protecting rare species in the late 1960s. There is no question that the passage of the Endangered Species Act of 1973 was the impetus behind the nation embracing the concept that endangered species and their habitats are valuable and should be protected. But the history of concern for the protection of biodiversity goes back even further, to when Aldo Leopold, Howard Zahniser (a journalist with a love for nature who drafted the Wilderness Act legislation), and Bob Marshall (a U.S. Forest Service scientist who helped organize the Wilderness Society) began campaigning for protected wilderness areas.

Aldo Leopold, the father of modern wildlife management, recognized the intricacies of nature when he wrote in A Sand County Almanac, "If the land mechanism as a whole is good, then every part of it is good, whether we understand it or not. If the biota, in the course of eons, has built something we like but do not understand, then who but a fool would discard seemingly useless parts? To keep every cog and wheel is the first precaution of intelligent tinkering." These wise words, written in the 1940s, may help us "tinker" with, or manage intelligently, our vast wild plant and animal resources, "nature's cogs and wheels," in the rapidly changing world of the new millennium.

We have tinkered with the land mechanism (the ecosystem) since time began. Agriculture, forestry, mining, and urban and industrial development have all impacted the wild

lands that native plants and animals need to survive. In the 1930s, when our nation recognized that some wildlife species numbers were declining, sportsmen, natural resource managers, and scientists rallied together and began restoring populations and managing numerous game or endangered wildlife species, such as the white-tailed deer, wild turkey, wood duck, bald eagle, and whooping crane.

What about the remainder of the "cogs and wheels" of the natural system? The largest percentage of native plants and animals are neither game nor rare. For example, less than 12 percent of all wildlife species are considered game animals, yet the survival of the other "cogs and wheels" is critical to the survival of game wildlife. How can we manage for all the parts that keep the ecosystem healthy? Before we can answer that question, we must ask, "What is this variety of life we are managing?" Is it the variety of unique genetic building blocks found among individuals of a representative species? Is it the variety of living organisms found in a particular area, such as the thousands of plants, mammals, amphibians, reptiles, insects, and other less visible organisms at places like Natural Bridge State Resort Park? Is it the variety of species and their interactions with one another and with the environment? Is it a landscape mix of wetlands, grasslands, forests, and meadows? The answer to all these questions is yes! We are managing for biodiversity.

Biodiversity is about living organisms and ecological processes. "Biological diversity refers to the variety and variability among living organisms and the ecological complexes in which they occur," stated Congress' Office of Technology Assessment in 1987. "Diversity can be defined as the number of different items and their relative frequency. Thus, the term encompasses different ecosystems, species, genes, and their relative abundance." The Keystone Center National Policy Dialogue on Biological Diversity adopted a simpler definition: "the variety of life and its processes." So what really is biodiversity?

Broadly interpreted, biodiversity has two components: first, the rich and varied forms of life found around us, from bacteria to buzzards, fungi to flying squirrels, and wildflowers to wild turkeys; second, the various interactions, processes, and cycles found in nature that link these groups into populations, communities, and ecosystems. Most of us inherently understand the first component. We are aware that there are many different kinds of plants, animals, and other organisms that make up the living world around us, though often we do not understand the sheer enormity of the numbers of living organisms. Scientists have identified and described about 1.4 million living species on Earth, but they estimate that perhaps as many as 28 million more remain unstudied.

Because of the complex interrelationships in any given ecosystem, however, many people without scientific training have difficulty understanding the second component of biodiversity. The best way to help explain this idea is by using an example. Imagine an ecosystem as a spider web. Each living organism has a unique position or role in an ecological community. This is the point of intersection with the spider web. Each of these

organisms is linked to another organism, just like the strands that connect points in a spider web. We cannot fully predict what will happen if we lose one point in that ecological spider web. As a species disappears from an ecosystem, other species that rely on it for their existence are weakened and ultimately threatened. Thus the intricate web of life in which it survived becomes less complex.

Because biodiversity is so complex, it is useful to return to the original question: What is this variety of life we are managing? Biological diversity includes genetic diversity, species diversity, ecosystem diversity, and landscape diversity.

Genetic diversity is perhaps the least understood of these. Each individual organism is a unique chemical and genetic factory unlike any other of its species. For example, no two humans are alike. A gene is a reservoir of information that has taken centuries to develop and cannot be duplicated or retrieved once it has been lost. A diverse or varied gene pool provides a hedge against an unknown future, allowing a species to adapt to constantly changing environmental conditions.

Species diversity is the level of biodiversity that usually receives the most attention. The term refers to the many different varieties of plants, fungi, fish, amphibians, reptiles, mammals, birds, and other organisms that make up the living world. To maintain species diversity, we must understand how species change from place to place and how they change over time at the same place. More than 3,000 vascular plant, 230 fish, 103 mussel, 105 amphibian and reptile, 350 bird, 75 mammal, and 12,000 insect species call Kentucky home. Of this number, 11 percent of the plants, 36 percent of the freshwater bivalves, 31 percent of the fishes, 23 percent of the reptiles and amphibians, 15 percent of the birds, and 33 percent of the mammals are listed as rare, threatened, or endangered.

Ecosystem diversity deals with the groups of various species living in an area, the ecological processes that link them, and the soil, air, and water that support them. Many different kinds of ecosystems—hardwood forests, wetlands, prairies, streams—occur in different physical settings. Table 2 lists the major ecological communities found in Kentucky.

To understand landscape diversity, we must take a step back and look at the geography of Kentucky. The political boundaries of Kentucky encompass many different ecosystems within a diverse topography. In the eastern mountains one can find communities characteristic of New England, whereas western Kentucky harbors ecosystems common to Texas and Louisiana. Kentucky's landscape is a mix of grasslands, bottomland hardwood wetlands, streams, forests, and meadows, presenting more diversity than an area composed mostly of grassland or forest. Now that you have a general understanding of the various levels of biodiversity, the next question is, "Why should we care?" Why should we care, for example, about some nondescript, rarely seen snail? Would it make a difference if we knew this snail never gets cancer? And if scientists discovered why this is so and applied this knowledge to prevent or cure cancer in humans? This is just one simple example of why people should care about protecting and managing for a variety of living organisms.

TABLE 2. Kentucky Ecological Communities

LACUSTRINE COMMUNITIES

Floodplain lake

PALUSTRINE COMMUNITIES

Riparian forest
Alluvial forest
Floodplain ridge/terrace forest
Bottomland hardwood forest
Wet prairie
Bottomland marsh
Sinkhole/depression marsh
Sinkhole/depression pond
Floodplain slough
Coastal plain slough
Acid seep
Calcareous seep
Cretaceous hills forested acid seep
Appalachian acid seep
Depression swamp
Cypress swamp
Shrub swamp
Bottomland hardwood swamp

RIVERINE COMMUNITIES

Sandbar
Mud flat
Typic gravel/cobble bar
Cumberland Plateau gravel/cobble bar

TERRESTRIAL COMMUNITIES

Deep soil mesophytic forest
Acidic mesophytic forest
Calcareous mesophytic forest
Acidic subxeric forest
Calcareous subxeric forest
Xeric acidic forest
Xeric calcareous forest
Xerohydric flatwoods
Appalachian mesophytic forest
Appalachian subxeric forest
Cumberland highlands forest
Coastal plain mesophytic cane forest
Bluegrass mesophytic cane forest
Appalachian pine-oak forest
Red cedar–oak forest
Hemlock-mixed forest
Virginia pine forest
Siltstone/shale glade
Limestone slope glade
Limestone flat rock glade
Dolomite glade
Cumberland Plateau sandstone glade
Shawnee Hills sandstone glade
Sandstone prairie
Limestone prairie
Tallgrass prairie
Sandstone barrens
Knobs shale barrens
Limestone barrens
Bluegrass savanna-woodland
Pine savanna-woodland
Cumberland Mountains xeric pine woodland

Biologists contend that if the loss of biodiversity continues, many aspects of our quality of life will be lost. The diversity of life benefits us in infinite ways. The answer to why we must maintain biodiversity touches on practical, ecological, aesthetic, and ethical reasons that ultimately affect our quality of life.

The practical reasons for maintaining biodiversity are many, and they cannot be disputed. The world's food supply, for example, depends on about twenty plant species that

Ice formation on Energy Lake at Land Between the Lakes.

were derived from native or wild ancestors. Twenty years ago blight wiped out about one-fifth of the corn crop in the United States. By crossing domestic varieties of corn with their wild cousin, scientists created a type of corn resistant to blight. One of our most important agricultural defenses against blight, pests, drought, and disease may be to invigorate domestic species by hybridizing them with their wild counterparts. With modern genetic techniques, scientists are now able to capitalize on new genetic information—information that holds unlimited possibilities for helping mankind and nature.

Imagine that you have a cold or fever and take aspirin to relieve the symptoms, or you have an infection and take penicillin to fight it. Did you know that aspirin is derived from the willow and penicillin from a common fruit mold? Or another example. A compound called cyclosporine was identified and extracted from a mushroom. Scientists discovered that this chemical had the ability to suppress the rejection response common in tissue transplants. Thousands of people undergoing heart, lung, liver, kidney, and bone marrow transplants are alive today because of the introduction of this drug. Many people are surprised to learn that one-fourth to one-half of all our medicines contain native or wild plant extracts.

Each "cog and wheel" of Leopold's land mechanism is part of the great body of genetic information that may be useful to humans. Because each species is unique, to lose

one species is to deny future generations the opportunity to use that species and its chemical and genetic secrets to improve their quality of life. The quest to identify useful organisms that may improve the quality of our lives has just begun. Scientists have described less than one-half of all living things on this planet. Of all the plants and animals we do know, less than 1 percent have been tested for their possible benefit to humans. We have barely started to unlock the potential benefits of the world's plants and animals. With the loss of each species we may be destroying the potentially important drug or agricultural commodity of tomorrow.

The ecological reasons are equally compelling. Biologically diverse communities of plants, animals, and other species provide indispensable ecological services. At the most basic level, diverse biological communities sustain all life, including human. Natural systems provide the oxygen we breathe, recycle wastes, maintain the chemical composition of the atmosphere, and play a major role in determining the world's climate. These are certainly not insignificant reasons. But there are additional ecological reasons that may be easier to understand.

Although scientists have been studying nature for years, we are still largely ignorant of the complex interrelationships in any given ecosystem. Remember the example of the spider web and losing individual intersection points? Remove one point and the web of life probably will not fall apart. No one knows how many of nature's "cogs and wheels" or species in the web of life can be removed without turning an ecosystem into rubble. No one can predict if or when a catastrophe will strike. It is certain, however, that we are eroding the fabric of life with each species lost. Consider a simple example. There is only one wasp species that pollinates the majority of fig trees that grow in the tropics. What would happen if that wasp were eliminated from the ecosystem? Because figs are an important food source for many tropical birds and mammals during the dry season, losing the figs might mean losing bats, spider monkeys, peccaries, and other species dependent on the figs for food. Once these animals were gone, we would lose the jaguars and other predators.

Species also serve as environmental barometers. Their conditions may tell humans that something is wrong with the environment. Just as canaries once warned coal miners of poisonous gases, some species warn us about unhealthy ecosystems. The same factors that cause more sensitive creatures to decline may ultimately affect the human population. Consider freshwater mussels. Mussels feed by filtering food from the water; as a result they accumulate environmental pollutants in their tissues. When water pollution levels become too high, these animals die. Increasing amounts of silt in streams from agriculture, mining, road construction, and urban development cause further problems for these freshwater clams. The number of mussel species in a stream is a direct measure of the water quality of that stream. How long before these toxins accumulate in the people who depend on that

TABLE 3. Native U.S. Species at Risk

MAJOR GROUP	PERCENTAGE AT RISK	MAJOR GROUP	PERCENTAGE AT RISK
Freshwater mussels	67.1	Butterflies/skippers	21.8
Crayfishes	64.8	Ferns	21.5
Amphibians	37.9	Tiger beetles	20.2
Freshwater fishes	37.2	Dragonflies/damselflies	18.3
Flowering plants	33.0	Mammals	16.1
Conifers	27.5	Birds	13.9

water supply for their drinking water? In Kentucky, many species of freshwater mussels have become extinct, and others are now rare or in danger of becoming extinct. This tells us we have severe water quality problems in many of our streams throughout the state. Throughout Kentucky and the United States the most highly threatened groups of organisms are associated with water (see Table 3).

It can be argued that endangered and threatened species serve as indicators of entire ecosystems in trouble. The northern spotted owl, for example, is an indicator of the loss of mature or old-growth, temperate rain forest, the red-cockaded woodpecker is an indicator of the loss of mature longleaf pine forests, and the golden-cheeked warble is an indicator of the loss of mature cedar thickets in the Texas hill country. It does not take a rocket scientist to figure out that white fringeless orchids are rare in Kentucky because they occur in a very threatened ecological community, the acid-seep. Table 4 provides a short list of examples of significant ecosystem decline or destruction.

The aesthetic beauty of the many and varied life-forms with which we share the earth is another reason for preserving biodiversity. As a society, we spend billions of dollars acquiring, protecting, and enjoying beautiful works of art, music, and architecture. We are outraged when vandals attack precious paintings or sculptures. Have you ever looked closely at a monarch butterfly, a lady's slipper orchid, or a Kentucky warbler? Their beauty and intricacy rival the finest works of art. Shouldn't we protect them? Do you enjoy hiking in the lush forests of our state? Do you like to hunt or fish? Are you a photographer capturing a white-tailed deer or a dwarf crested iris on film? Are you inspired to paint because of the beauty of nature surrounding you? These and many other aesthetic and recreational activities depend upon healthy, biologically diverse ecosystems.

Finally, many people believe we should manage for biodiversity because we have a moral or ethical responsibility to future generations. We are wiping out species at the rate of at least one per day. Future generations are entitled to expect an environment as biologically rich as the one inherited by our own generation.

TABLE 4. Selected Ecosystem Declines in the United States and Kentucky

ECOSYSTEM OR COMMUNITY	PERCENTAGE OF DECLINE OR DEGRADATION
Pacific Northwest old-growth forest	90
Northeastern pine barrens	48
Tallgrass prairie	96-98
Palouse prairie	98
Blackbelt prairie	98
Midwestern oak savanna	98
Bluegrass savanna (unique to Kentucky)	99.9
Longleaf pine forest/savanna	98
Southeastern coastal plain canebreaks	98
Riparin or stream-side forests	70-90
Northeatern coastal heathlands	90
Wetlands	50% (80% in Kentucky)

For me, it is an ethical issue. The good Lord gave humans dominion over the plants and animals, but he also trusted us to be good stewards. It is our duty to care for the natural world, for if we don't, "the land mourns, and everything that dwells in it languishes; the beasts of the field, the birds of the air and even the fish of the sea perish" (Hosea 4:3).

Perhaps this section should end with a few thoughts about rare species and ecosystems in Kentucky. In many cases, species and communities now rare in Kentucky may have always been rare or uncommon. The grass pink orchid, the rose pogonia orchid, and dozens of other species were probably never common because their habitat needs are highly specialized. On the other hand, many species and communities have become rare because of human activities. There is no question that a species such as running buffalo clover was at one time much more abundant. Habitat destruction and the subsequent invasion of exotic organisms rank as the two prime reasons most species populations decline or become extinct.

The Kentucky Chapter and Nature Preserves have listed eleven rare plant communities that occur in Kentucky: the forested canebreak in the Inner Bluegrass region; the post-oak flatwoods and mesic lowland flatwoods in the Coastal Plain and the western Pennyroyal regions; the central dry-mesic barrens in the Shawnee Hills; the tallgrass prairie and moist tallgrass prairie in the western Pennyroyal and Coastal Plain; the eastern alkaline glades of the Pennyroyal; the shale glades found in the Knobs; the shrub/acid-seep wetlands found in the Cumberland Mountains and Plateau; and the southern Appalachian mafic cliffs of the Cumberland Mountains. As you will discover in this book, both the Kentucky Chapter and Nature Preserves have done an excellent job of protecting at least one of each

of these rare community types. Protect the communities and you protect the rare species associated with them.

How does the Kentucky Chapter and Nature Preserves protect our unique biological heritage? It takes money, pure and simple. Money to do inventory to identify species and sites, money to hire biologists, and money to purchase land. But we must face the fact that we do not have unlimited resources, either financial or human, for protecting every single acre of natural land. Organizations must have some system that enables them to protect the most important areas or species first. As biologists began collecting information about species and their communities, it became increasingly clear that better information on the status and distribution of organisms and natural communities was necessary if they were to make sound decisions regarding the expenditure of limited resources. In 1974 the South Carolina Department of Wildlife and Marine Resources and the Conservancy launched the first state Natural Heritage Program. Since that time, all fifty states, the District of Columbia, five Canadian provinces, and numerous agencies have adopted this computerized database methodology of classifying, coding, storing, and retrieving information on "elements" of biodiversity.

What is an element? As used in this context, an element is nothing more than shorthand for an organism or natural biological community. The element is the primary functional unit of the Natural Heritage Program methodology. Using the term "element" makes life easier on everyone who uses the information in the database. Once the information has been collected in the field, biologists assign the element a rank according to its rarity and degree of endangerment. Information on the element is then entered into the computerized database, mapped, digitized, and stored. Initial records often are obtained from the scientific literature, fieldwork, knowledgeable individuals, or museum or herbarium specimens. Then the hard work begins. Biologists at Nature Preserves coordinate field inventories to confirm the precise location of each species or community, population size, and vulnerability or threats (in Kentucky, more than six hundred elements are considered rare, threatened, or endangered). The field aspects of this system are ongoing, and information is added or updated continually. The end product is an ever-evolving and increasingly more definitive atlas of information.

The important thing about this system is that it is standardized all over the United States and throughout the world, allowing scientists to compare organisms or communities for their relative contribution to biodiversity on a state, regional, national, and global scale. Nature Preserves developed and standardized the ranking system that is used by the Kentucky Chapter to prioritize areas that need protection or some other form of conservation activity. Biological characteristics that suggest need for a significant level of protection include the presence of rare species, biological richness of the area, an outstanding example of a high-quality ecological community, or a high-quality stream with an abundance of

aquatic organisms. Individual species are given a "G" rating that indicates their level of global rarity. In Kentucky, most of the G1 (the rarest of the rare) species are mussels, such as the orangefoot pimpleback, or cave beetles, such as Roger's cave beetle. These species, like Short's goldenrod, are globally rare, having low populations that occur in limited areas. These are also species that could be highly threatened by destruction of their habitat. At the bottom of the ranking system is G5, for a species that is threatened within the state but more common elsewhere. The western pygmy rattlesnake, for example, occurs in a very isolated population in western Kentucky but is more common in other states. The painted trillium is another G5, occurring at high elevations in the Cumberland Mountains and threatened within the state but abundant in the northern hardwood forests of other states, where it would not be a listed species.

The biodiversity or "B" rankings indicate the professional evaluation of the significance of any particular parcel of land. At the top of the ranking system, B1, are those communities that have outstanding significance as natural areas. To receive this ranking, an area must be the best example of an ecological community that is globally endangered. These communities, almost by default, contain numerous rare species. Biologists must be able to defend such a ranking based on targeted elements and documentation that the ecological processes and system is still intact.

The Big South Fork of the Cumberland River in southern Kentucky is an excellent example of a B1 macrosite (large area). This area contains a very high-quality river system with numerous rare fish, mussels, and other aquatic organisms that are ranked as G1 or G2 species. In addition, it harbors globally rare plants such as the Cumberland sandwort (a G2 species) and animals such as the Indiana bat (also a G2 species). Sometimes one single element, such as Short's goldenrod at Blue Licks Battlefield State Park or at Buffalo Trace Preserve, can result in a B1 ranking.

The second-level, or B2, communities have very high significance, such as the best occurrence of a globally endangered organism or the single most outstanding occurrence of a globally threatened and rare organism or natural community. An example is Bad Branch, which has a high-quality stream with excellent water quality and many organisms rare in the state, such as the painted trillium. Another example is the Cave Hollow area of the Daniel Boone National Forest, in which numerous individual caves harbor rare bats.

B3 communities have high significance and may hold marginal occurrences of globally threatened or rare organisms. These communities may have a concentration of state-endangered elements. Ash Cave in the Cave Hollow B2 area is classified as a B3 site because about one hundred Indiana bats and Virginia big-eared bats use the cave.

The B4 communities are moderately significant and have excellent occurrence or multiple concentrations of state-threatened or endangered species or natural communities. Axe Lake Swamp in western Kentucky is an example of a B4 community that is part of a

Overleaf: *Rock Bridge in Daniel Boone National Forest.*

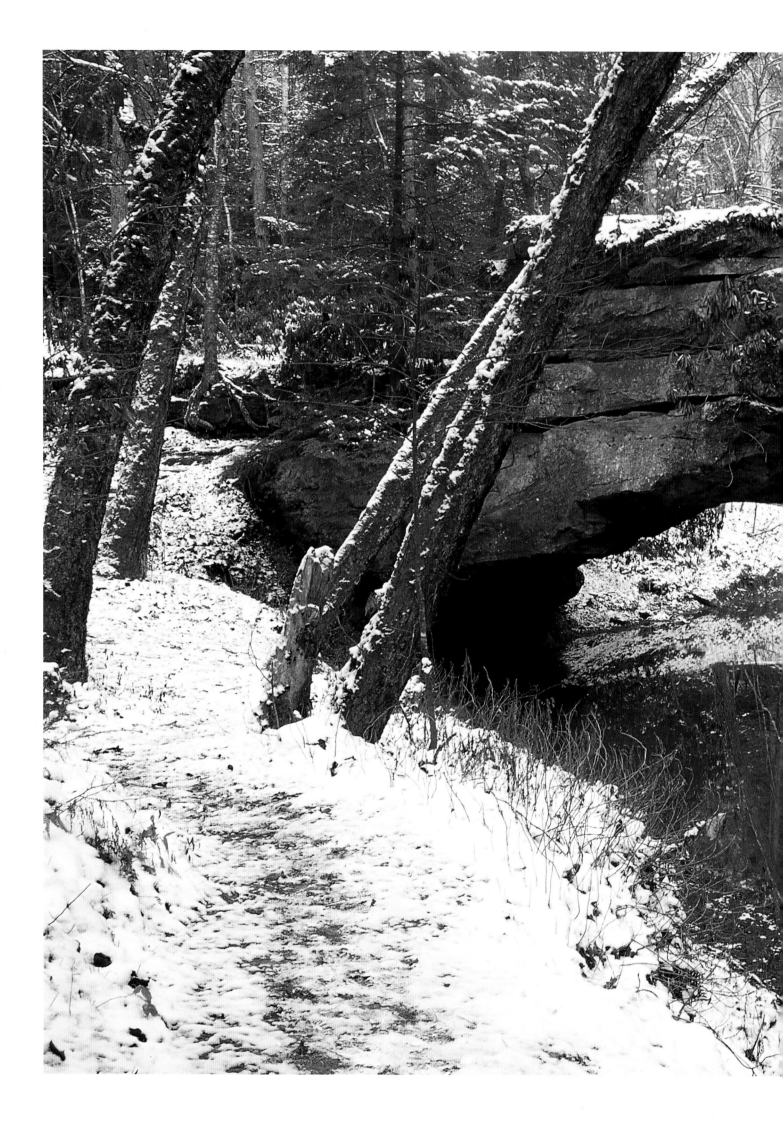

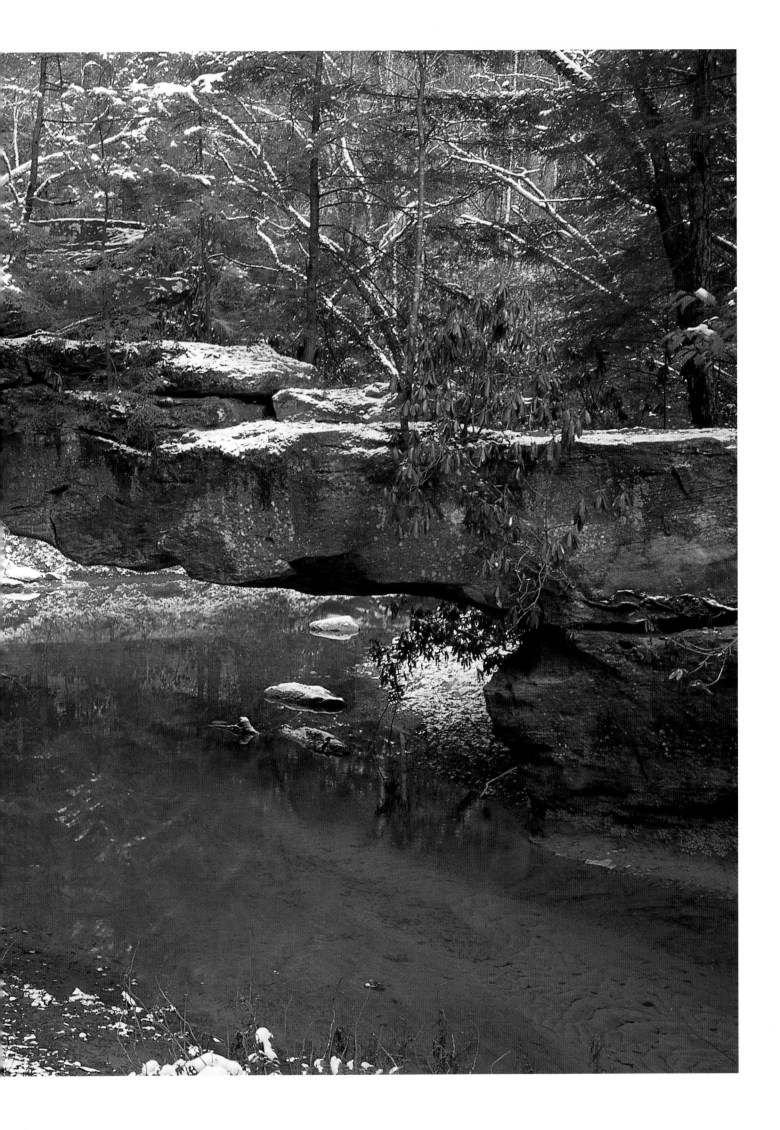

larger macrosite, the Ballard Bottoms, which is ranked B3. These wetland communities hold numerous species rare in Kentucky, such as green tree frogs and copper iris.

The final ranking category is B5. In general, these sites have no priority as protection sites for either the Kentucky Chapter or Nature Preserves because they contain no rare or threatened organisms. This does not mean these areas are not worthy of protection by another state agency, such as Kentucky Fish and Wildlife or a local or county government. The Jesse Stuart Nature Preserve in Greenup County would be an example of a B5 site. No rare organisms are found there, but it has the potential to be a foraging site for the Indiana bat because of its proximity to Bat Cave Nature Preserve in Carter County. In addition to the global listing, Nature Preserves also maintains an "S" listing, which ranks communities and species according to their rarity in the state.

Although data are gathered primarily in support of monitoring and developing protection priorities, this information is also provided to other agencies, organizations, businesses, and individuals for the purposes of resource management, development planning, or research. Some other ways the data are used include ensuring compliance with endangered species, wetland, mining, or clean water laws and regulations by developers or anyone who requires a federal permit to proceed with particular activities associated with those acts. By using the database information during planning stages, it is hoped that development or transportation projects can reduce any possible environmental impacts on significant sites. The information also assists managers of parks, wildlife management areas, and other wild land areas in making informed decisions concerning management practices on their properties. Finally, the data are invaluable for assisting with research and long-term environmental monitoring.

Inventories of natural areas are the most important tool biologists have in determining the relative scarcity of natural communities. The timely completion of any state's natural area inventory is a critical factor in identifying the areas in need of protection and management. Nature Preserves developed the county natural areas inventory in 1988, but by 1996 it had sufficient resources to complete only twenty-three counties and anywhere from 10 to 80 percent of fifty additional counties, leaving forty-seven counties completely unassessed. At the present rate, it will take another thirty years to complete this inventory. By then much will be gone.

Completing the inventory is vital. The value of prompt identification can be illustrated with a single case study: Blanton Forest. Before the natural areas inventory in Harlan County was begun in 1992, the largest old-growth forest known to exist was Big Woods in Mammoth Cave National Park. While flying in a helicopter during the inventory, an ecologist for Nature Preserves noticed an area on Pine Mountain with exceptionally large tree crowns. This led to the "discovery" of Blanton Forest. At this time the size of the old-growth forest measured 2,350 acres. By examining old aerial photographs, it was deter-

mined that this forest had covered more than 7,500 acres in the late 1970s. They say timing is everything. In this case, conducting an earlier county natural area inventory would have revealed a much larger old-growth forest worthy of protection.

The county natural-area inventory is a well-defined process conducted in five systematic steps: (1) biologists evaluate aerial photographs, geologic, topographic, and soil maps, and any other available resources, to select potential natural areas; (2) a helicopter aerial survey is conducted to determine the accuracy of the desk work and to eliminate sites that no longer exist; (3) a Nature Preserves staff member contacts the owners of the potential natural area and requests permission to visit the site to obtain qualitative data; (4) biologists conduct a field study to collect data, then analyze and process the data into the Natural Heritage Program database (at this point Nature Preserves uses this data to prioritize areas for conservation action and to determine if the site is suitable as a state nature preserve); and (5) Nature Preserves develops a protection strategy for significant natural areas that considers all possible options for protection and may involve other agencies and organizations, including but not limited to the Kentucky Chapter.

A variety of methods are used to protect sensitive areas, ranging from voluntary agreements with private landowners through the Natural Areas Registry to outright purchase. Usually the Kentucky Chapter can purchase land more quickly than Nature Preserves because of the length of time required for the latter to comply with various state regulations. For example, Nature Preserves can purchase land only at the fair market value, and the appraisal must be conducted by a state-approved appraiser. If the purchase price exceeds $100,000, an additional appraisal is required before other purchasing protocols can be initiated. Although purchasing land seems pretty straightforward, some landowners ask an astronomical price for the land once they learn the state is interested in purchasing it.

Sometimes suitable land is donated during the landowner's lifetime or is included in an individual's will. These are considered charitable contributions, since they ensure the protection of the land while reducing the taxable value of the estate. Only three of the original state nature preserves were acquired in this way. Sometimes individuals donate land that is not ecologically significant. In this case, the Kentucky Chapter will agree to accept these tracts in order to sell them and use the proceeds for more ecologically important areas. Landowners sell their property at below fair market value, and the difference between the fair market value and selling price may be considered a charitable contribution.

Several additional methods can be used to protect land. The first is a voluntary verbal agreement between a private landowner and Nature Preserves. The property is then entered into the Natural Areas Registry and the landowner is recognized for owning and voluntarily protecting an outstanding natural area. Advice is also provided on how to manage the area. Unfortunately, this is not a binding agreement, and if the land is sold, a new

agreement must be arranged with the new owners. In this case, the land always belongs to the property owner, who receives no tax benefit. Typically, the landowner agrees to contact Nature Preserves or the Kentucky Chapter before implementing changes that may affect the rare species or community or before selling the property.

Sometimes land can also be protected through a conservation easement. This is a legal transaction by which the landowner agrees to terminate some specific rights associated with his or her property. This could be the right to harvest timber, mine for coal or other minerals, or even develop the property. The specific agreements are then contained in a conservation easement that remains attached to the deed for the land. If the land passes on to heirs or is sold, the conservation easement remains in effect in perpetuity.

Generally speaking, the most expensive avenue is purchasing the land outright. One of the great benefits for a chapter of a national organization is the ability to borrow capital quickly and at very low interest rates when land becomes available for purchase. Once a purchase option or fee simple title has been obtained, the Conservancy may then pass the title or option to an appropriate governmental agency and be reimbursed for the purchase price. This was one method of acquiring state nature preserves before passage of the Kentucky Heritage Land Conservation Act. This has also been a very effective method of adding ecologically sensitive areas to the Daniel Boone National Forest.

When the land becomes a preserve, it then must be managed. Management varies with each preserve, ranging from minimal actions, such as boundary posting and monitoring in the case of some old-growth forests, to providing frequent desirable disturbances, such as periodic burning of a prairie. Perhaps the biggest expense at this point is having sufficient resources, financial and human, to monitor activity on the preserve, develop a plan, and conduct whatever management is required to maintain the preserve in a predetermined ecological condition. The Kentucky Chapter and Nature Preserves use volunteer assistance with monitoring and management, but there are some things that volunteers can not do and staff must handle. Common management activities include prescribed burning, exotic plant removal (either by hand or by herbicides), fencing, litter cleanup, trail construction and maintenance, and boundary posting and patrolling. Hunting, even as a management activity, is not currently allowed on any land owned by the Kentucky Chapter or Nature Preserves. Monitoring these activities, in addition to simply monitoring plant and animal populations, keeps the stewardship staffs working overtime.

Because some preserves contain very rare and sensitive organisms or fragile habitats, they are not open to the general public. I have been fortunate enough to visit many preserves to photograph the flora and fauna for this book and for other projects. Most people can gain access to these preserves by attending one of the regularly scheduled field trips or volunteer work days. For those preserves that are open to the public, the following activities are forbidden in an effort to protect the land and its inhabitants:

1. Bicycling, camping, building fires, horseback riding, prospecting, rock climbing, spelunking, or swimming

2. Collecting plants, animals (either dead or alive), or mineral specimens, including shells, berries, nuts, mushrooms, or wildflowers

3. Using motorized vehicles (in particular, off-road vehicles) of any sort except on authorized roads

4. Fishing, hunting, or trapping unless otherwise specified, as in the case of Metropolis Lake in McCracken County

5. Taking pets, including leashed dogs, with the exception of seeing-eye dogs

6. Artificially feeding wildlife

7. Introducing any plants or animals

Although much has been accomplished in the last twenty-five years, there is much more that needs to be done. The pressures on our natural areas are greater now than ever before. Time is of the essence if we are to protect the remaining Last Great Places. You can continue to help by becoming a member of the Nature Conservancy, by contributing to Nature Preserves' trust fund, by purchasing an environmental license plate, by contributing to the nature and wildlife fund tax checkoff, by making an outright financial or land-tract donation to either organization, and by examining your own lifestyle to determine if you are living in harmony with the natural world.

THE LAST
GREAT PLACES

3

THE BLUEGRASS

Today, there are few sites in the Bluegrass region that are managed purely for their natural qualities. The remaining natural areas certainly do not represent all the ecological communities that historically occurred in the Bluegrass. Most of the protected sites occur along the Kentucky River Palisades and its primary tributaries, such as Jessamine Creek, and within several significant mature and old-growth forests in northern Kentucky, including Boone County Cliffs and Dinsmore Woods on Kansan glacial deposits and the Lloyd Wildlife Management Area (Lloyd Woods), which is a small but very impressive old-growth forest in Grant County. At present, the only intact, protected savanna is a tiny ten-acre remnant at Blue Licks Battlefield State Park. However, both the Conservancy and Nature Preserves are diligently working to find the "best" remnant savannas where the trees remain intact. Once these sites are protected, they can begin the laborious task of determining not only what to restore in the understory but also how to restore the entire community and bring back the pre-European bluegrass savanna. Not an easy task.

For the purpose of this book, the Bluegrass region can be subdivided into the Inner and Outer Bluegrass and the Eden Shale Belt, which directly surrounds the Inner Bluegrass. This subdivision is based primarily on the underlying geology. The Inner Bluegrass contains the oldest limestone rocks in the state. The geology is unique and is determined by the outcrop of the Middle Ordovician limestones. The Eden Shale Belt, or "Eden Hills," contains shales from the Upper Ordovician age. The Outer Bluegrass, also of Upper Ordovician origin, contains more limestone than the Eden Shale Belt. To simplify matters, I have placed the belt within the Outer Bluegrass region. The two primary faults are in the

Overleaf: *Sunset along the Kentucky River.*

56

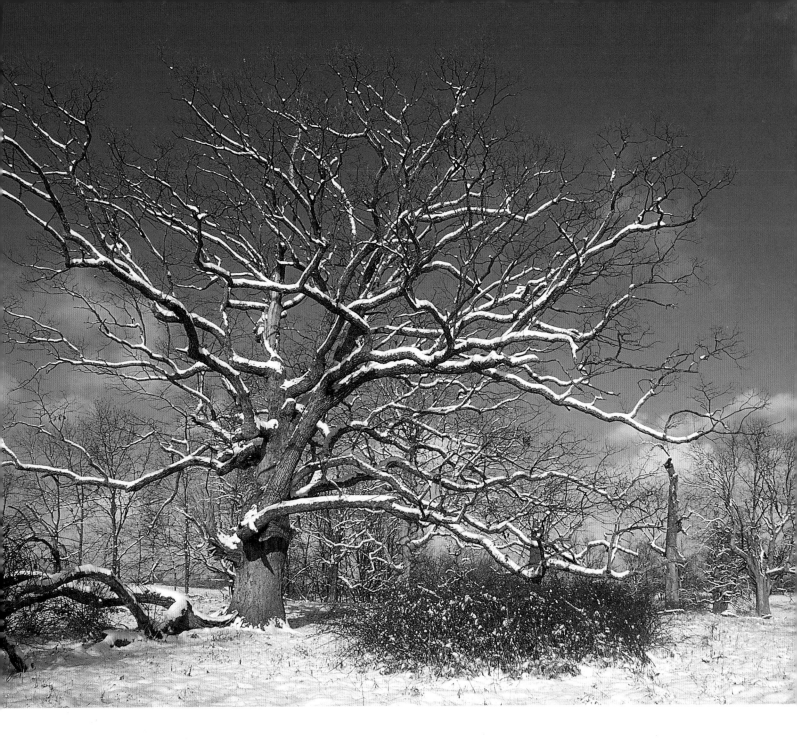

Kentucky River Fault Zone. In this area, younger Upper Ordivician shales dropped down into the rock fractures, creating a less fertile soil and a difference in the vegetation found there. This is one reason that most of the protected lands within the Bluegrass region lie in the Kentucky River Palisades and its associated drainages. With this foundation, let's begin our journey to discover the uncommon biological wealth of the Bluegrass region.

Few remnants of the blue-grass savanna exist in Kentucky. Most of these blue ash and bur oak savannas are located on private land.

THE INNER BLUEGRASS

When most people think about Kentucky, they think of the Bluegrass region, Thorough-bred horses, white fences surrounding lush green pastures, and bourbon. Author Julian Campbell writes, "Due to its salt springs, rich soils and open woods, which were easily

The palisades provide habitat for a variety of rare and unique organisms, including the starry cleft phlox, shown here.

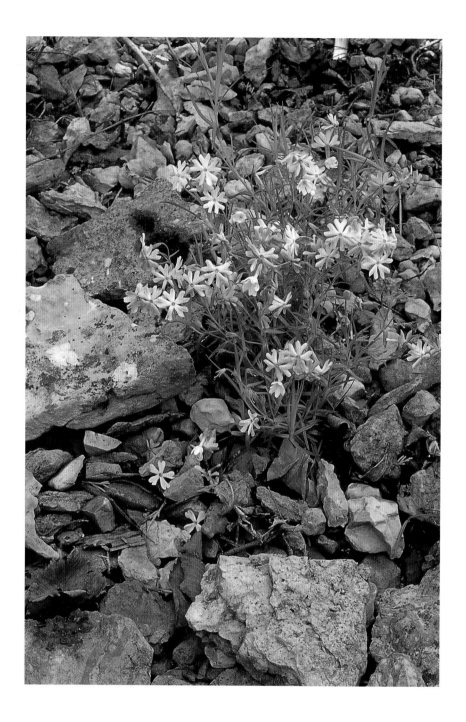

cleared, this was the first region of Kentucky to be intensively settled by Virginians. Early on it became the agricultural, financial, and political 'Heart' of Kentucky." Kentucky's historian laureate, Thomas D. Clark, looked at it this way: "Bluegrass Kentucky is more than a region which can be definitely located by a geologist or a geographer upon a soulless map. It is not alone a matter of geographical tangibility, but it is likewise a state of mind . . . and a satisfactory way of life." This region's early settlement and subsequent "satisfactory way of life" have left an indelible mark upon the public perception of Kentucky.

This unique landscape, with its moderate climate and fertile soils, led to the production of high-quality livestock, particularly the Thoroughbred horse. It also influenced the

character of the human culture and lifestyle associated with the horse. The Bluegrass region became quintessential Kentucky. Unfortunately, these developments took a heavy toll on the region's original vegetation and wildlife. Settlement occurred so rapidly, and without documentation of existing flora and fauna, that we will never know for certain what this region looked like before European colonization. What we do know is that there are some "patriarch" trees—bur, chinquapin, and Shumard oaks; blue and white ash; and coffee trees—that remain in the landscape and serve as narrators, telling us about earlier times when the "tree was placed in a beautiful plain surrounded by a turf of fine white clover . . . to which there is scarcely anything to be likened" (Col. Richard Henderson's journal, May 14, 1775). Unfortunately, these massive monoliths of ages past are no longer producing the next generation of patriarch sentinels, and we don't know why.

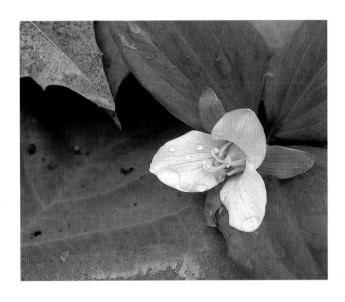

Snow trillium.

Destruction of the bluegrass savanna is certainly nothing we can take pride in. Why? We have the distinction of being one of the very few states that have allowed the functional extinction of a unique ecosystem found nowhere else in the world. Considering this extinction, you might ask, Are there any Last Great Places left in central Kentucky? The answer might surprise you. Let's take a journey through time to rediscover the natural biological heritage of this region.

In 1950, E. Lucy Braun, a noted botanist, described this area as "the most anomalous vegetation area of the eastern United States." The original lush, grassy meadows under the massive blue ash and bur oaks, grazed by bison and elk, must have been an astonishing site to the early settlers. The first trees encountered by Thomas Walker as he crossed the Ohio River near Maysville were blue ash, the Kentucky coffee tree, and honey locust, all typical of the Bluegrass region. The unique savanna landscape with its accompanying plants and animals appeared to be "a second paradise" to Daniel Boone as he peered down "from the top of an eminence . . . and saw with pleasure the beautiful level of Kentucky." In 1782, the infamous frontier renegade and so-called white savage Simon Girty, addressing the assembled Native American tribes before marching on Bryan Station, described the Bluegrass: "The fertile region of Kentucky is the land of cane and clover . . . spontaneously growing to feed the buffaloes, the elk and the deer; there the bear and beaver are always fat." News of this exciting land with its rich, fertile ground and abundant wildlife spread quickly along the eastern seaboard. People began pouring in by the thousands. By 1790, the population of Kentucky is reported to have reached 3,677 (Wharton and Barbour 1991). It was by no coincidence that this rapid population growth led to the quick demise of wildlife and natural communities. No botanists or zoologists were present to record the original flora or fauna.

Braun perhaps does the best job describing the extinction of this unique ecosystem: "The Inner Bluegrass is a fertile and prosperous section of rolling land with a mild karst topography, interrupted near its southern boundary by the gorges of the Kentucky River and its tributaries. Except in these gorges, which are in no sense representative of the Bluegrass, no natural vegetation remains. Old forest trees, widely spaced in a carpet of Kentucky bluegrass, dot the extensive estates. From these it is not possible to construct a picture of the original condition. . . . The absence of undergrowth, of shrubs and native herbs, is striking; hence no clue to original conditions may be obtained from this source. The bluegrass (*Poa pratensis*) from which the section gets its name is generally conceded as not indigenous here; it was not part of the original vegetation."

From the few early records that did describe the trees and the remaining large presettlement trees found on horse farms and other "woodland pastures" we can arrive at a glimpse of the presettlement Bluegrass "forest." In general, this region was well timbered, but not with dense forest. The trees were scattered and open grown, their limbs stretching out to touch the clear blue sky and dropping to the ground only to begin the process of reaching to the sky again. Col. Richard Henderson wrote about one of these open-grown trees in his journal: "The trunk is about four feet through to its first branches, which are about 9 feet high from the ground. . . . It so regularly extends its large branches on every side . . . as to form the most beautiful tree[,] . . . and every fair day it describes a semicircle on the heavenly green around it upwards 400 feet, and anytime between 10 and 12[,] 100 persons may commodiously seat themselves under its branches. This divine tree . . . is to be our church, statehouse, council chamber, etc." (May 14, 1775).

These trees had, and still have, character. They were not the dense forest trees that are perfectly pruned, straight and tall, reaching for the stars so they can compete for sunlight with their neighbors. Braun stated, "These cane lands and wild rye lands were not treeless and must have contrasted strongly with true grasslands. . . . The forest of the Bluegrass could not have been dense if it was adorned with variety of flowers of most admirable beauty in all but the three winter months. The lack of showy flowers during all the summer months is certainly characteristic of our denser deciduous forests."

What little "remnant" savanna that remains occurs in isolated, widely spaced patches, and the tree composition probably has not changed a great deal since the presettlement period. Francoix Michaux described the trees growing on "first class land" as coffee tree, walnut, ash (white, blue, and black), hackberry, buckeye, bur oak, sugar maple, beech, and poplar. C.W. Short's 1828 Florula Lexingtoniensis stated that black locust occurred in "profuse abundance," as it does today. Other common trees he encountered were sugar maple, black and white walnut, hackberry, wild cherry, "chestnut white" oak (interpreted to mean chinquapin oak), and "black" oak (interpreted to mean bur oak). White and blue ash were abundant, as were shellbark hickory and common buckeye. Papaw was a common understory tree. Hence the native forests or areas with open-grown trees, particularly those

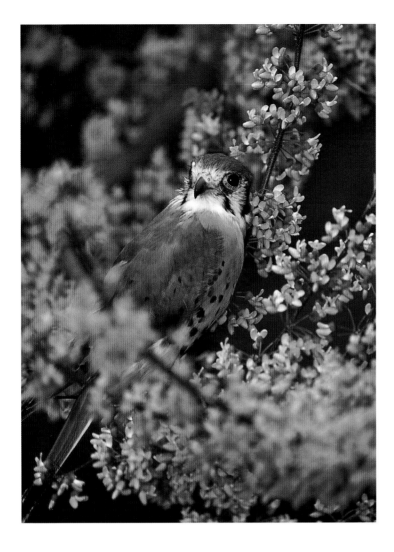

The bluegrass savanna landscape provides excellent habitat for birds such as the American kestral, which needs a lot of open space for foraging and large, scattered trees for nesting.

growing on the rich, fertile soils, are distinct from those of all other areas of the state and may have changed little over time.

What of the understory? What about the land of cane and clover? There are numerous historical references that mention extensive "canebrakes." John Filson, Kentucky's first historian, wrote in 1784, "Here we find mostly first rate land. . . . Great tract is beautifully situated, covered with cane, wild rye, and clover. . . . There are many canebrakes so thick and tall that it is difficult to pass through them. Where no cane grows there is abundance of wild rye, clover, and buffalo grass, covering vast tracts of country." In 1783, settler Spencer Records wrote, "We found ourselves in a large canebrake where we could get no wood to make a fire." Gilber Imlay, a British traveler, commented that "the country is immensely rich, and covered with cane, rye-grass, and the native clover. The cane is the reed that grows to the height frequently 15 or 16 feet, but more generally 10–12 feet, and is in thickness from the size of a goose-quill to that of two inches." Finally, James B. Finley wrote in his Autobiography that his father settled on Cane Ridge in Bourbon County on "part of an unbroken canebrake extending for twenty miles." Braun speculated that "the great quantity of cane, mentioned repeatedly in early publications, must have presented an aspect not now

found in any deciduous forest. . . . It is difficult to picture a forest land, covered with cane, wild rye, and clover." Certainly there is evidence that extensive canebrakes were a feature on the landscape, but the entire understory could not have been completely dominated by this "dense, thicket-forming, rank coarse grass" because there are also numerous references to "open, grassy, meadows" in early writings.

John Filson continued his discussion of the Bluegrass region: "The fields are covered with abundance of wild herbage not common to other countries. The Shawanese salad [Braun interpreted this to be waterleaf, or Hydrophyllum], wild lettuce, and pepper-grass, and many more, as yet unknown to the inhabitants." James Nourse wrote of the region in his journal in 1775, "It is light with timber. . . . The growth of grass under amazing [sic]; blue grass, white clover, buffalo grass . . . and what would be called a fine swarth of grass in cultivated meadows; and such was its occurrence without end in little dells." A year later Levi Todd reported that "between the brakes, spaces of open ground as if intended by nature for fields . . . produced amazing quantities of weeds of various kinds, some wild grass, wild rye, and clover." In 1788, Thomas Hutchens, a geographer and surveyor, described "extensive meadows or savannas." There is even one early record of the grassy meadows being called "prairie." John Bradbury wrote in 1809, "Along the Elkhorn there were great beds of cane, and, at one pleasant spot, a prairie, grass covered and treeless."

What we don't know about the grassy meadows is what the specific plant composition was. It is generally believed that the grasses were dominated by various species of wild rye, and we know that the clover was running buffalo clover, one of only two native North American clovers. Most ecologists and botanists now agree that Kentucky bluegrass was probably not a component of the original herbaceous plant community. Did the prairie grasses, or the warm season bluestems, Indian grass, and switchgrass occur in the grassy meadows? One can only wonder. They may not have occurred in the Inner Bluegrass because there are no remnant patches except in rocky gravel bars along the Kentucky River. They almost certainly occurred in the Outer Bluegrass because several nice patches of big bluestem, Indian grass, little bluestem, and switchgrass have been documented. Sometimes these species pop up out of nowhere after resource managers burn old fields or make forest openings. Other showy herbaceous plants that undoubtedly occurred in the Bluegrass include Miami mist and various asters and goldenrods, the latter two giving rise to spectacular fall colors along roadsides and in idle pastures and old fields.

The Palisades

The Kentucky River Palisades and associated gorges along creeks contain the largest, and perhaps only, natural areas within the entire Inner Bluegrass region. This area has outstanding scenic value in addition to harboring numerous rare organisms. Within the central

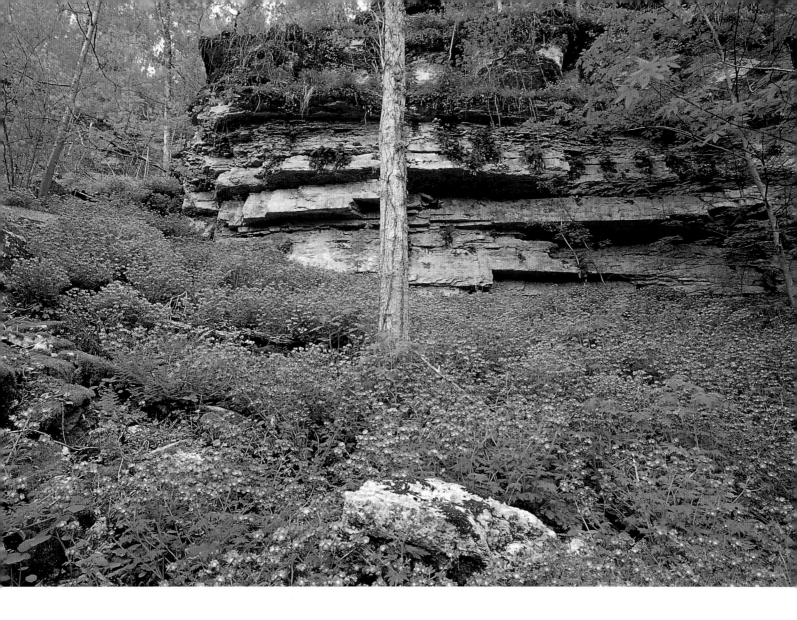

Kentucky landscape, the palisades are the only Last Great Place remaining. Let's take a trip down the river to get a feel for the unique qualities of this special place.

The weather forecast predicted a break in the storm followed by clearing and a wonderful evening. So I called my good friend Scott and said, "Let's go down by the river and try to get some fall color shots if this weather's going to break. We might actually get some great sunset shots."

We arranged to meet on Sunday, taking our two children, Jeremiah and Jayson, along. We loaded up the boat and headed for Camp Nelson. Not long after we put the boat in the water and began to meander down the river at a leisurely pace, the clouds gave way to beautiful sunny skies. It was late afternoon when we stopped somewhere along Polly's Bend, where the limestone cliffs are reflected in the slow-moving greenish water. The golden late afternoon light created a surreal effect upon the palisades, making them almost glow. After photographing the reflection of the cliffs in the river, we decided to try to find a spot where we could get images of the sunset reflected in the water.

Back in the boat, a few more meandering miles, and we located a spot where we predicted the sunset would be perfect for our cameras. We docked the boat, got all our gear

The Palisades region is noted for its stunning limestone cliffs. The best way to see the palisades is by boat, where you may be treated to a display of purple phacelia under the cliffs.

out, and the boys began exploring along the banks of the river. It was not yet sunset, so we poked around. As with all good adventures, the boys' curiosity led them to a number of discoveries. In some nice alluvial soil patches surrounding large rocks that jutted out into the river, they found several diamond-shaped gypsum crystals. My discovery was a bit different. I looked around and noticed one of the nicest patches of big bluestem grass I had seen anywhere in the state of Kentucky. I wondered to myself, How did that get here? Surely this grass must have existed in the Bluegrass savanna at some point in the past. But several botanists in the state contend that the native prairie grasses never occurred in the Bluegrass. What I did not know at the time was that this small riverbank ecological community, dominated by big bluestem, river oats, riverbank goldenrod, and shrubby St. John's wort, is considered a globally rare vegetative type. You might also encounter switchgrass, tufted hair grass, or blue false indigo on these grassy, steep, rocky riverbanks.

As we sat there, the ripples in the river dissipating, the water became glasslike and the magnificence of the sky was reflected on the water. Perfect for a sunset reflection photograph. But then we heard something. "Is it a boat?" asked Scott. "I hope not," I replied. "That will completely ruin the reflection of the sunset on the river." We waited a few minutes, but no boat. After a few more minutes the sound stopped for a brief time, then resumed. No boat. But what could be making that sound? We soon discovered the source. Someone along the bank, not far from us, was filling a bagpipe with air. Within minutes, incredible sounds began to emanate from that point, filling the silence of the wilderness with some of the most beautiful music I have ever heard. As we sat there and enjoyed the music, I thought, What a treat. Here we are in this unspoiled area along the Kentucky River, a beautiful wild area, and we are listening to the melodies of the Scottish countryside. Then, as the sky began to change colors, we received our second treat of the evening, an incredible sunset. The sky turned purple, then red and orange, then a more intense purple, then more intense red and more orange. Then it was gone.

After a few intense moments of shooting film, we sat quietly, waiting for the light to disappear completely from the sky, feeling privileged to have been given several wonderful gifts that afternoon along the Kentucky River. First the gift of seeing our children explore the bank and discover interesting rocks and plants. Then the gift of wonderful light on the palisades, those four-hundred-million-year-old rocks. Finally, the gift of seeing a wonderful sunset, hearing spectacular bagpipe music, and knowing that it doesn't get any better than this.

This was just one of many trips Scott and I have taken along the Kentucky River to photograph, or fish, or just look. There has never been a time on this river when we haven't been treated to something special. One time we watched a massive white-tailed buck swim across the river right in front of us. Once on the bank, he looked like a mountain goat as he clambered almost straight up the cliff, as if it were no obstacle, until he was out of sight. We almost always see wood ducks and Canada geese flying in front of us or watching

One of the most significant ecological sites in the Palisades is Jessamine Creek gorge. The blue phlox shown here appears just prior to where the creek drops into the gorge.

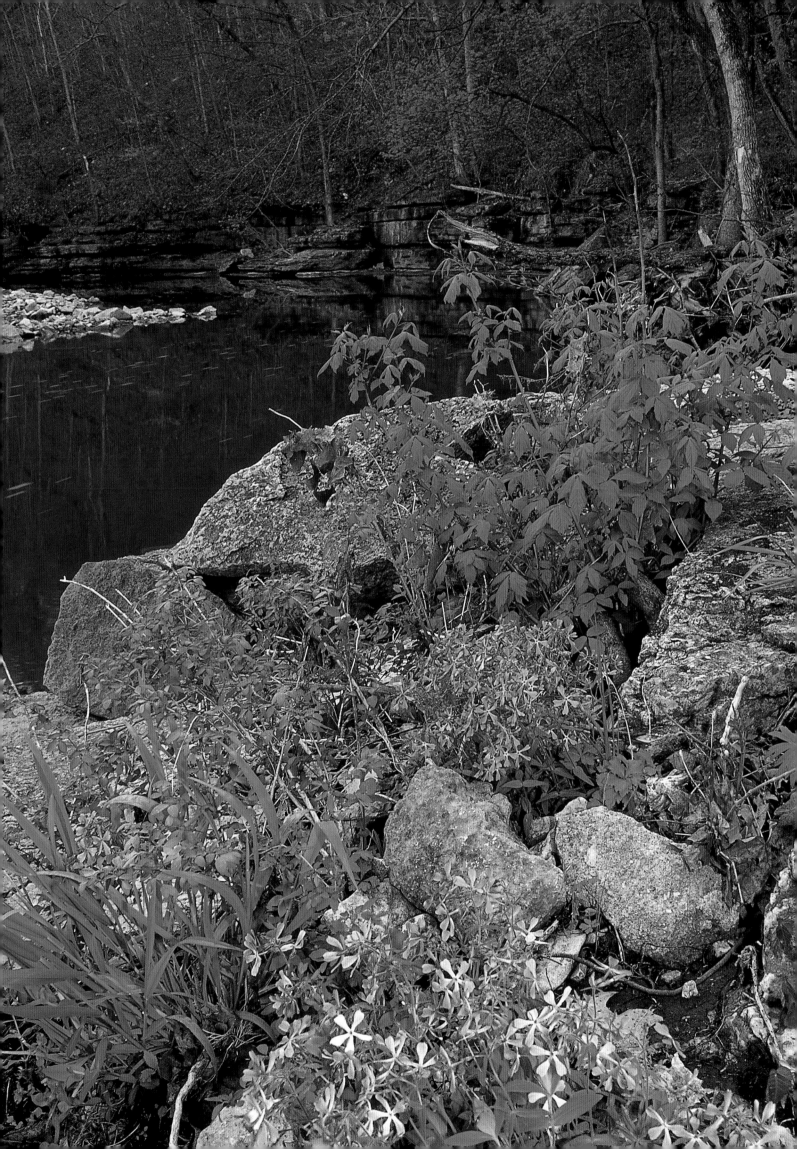

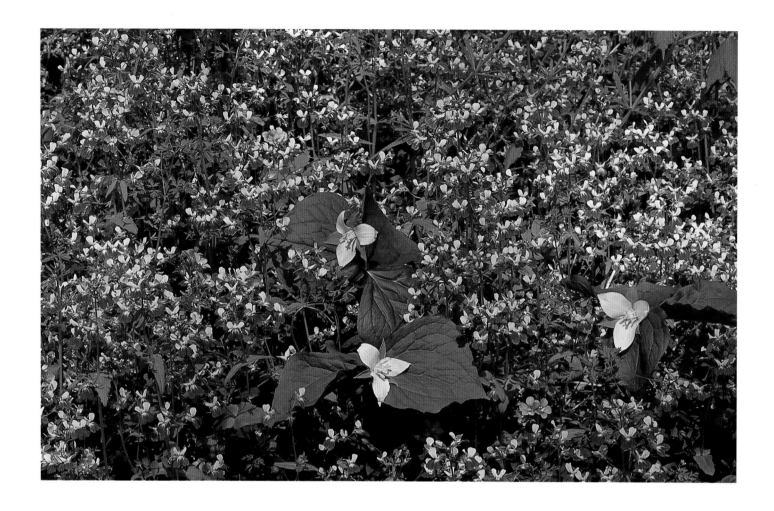

Raven Run is noted for its outstanding display of blue-eyed Mary flowers, shown here with nodding trillium.

closely over their brood of youngsters. We often see green herons and kingfishers, and one time we were treated to an osprey catching fish. The Palisades region is certainly the Last Great Place of central Kentucky. In fact, it is probably the only significant natural area left in the Inner Bluegrass physiographic region. In one gorge alone, more than four hundred vascular or flowering plants have been identified.

Both the Kentucky Chapter and Nature Preserves have recognized these outstanding natural qualities and have worked to protect the Palisades region. The Kentucky Chapter has acquired Jessamine Creek Gorge, the Jim Beam Preserve, White Oak Creek Preserve, Crossen Preserve, the Sally Brown Preserve, and the adjoining Crutcher tract. Nature Preserves has the Tom Dorman Preserve in Jessamine and Garrard Counties. Other protected lands in the region include the Shakertown property, the Bluegrass Sportsman League, Floracliff State Nature Preserve and Raven Run Nature Sanctuary in Fayette County, and the Kirwan Nature Preserve and Buckley Wildlife Sanctuary in Woodford County.

The Kentucky River's palisades and associated gorges contain the largest concentration of forest within the Inner Bluegrass region. The steep and rugged mesic forests are dominated by sugar and black maples; basswood; northern red, chinquapin, Shumard, and white oaks; white and blue ash; black walnut; Kentucky coffee tree; American and slippery

elm; shellbark and bitternut hickorys; tulip poplar; and Ohio buckeye. Less common trees include rock elm, yellowwood, and yellow buckeye. Typical understory shrubs include dogwood, black haw, hornbeam, bladdernut, and spicebush. Rare or unusual herbaceous plants found in the rich forests include narrow-leafed wild leek, synandra, and Short's rock cress, which occurs in erosion-prone areas around tree bases.

One of the most spectacular aspects of these mesic forests is the outstanding spring wildflower display. The nutrient-rich, limestone-based soils give rise to a floral show that is virtually unrivaled in North America. It can begin as early as February, depending on the weather, but often starts in earnest in early March, when spring cress, cut-leaf toothwort, hepatica, and the snow trillium show off their beautiful colors. It continues until early May, when the leaves in the forest canopy are flush with new growth and the forest gets darker. The end-of-spring display is often signaled by the flowering of wild hyacinth, fire pink, and Miami mist.

Raven Run Nature Sanctuary, owned and managed by the Lexington-Fayette Urban County Government, is widely known for its outstanding display of blue-eyed Mary, which flowers in mid-April. Hikers, naturalists, and photographers descend upon this region by the thousands during the spring wildflower season to revitalize themselves after a long winter. They come to observe, paint, photograph, and enjoy the grandeur Mother Nature has to offer at one of her finest hours.

Many folks do not get up early to meet the morning sunrise, particularly during the work week. For a photographer and naturalist, mornings are a special time of day. I have always enjoyed getting up early, getting my feet wet with dew, listening to and observing birds and photographing wildflowers. An added bonus is that early in the day there are few people on the trail to interrupt the solitude and my soul's refreshment by the magnificent world the Lord gave us.

Follow me on a morning walk through Raven Run. After checking in at the nature center, I walked through the meadows and down the blue trail heading toward the old mill. As I casually strolled along, I occasionally stopped and listened. "Chick a dee, dee, dee" called the diminutive Carolina chickadee. That sound was broken by the loud drumming of a male ruffed grouse. Here I was in central Kentucky, a landscape dominated by horse farms and suburbia, fifteen minutes from the city, and this wonderful bird, found more commonly in the forests of eastern Kentucky, was participating in its annual tradition of trying to find a mate. If it weren't for the forested corridor along the banks of the Kentucky and its tributaries, many birds would not be found here in any abundance.

As I walked farther, I noticed six deer. They stopped, looked, and listened. I didn't move. The wind was in my favor, sending my scent away from their sensitive noses. But the deer appeared to be spooked, then quickly descended the slope and disappeared across Raven Run Creek. Why? I walked a few more yards before the blood-curdling cry of a

bobcat provided me with the answer. As I continued my walk past the mill, up the slope, and over to the flower bowl, I heard "gobble, gobble," coming from the power line right-of-way. Ten years ago this booming sound, which heralds the coming of spring, would not have been possible. Thanks to the Kentucky Department of Fish and Wildlife's restocking efforts, wild turkeys are now abundant in all parts of the state, including central Kentucky.

It was early April. Spring had definitely sprung with a profusion of white and yellow trout lily, bloodroot, twinleaf, rue and false rue anemone, spring cress, cut-leaf toothwort, hepatica, and yellow corydalis. I spent all morning photographing until my film ran out and I was tired and ready to call it a day. I repeated this ritual throughout the spring season, and each week something new came into bloom. The following week it was sessile trillium, Dutchman's breeches, squirrel corn, Virginia bluebells, and early saxifrage. Following that it was wood poppy, blue-eyed Mary, bent trillium, dwarf larkspur, Jacob's ladder, and violets. From late April into early May the season finished out with fire pink, wild hyacinth, columbine, and Miami mist. Each week new birds, migrating from their Central and South American winter residences, broke the morning silence. Some, such as the yellow-breasted chat and blue indigo, would stay and breed. Other songbirds would rest, then move north to their breeding grounds.

The Palisades region harbors the largest concentration of rare plant and animal species within the Bluegrass region. Some of these species occur in a most unusual habitat for this area, dry rock cliffs, cliff tops, and the ledges of rocky points at the mouths or bends of secondary streams. I have been fascinated by what I call "life on the edge." These plants, which can occur in remarkable concentrations, grow in minute amounts of soil. They survive these hot, dry conditions because they are uniquely adapted for this life on the edge.

These plants exist in a red cedar–chinquapin oak forest. Well, forest may be a bit of a stretch. Red cedar, usually considered a pioneer tree, was a stable component of this vegetative community, even prior to European settlement. In his 1773 journal, James McAfee wrote, "We crossed the [Kentucky] river at high hills and cedar banks." Henry McCurtie in his 1818 treatise Sketches of Louisville and Its Environs wrote about the Kentucky river cliffs, "some of which are from four to five hundred feet in height, crowned with groves of red cedars." Other woody plants encountered here include wafer ash, prickly ash, ninebark, and aromatic sumac.

This plant community includes several rare grasses and wildflowers that could be classified as threatened or endangered, among them Svenson's wild rye grass, mountain lover, and starry cleft phlox. Other rare plant species that occur in this habitat include glade and purple melic grasses, prairie-satin grass, glade and Walter's violets, and northern mouse-eared chickweed. Purple cliff brake and wall rue ferns are commonly seen in many crevices. Other more common wildflowers, such as prickly pear cactus, American agave, wild columbine, Carolina pink, hairy penstemon, pink stonecrop, and aromatic aster, can

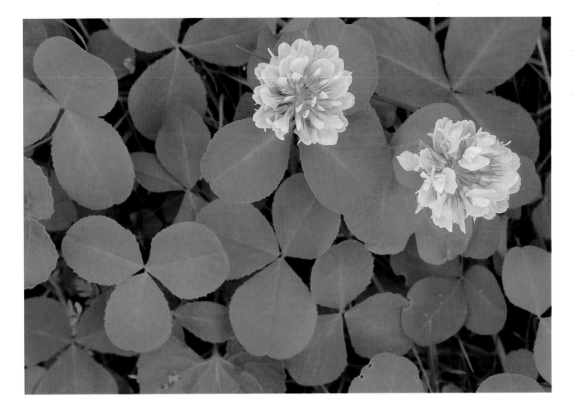

be locally profuse and provide spectacular floral displays at certain times during the growing season.

The cliffs and other habitats, particularly caves, associated with the karst topography in central Kentucky provide habitat for two federally endangered bats, the Indiana and gray, as well as several other rare species, including the northern long-eared and evening bats and the Allegheny wood rat. At least twenty-five mammal species and thirty-five reptile species call the palisades home. I will not easily forget the time I was photographing yellow trout lily and I found a young Jefferson's salamander in a rotting log. It was such a treat to share this discovery with a family from out of state who were visiting Raven Run. The two young children were delighted to see and hold such a fascinating, "slimy" creature.

Although the forests and cliffs are the dominant landscape features harboring rare and unique species, many of the old fields associated with the preserves or sanctuaries provide outstanding habitat for a variety of butterflies. Patches of common milkweeds, dogbanes, asters, and goldenrods attract numerous butterflies. I have captured on film mourning cloak; hackberry; tawny emperor; green and gray commas; hop merchant; spring azure; Edward's and gray hairstreak; zebra, tiger, and black swallowtail; monarch; buckeye; and silver-spotted skipper (along with many other skippers). On one spectacular day I happened upon a great purple hairstreak, a rare butterfly in Kentucky, nectaring on dogbane at Raven Run.

Although this region has great natural diversity, it also has outstanding scenic and historic qualities. The pale chalk-colored cliffs, glowing with morning or evening light, and

Overleaf: The Kentucky Chapter of the Nature Conservancy, the Kentucky State Nature Preserves Commission, and the Kentucky River Authority have taken the lead in protecting forests along the Kentucky River. These forests and associated creeks represent the only significant wildlife habitat remaining in the Inner Bluegrass region.

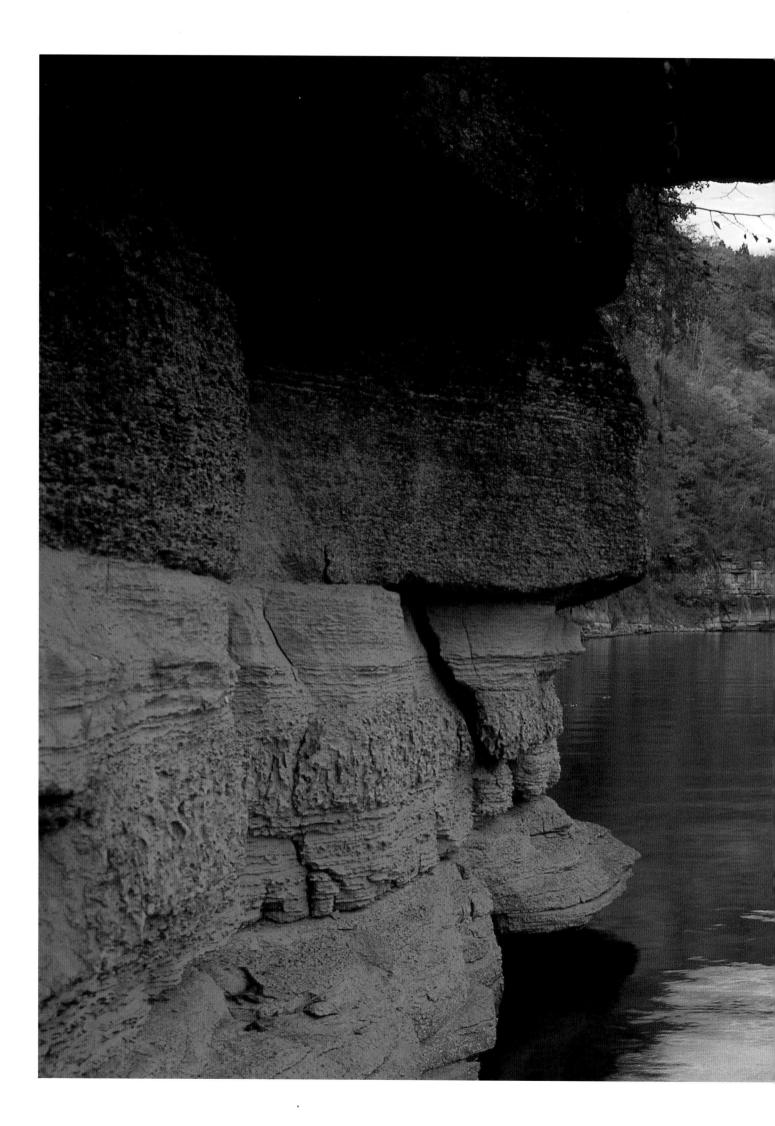

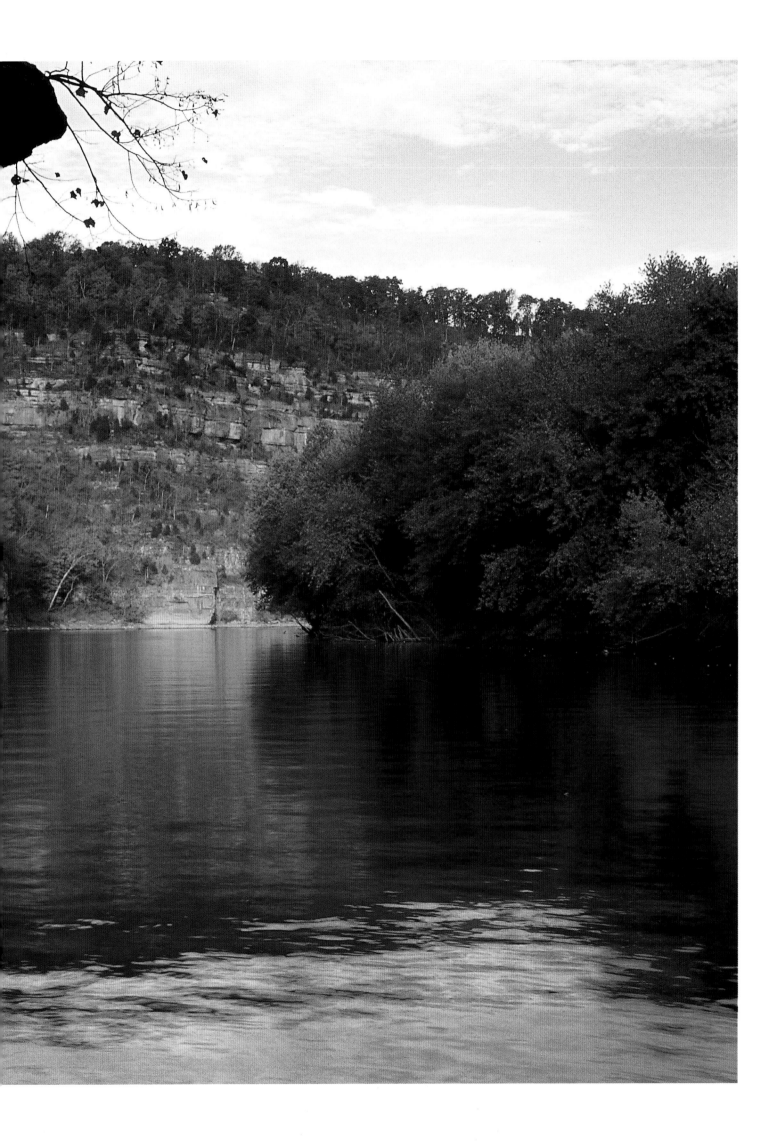

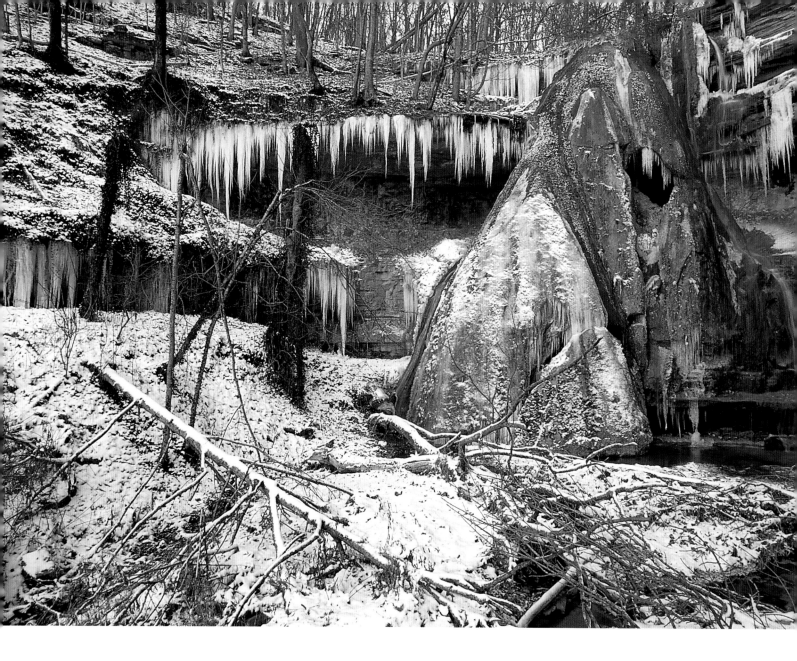

Elk Lick Falls, a petrified waterfall in Fayette County.

reflected in the Kentucky river, are a sight to behold. Numerous waterfalls and cascades drop from the uplands into the river. Perhaps the most interesting waterfall is located on the Floracliff State Nature Preserve in Fayette County. This preserve is not open to the public except for guided tours. It was owned by the late Mary E. Wharton, a botanist who taught at Georgetown College. Elk Lick Falls, a "petrified waterfall" or tufa formation, is located on the eastern end of the preserve. It is one of the largest and most beautiful surface deposits of travertine in the eastern United States. It was created by the precipitation of calcium carbonate, which emanates from the springs above the falls. As the slow trickle of water drops over the edge of the cliff, the agitation drives off some of the carbon dioxide necessary for holding calcium bicarbonate in solution.

The palisades area of central Kentucky has remarkably diverse natural communities, including fairly mature second-growth forests (no old-growth has been found in this area of the state), grassy cliff tops, cliffs, caves, springs, seeps, upland stream habitats, and numerous waterfalls and cascades.

THE OUTER BLUEGRASS

The Forests

As in the Inner Bluegrass region, there are few areas in the Outer Bluegrass that have not been disturbed and would be suitable for protection. For example, virtually all the distinctive forests dominated by white oak of the Eden Shale region have been logged. There is a great deal of second-growth forest, but it is generally of poor quality because of continued "high grading," the philosophy of logging the best trees and leaving the rest. The most significant sites in the Outer Bluegrass occur in northern Kentucky, although there are several Nature Preserves in the Eden Shale Hills region, including Quiet Trails and the Blue Licks area. Quiet Trails was one of the preserves donated to the Nature Preserves and it does have some outstanding natural qualities, including an unusually high degree of woody plant diversity, a fact that alone qualifies it as a preserve.

Surprisingly, three small tracts of old-growth forest occur in northern Kentucky—surprising because of their proximity to the large Cincinnati metropolitan area and sprawling suburbs in Boone, Kenton, and Campbell Counties. Perhaps the largest trees in the state occur at the Lloyd Wildlife Management Area in Grant County. This area is managed by the Kentucky Department of Fish and Wildlife Resources. In one sense, this was Kentucky's first nature preserve, and Fish and Wildlife ended up with the land because at the time there was no other agency that would protect it. It is easy to reach. The area consists of two twenty-acre tracts of old growth separated by a highway and several fields.

I will never forget my first trip into Lloyd Woods. The tract adjacent to the highway contained some spectacular specimens. I was impressed by the size of the extremely large walnut, yellow poplar, sugar maple, white oak, green ash, and beech trees. These monoliths were larger than any I had observed in any other old-growth forest in the state, perhaps because they are growing in incredibly fertile Bluegrass soil. I was impressed by the springiness of the soil and felt somewhat like Tigger bouncing in the hundred-acre wood.

E. Lucy Braun documented sixteen tree species in the canopy of this forest, which was dominated by white and black oaks (about 30 percent), beech (22 percent), and sugar maple (15 percent). As I went from tree to tree searching for something to photograph, I noticed the understory was brimming with papaw, which was to be expected in the Bluegrass region. More stunning was the observation that there were tremendous amounts of sugar maple, both seedlings and saplings. Bill Bryant confirmed my observation. He has indeed documented the fact that in the future the forest will become less diverse and will be dominated by sugar maple.

The other striking features were how dark the forest was and that there was little to no herbaceous layer except for the exotic garlic mustard. In fact, almost the entire understory

was dominated by that single species. The sad ending to this tale is that there may not be a way to rid the forest of that exotic species. What a shame. The result for me was that this forest was not very photogenic, except for the interesting tree crown patterns formed by the exceptionally large trees. But as long as I live I shall never forget the size and number of those trees!

The other two old-growth forests in the Outer Bluegrass region occur in Boone County. If there is an unlikely place for a natural area, this is it. The first time I visited Boone County Cliffs I walked the trail during the late summer and kept thinking, Where are the cliffs? I was somewhat impressed by one particular stand of big beech trees, but I kept looking for the cliffs. My intention was to return during the winter and spring to look for a photographic image. In the interim, I called Joyce Bender, stewardship coordinator for Nature Preserves, and asked, "Where are those blankety blank cliffs?" She replied, "Well, they are not really cliffs. They are glacial deposits with lots of gravel and limestone pebbles in them." She pointed me in the right direction, and off I went. I waited for a decent snow-fall, followed her directions, and "discovered" the twenty- to thirty-foot "cliffs," Big Rock outcroppings. I spent a good bit of time there that day, most of it in amazement at the ice hanging from the spicebush shrubs in the understory.

I returned the following spring when the woodland was shedding its winter bleak-ness. Spring had definitely arrived, with its profusion of striking, boldly colored wildflow-ers, fiddlehead ferns, and rapidly flowing water in the stream. These rich, calcareous woods were spectacular, and wildflowers carpeted the forest floor. Trout lilies, wood poppies, ses-sile trillium, Dutchman's breeches, and many other flowers put on their best Sunday going-to-church outfits before the trees could shade the ground and turn everything green. The dominant trees in the forest are typical of the Outer Bluegrass region: sugar maple, bass-wood, beech, white oak, white ash, slippery elm, black cherry, and the occasional yellow-wood. It is an incredibly diverse mesophytic forest; more than three hundred different plant species have been recorded on the preserve.

I took my son with me that day, and we hiked the trail, stopping every few minutes to photograph something he found interesting. We would stop to listen for birds because more than ninety species have been recorded there. At the top of the hill we were rewarded with an incredible display of bloodroot, such a concentration of blooms in two separate patches as I have never seen anywhere else in the eastern United States. It was one of those days when I really didn't care if I got any decent images because I was enjoying an adven-ture in the great outdoors with Jeremiah. At the end of the day, after all that hiking and photographing, he was tired and nodded off as soon as the car tires carried us down the pavement. He slept on the way home and as I looked over at him, sunlight streaming through the window, his face as radiant as that of a little angel, I thought of how blessed I was to have had such a great day in the woods with such a fine young boy.

One of the finest examples of savanna found in the Outer Bluegrass region occurs at Blue Licks Battlefield Nature Preserve. Short's goldenrod and butterfly milk-weed are characteristic plants of this region.

The great purple hairstreak is considered rare in Kentucky. This one was photographed in Fayette Country on spreading dog bane. The only known reproductive colony is located near Paducah.

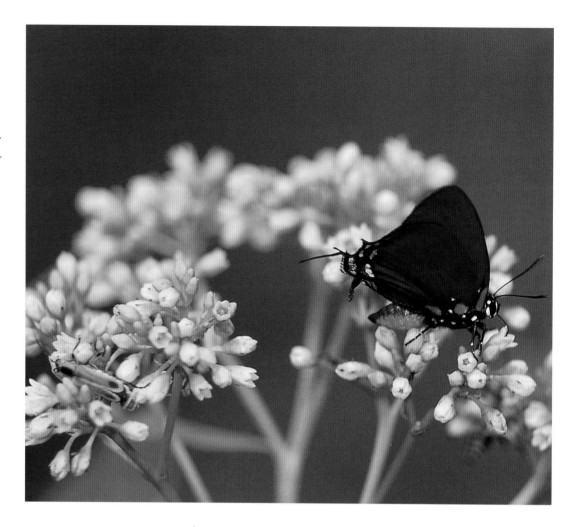

Just a hop, skip, and a jump from Boone Cliffs is Dinsmore Woods. This small tract of mature forest is unique in Kentucky in that it is the only region that was glaciated. The Pleistocene glaciers covered this land with ice, and, as they retreated, deposited outwash of Nebraskan, Kansan, and Illinoian age materials as well as wind-blown silt (loess) from the Wisconinian age. This resulted in a soil that has a limestone base covered with moist, deep, fertile soils with a high pH. These conditions have produced a diverse mixture of tree species, including sugar maple, white ash, white oak, northern red oak, Shumard oak, and chinquapin oak. There is also a rich spring flora that is comparable to the rich woods found along the Kentucky River Palisades region. Unfortunately, the exotic and highly invasive garlic mustard runs rampant at this preserve, just as it does at Lloyd Woods and Boone Cliffs. Only time will tell if our native flora or the garlic mustard wins the war of domination in the forests of the Bluegrass region. If the garlic mustard does not win, it will probably be defeated by the bush honeysuckles that were introduced and now dominate the shrub layer of many forests in central Kentucky.

The Dinsmore Homestead Foundation owns and protects an additional thirty acres immediately adjacent to the woodland. Their property surrounds the original farmhouse.

Next to the woods, just off the trail that leads into the preserve, lies one of the best populations of the federally endangered running buffalo clover in the state. The species thrives in semi-shade and is often located next to trails. This has led some ecologists to think there is a link between disturbance and the health of the remaining populations of this species.

Savanna

I met Deborah White, a botanist with Nature Preserves, at Blue Licks Battlefield State Park in search of the globally rare Short's goldenrod. The park and its environs host some of the only remaining populations, occurring along an ancient buffalo trace (a well-worn path the bison followed on their way to the natural salt licks in the region). We found many plants that morning, and I managed to get some closeup photos, but no habitat shots that would provide a sense of the tough conditions under which this plant survives.

This unique goldenrod was first discovered about 1840 at the Falls of the Ohio by Charles Wilkins Short. It was "lost" to science until E. Lucy Braun discovered a population growing near the community of Blue Licks. Since that time a total of thirteen populations of this state endemic have been identified. It occurs only in Robertson, Nicholas, and Fleming Counties, and nowhere else in the world. I became fascinated by the plant, and as luck would have it, Joyce Bender told me of a recent fifteen-acre addition to the park that had several excellent clumps of the goldenrod. I contacted Carey Tichenor, chief naturalist for the Kentucky State Parks, and he agreed to show me this additional property. When we walked into the woods, we hit the mother lode, finding not only a dozen or more clumps of Short's goldenrod but a true, honest-to-gosh remnant bluegrass savanna. Several large bur and Shumard oaks were surrounded by a sea of grasses and wildflowers. There were even some bur oak youngsters sprouting under the massive trees. Yes, there is hope for future restoration of this and other savanna sites. There were many young black haws and other trees (evidence of a lack of disturbance, but a problem easily handled by controlled burns) that obstructed the grand view of the big trees and grassy understory. I took a few additional photos and planned a future shoot. I returned six different times over the course of a month to obtain an image that I felt gave a sense of this Last Great Place. On the last trip I found a wonderful patch of Short's goldenrod growing at the edge of an opening with lots of prairie plants, including little bluestem grass and butterfly weed. I took numerous photos but never really captured the true sense of place. Perhaps another time.

Because Short's goldenrod has a restricted range, small populations, and habitats that are threatened, the U.S. Fish and Wildlife Service listed it as an endangered species in 1985. The Kentucky Chapter (with the Buffalo Trace Preserve in Fleming County), Nature Preserves, and Blue Licks Park are working vigorously to protect it. Some of the best populations of this plant occur in the park and along the adjacent highway. Yes, the highway right-of-way! This little plant is closely linked to disturbance. Ecologists have long speculated that

the bison were essential to its survival by creating appropriate habitat, that is, bare ground, and by dispersing seeds to new areas.

Glades

Between the Outer Bluegrass and the Knobs lies a series of dolomitic xeric limestone glades. At one time there was probably a substantial amount of grassland that separated the Bluegrass from the Knobs region. Perhaps these glades should be included in the Knobs section, but I chose to put them here because they provide a transition to the Knobs region.

The two best examples of the grasslands that occur here are Pine Creek Barrens in Bullitt County and Crooked Creek Barrens in Lewis County. These two preserves are some of our best examples of the "Big Barrens" grassland region of Kentucky, even though they do not occur in the Pennyroyal physiographic region. I have visited these preserves occasionally and have come to appreciate them as outstanding examples of a grassland ecosystem unique to our commonwealth. A quick stroll through Pine Creek Barrens might make these grassland systems seem more interesting.

In Tallgrass Prairie, John Madson writes, "One fine morning, certain prairie slopes look as if patches of sky had fallen there and you know that the bird's-foot violets have come. From then until hard frost, there will be no time when the prairiescape is not enameled with flowers of some kind." Bird's-foot violets are indeed at Pine Creek, but a quick stroll around the barrens in spring is a treasure to be savored. If you look carefully you will locate a globally rare glade cress growing at the edge of a rock outcropping. Nearby, under a cedar tree, you are likely to find the state-listed glade violet or yellow star grass growing in a thin amount of soil on top of a rock. Hoary puccoon, with its bright yellow-orange color, sticks out among the dried brown grass, yet to show life. Look closer for the shooting stars. American toads abound this time of year, inhabiting it seems every small, wet area.

The longer days of June bring out taller, showy flowers, including the narrow-leafed (pale purple type) coneflower, gray-headed coneflower, black-eyed Susans, white euphorbia, scaly blazing star, and bergamot. And butterflies. Oh those spectacular flying flowers! Great-spangled fritillaries, meadow fritillaries, red admirals, buckeyes, clouded sulphur, northern cloudy wings, hairstreaks, and swallowtails float through the air, stopping to drink the sweet sugar-water of those summer flowers. This is the time of year you are likely to encounter a northern fence lizard basking on flat rocks. In late summer you may see a second flush of color with the asters, particularly the rare western silky aster, goldenrods, obedient plant, false foxgloves, and the state-listed great plains ladies' tresses orchid.

As summer progresses into fall, signature prairie grasses become the dominant focal point of the environment. This is one of only a few locations I know of where you can see the grasses following the typical soil moisture gradation found in the "true" prairies west

and north of Kentucky. Prairie dropseed and little bluestem inhabit the drier, upland sites and grade into stands of Indian grass, down to the deep, rich soil species, big bluestem. In the late afternoon, when the sun is low on the horizon, the colorful grasses are breathtaking: the deep reds of big and little bluestem, the yellows of prairie dropseed, and the orange of Indian grass, all gently blowing against a backdrop of a brilliant blue sky.

Trees and shrubs you are likely to encounter on the barrens and in adjacent woodlands include red cedar, redbud, persimmon, fragrant sumac, Carolina buckthorn, post, blackjack, and shingle oaks, and winged elm. Unfortunately, the prairie openings are too small to harbor many rare songbirds, but you can certainly see lots of colorful "edge" species, such as indigo buntings and yellow-breasted chats. Perhaps the most abundant wildlife are those not seen but heard: the birds and frogs. If you look carefully, you might even be treated to a Cope's gray tree frog blending in with its surroundings.

Pine Creek Barrens is certainly one of Kentucky's Last Great Places. The landscape provides something interesting for the eyes and ears in every season. Carl Sandburg said it best when he wrote in "Prairie":

> The prairie sings to me in the forenoon and I know in the night
> I rest easy in the prairie arms, on the prairie heart.

4

THE KNOBS

One of the most unusual habitats in the Knobs region is the limestone slope glade. These unique prairie or grassland communities are usually found in shallow, shale soils on southwestern slopes.

The Knobs is a unique area that acts as a transition between the Outer Bluegrass region and the Cumberland Plateau to the east and the Mississippian Plateau to the south and west. The knobs are low yet well-defined cone-shaped hills. Originally part of the Muldraugh's and Pottsville escarpments, they are distinctive in that they are shale overlain by resistant cap rock. This rugged topography forms a band around the Bluegrass region, offering many outstanding promontory points overlooking the Bluegrass.

The forests of the Knobs region are remarkably similar to those found farther east on the Cumberland Plateau. Robert Muller, forest ecologist at the University of Kentucky, describes these forests as similar to the mixed mesophytic forests but differing in the increased importance of limestone-associated species such as blue ash, chinquapin oak, hackberry, and eastern red cedar. He further differentiates these forests by the replacement of yellow buckeye with Ohio buckeye and white basswood with American basswood as well as the general absence of the magnolias. Nature Preserves protects two significant forests in this region, Pilot Knob in Powell County and Vernon-Douglas Preserve in Hardin County.

Pilot Knob, also called "Boone's Overlook," is managed by Eastern Kentucky University. This 730-foot knob has tremendous historical significance, as it is believed to be the knob on which Daniel Boone stood when he first looked out over the Bluegrass. From the summit you can also see the knobs to the north and the Cumberland Plateau to the southeast. Like other forests of the Knobs, the summit or plateau is dominated by a pine-oak-heath community on xeric sandstone soil. You are most likely to encounter pitch,

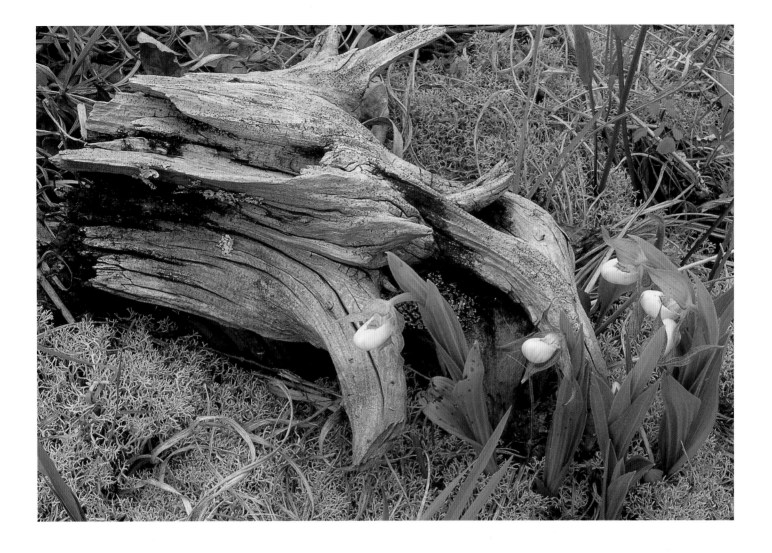

short-leaf, and Virginia pine interspersed with chestnut trees and scarlet and white oaks. The understory, dominated by a wide variety of plants in the heath family—including mountain laurel, huckleberries, blueberries, and long-leaf rhododendron—is unique. This is also the area in which you find our native deciduous azaleas, which provide a profusion of springtime color. Interesting and showy wildflowers that occur on these sites include pink lady's slipper orchids, dwarf iris, yellow star grass, and bluets.

On east-facing slopes and in coves you encounter a mesic forest with sugar and red maple, American beech, tulip poplar, northern red and white oaks, and sweet pignut and shagbark hickories. On these sites are found also the richest spring flora, including several trilliums, yellow lady's slipper orchid, and a host of other showy species. The west-facing forests, being drier, are dominated by a variety of oaks and hickories.

Although the forests of the Knobs are interesting, the most biologically significant communities in this region are the xeric limestone slope glades. The glades usually occur as a series of grassland openings on thin-bedded Salem limestone soils on south- and west-facing slopes about two-thirds of the way up a knob. You can often identify these sites from

One of the rare plants found only on limestone slope glades is the white prairie lady's slipper orchid.

The spring floral display on limestone slope glades is unparalleled. Nowhere else in Kentucky can you find the yellow lady's slipper orchid growing beside hoary puccoon, Indian paintbrush, and dwarf crested iris.

the highway because of the distinctive red cedar ring that usually encircle the communities. Additional red cedars and flowering dogwoods may be scattered within. These areas may be characterized by rocky soils and harbor an incredible number of plants that are rare in Kentucky. What makes them so unusual is that many of the prairie species found here, such as the white lady's slipper orchid and prairie dock, are considered moist or wet prairie species in other locales. It is on these glades and the dolomitic limestone glades that you are likely to find other rare plants, such as the Indian paintbrush, western silky aster, great plains ladies' tresses orchid, and Crawe's sedge. These are not only among our most unusual biological communities but also among the places I most love to visit because they are incredibly scenic. I hope the following story will give you a sense of their beauty.

"The best display of Indian paintbrush in the state is on a glade, privately owned, next to Thompson Creek Glades in Larue County. The best way to get there is to talk with the landowner and ask for permission to cross his land." These directions from Marc Evans, Nature Preserves ecologist, enticed me to meet the landowner, Joe Spaulding. Joe was more than happy to let me visit his glade. He told me to visit anytime, and I have done so often. We usually sit and have a cup of coffee before I wander down the slope into the beautiful forest opening.

During my first trip I was amazed at the beauty of this grassland in early May. Indian paintbrush was everywhere. These intense red and orange flowers were interspersed with bright yellow hoary puccoon and light lavender prairie phlox. As I walked around the

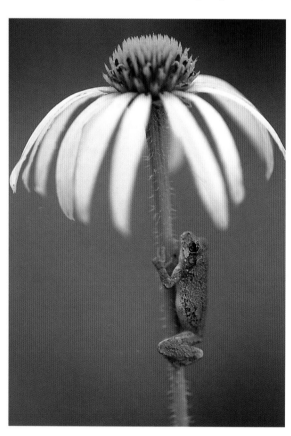

The narrow-leafed coneflower is common on limestone slope glades. This young Cope's tree frog was found one morning at Thompson Creek Nature Preserve in Larue County.

glade, listening to a wild turkey gobble across the creek, I was struck also by the incredible display of yellow lady's slipper orchids and purple dwarf crested iris.

I returned later, in mid-June, to photograph the pale purple coneflower and scout the area for future photographic endeavors. As I descended the steep, southwest-facing slope, I noticed how thin the soil was, with numerous exposed rocks. As I gazed over the meadow, my eyes immediately moved to several white flowering plants—pale purple coneflowers. The next morning I returned half an hour before sunrise, set up my shot of purple coneflowers against the pre-sunrise sky, and waited for the pinkish-purplish sky to match the color of the flower. Finally, after a fifteen-minute wait, it happened. It lasted two minutes, just long enough to get a half-dozen images on film. I then moved to photograph the white pale purple coneflower and looked down to find a young gray tree frog sitting on a prairie dock leaf. I quickly fumbled for my macro equipment, put the camera on the tripod and got several images on film. To my surprise the frog jumped right onto the pale purple

At the edge of the Knobs bordering the Bluegrass region, some of the highest quality prairie barrens occur. Two excellent examples of this habitat type are the Crooked Creek Barrens, represented here by rough blazing star and false fox-glove, and Pine Creek Barrens.

Overleaf: A stand of native prairie grass succumbs to the "red buffalo." As violent and intense as these fires may be, it does not harm the prairie plants and in some sense is essential in maintaining vibrant grass-land communities.

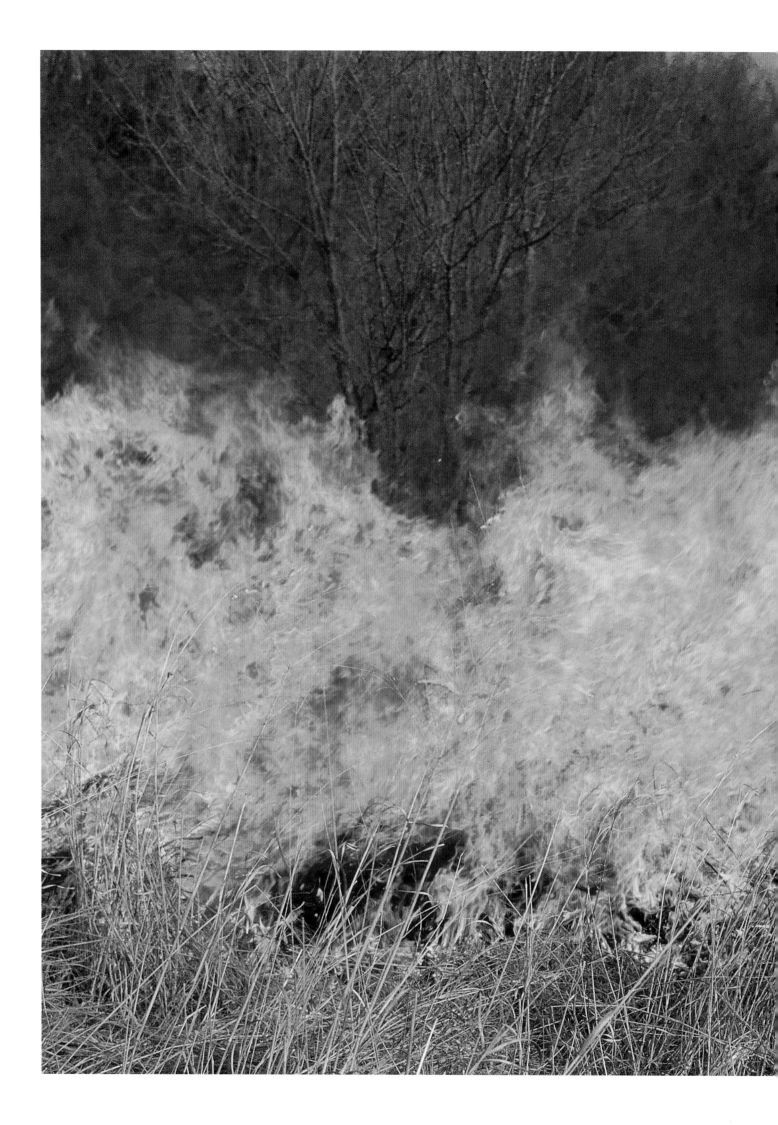

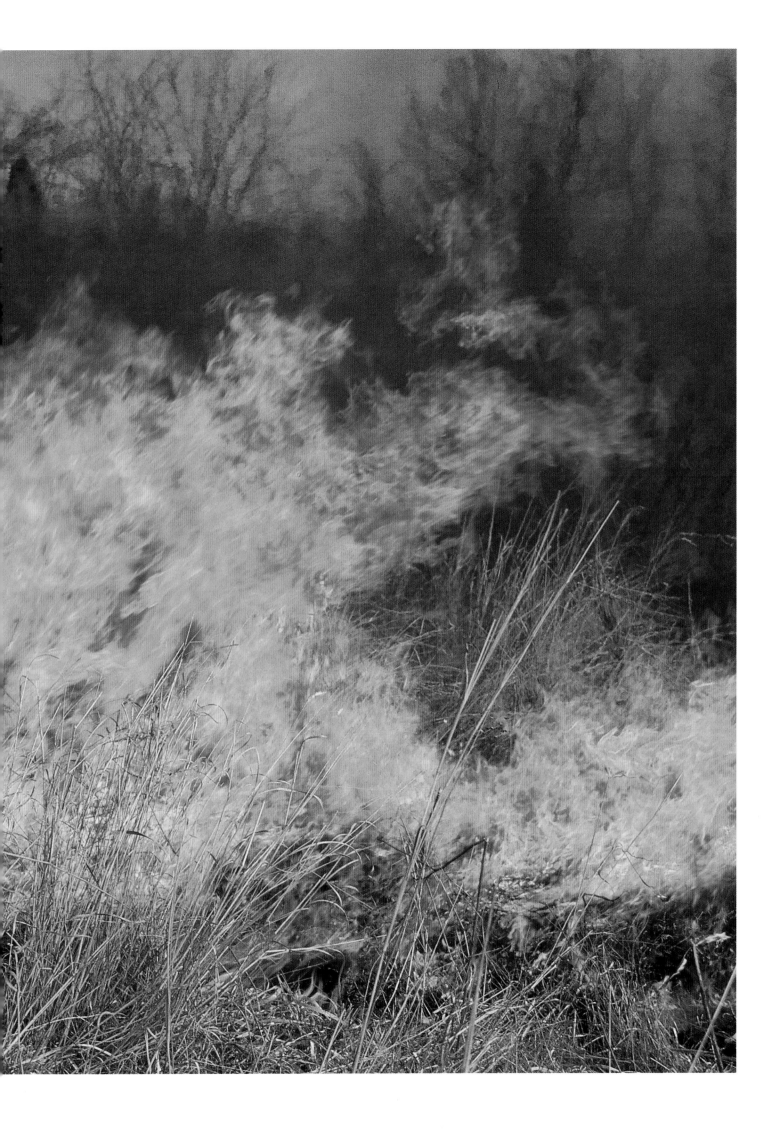

coneflower and began to crawl up the stem. Frantically, I repositioned the camera and tripod and got two frames before the frog reached the top of the flower. He then sat on that flower for the longest time (all the while I was taking pictures) until I left the area. For a photographer, that was a particularly fruitful day because the sunrise image made it onto the state's nature and wildlife tax checkoff fund poster, and the frog image made it onto the cover of a national magazine.

Over the years I developed a personal friendship with Joe, a former timber buyer who retired at a young age because of his battle with cancer. I remember many visits in the spring, when Joe and I would discuss life over a cup of coffee while sitting on his porch. Sometimes we would talk about the "special place down the hill," the glade. I felt great sadness as I watched his health decline, then improve, then decline when the cancer came back. I suspect I will continue to come back to Spaulding Glade, a registered natural area, even though I have plenty of spectacular photos of this place. It might be because of its special quality and scenic beauty. But more than that, it will remind me of Joe and those great talks we've had on his porch. Joe plans on leaving the glade to Nature Preserves after he passes away, with one small request: that he and his wife be buried at that "special place" at the bottom of the hill.

The flowering season begins in earnest on our xeric limestone prairies or slope glades in late April with the profusion of bird's-foot violets. One fine day I found lavender, white, and the spectacular bicolored bird's-foot violet mixed in with numerous white and lavender shooting stars. Another spring day brought me to Jim Scudder Glade with Joyce Bender of Nature Preserves. To my delight we found the white prairie lady's slipper orchid growing near yellow lady's slipper orchids, and to my surprise a hybrid between the two species. It was a spectacular specimen. Other rare plants likely to be found at some of the preserves include Carolina larkspur and glade violets.

The flowering profusion on these glades continues into June with pale purple coneflowers, black-eyed Susans, scaly blazing star, yellow coneflower, and white false indigo. Perhaps these grassy openings in the forest become most colorful in mid to late summer and fall when spiked blazing star, wild quinine, rattlesnake master, wild bergamot, and butterfly weed bloom profusely. This display is followed by numerous goldenrods, including the state special concern species, Buckley's goldenrod, and asters, including several rare species, such as the state-threatened silky aster. One might also encounter the grooved yellow flax, a species of special concern. Each glade appears to contain a botanical specialty. At one it might be the Indian paintbrush. At another it might be Carolina larkspur, and at still another it might be the white prairie lady's slipper orchid.

Because of the shallow nature of the soil, grasses dominate the glade communities. Little bluestem and side-oats grama appear to be the dominant species. Other showy flowers likely to be found include prairie dock, rough blazing star, and robin's plantain.

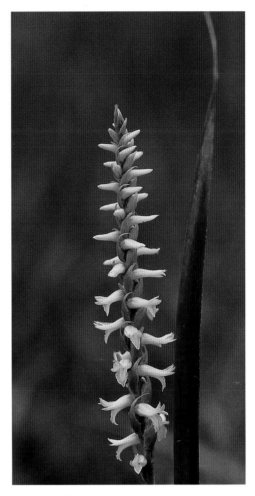

Numerous rare plants occur on barrens, including Eggelson's or glade violet, a globally rare glade cress, great plains ladies' tresses orchids, western silky aster, grooved yellow flax, Crawe's sedge, and prairie dropseed grass.

The numerous rock outcrop-
pings found on limestone
glades provide excellent
basking and feeding sites for
northern fence lizards.

The diverse wildflowers
found on prairie barrens
attract a wide variety of
butterflies, including the
American copper and
tawny emperor, seen here
with a bumble bee feeding
on purple coneflower, a
classic prairie plant.

Sometimes, if you are lucky, you can make a wonderful discovery. Dave Skinner, Eastern Regional Preserve manager for Nature Preserves, can attest to this. On August 27, 1998, he was working at one of the newest preserves, Crooked Creek, when he spotted a plant with beautiful pinkish-purplish bell-shaped flowers. Dave asked staff botanist Deb White to help identify it. It was the ear-leaf foxglove, a new plant for Kentucky. Dave and Aissa Feldmann returned and found 135 of the lovely plants. Another one of those "peculiarities or speciailties" growing on Kentucky's xeric limestone prairies.

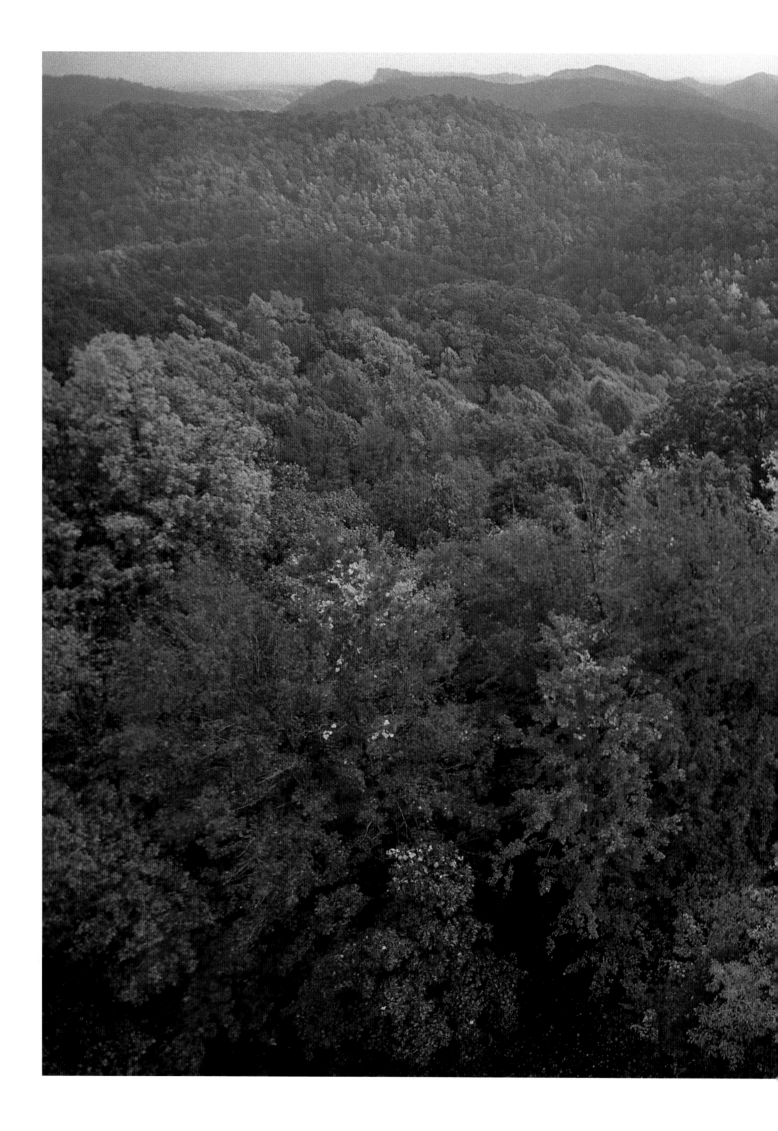

5

EASTERN KENTUCKY

I will never forget my introduction to Eastern Kentucky and the natural beauty of this region. I had read a great deal about the Red River Gorge, and my first forays into the forests occurred in this area, with its hundreds of sandstone arches. As a "prairie rat" I was not familiar with hills (I really didn't consider them mountains, and the forests obscured my view). One of the rangers in Daniel Boone National Forest suggested I visit with Wilson Francis, naturalist at Natural Bridge State Resort Park in Powell County. I introduced myself to Wilson, explained who I was, and asked for directions to the "best" wildflower trails in the region. I was particularly interested in observing and photographing yellow lady's slipper orchids. Wilson probably is asked that question a hundred times a year, but he was kind and gracious and full of information.

With map in hand I began my journey, first on the Rock Garden Trail. As I climbed up the beginning trail before splitting off on the Rock Garden Trail, out of breath, out of shape, and puffing like I was taking my last breath, I was treated to a beautiful patch of large white trilliums. This only heightened my interest in reaching my destination. I stopped for a moment, breathing air heavy with moisture, took stock of my surroundings, and trekked on to the Rock Garden Trail. At first I wondered if Wilson was sane. There were few flowers, just a bunch of hemlocks and one little "eft" stage of the red-spotted newt. I gave him the benefit of the doubt and kept going. But as the trail curved to the left and turned to a north-facing mesic slope, I stood flabbergasted at the beauty of the place. Large rocks were draped in moss and covered with purple and white. Between the rocks, clusters of white and red trilliums carpeted the ground so profusely that I had to be careful where I took my next step.

I sat on a rock, removed my camera gear and tripod, and tried to absorb it all. The fog and mist were beginning to lift. As I sat motionless on that rock, a brilliant yellow-and-

Overleaf: *Fall color at Robinson Forest.*

black hooded warbler hopped from flower to flower, branch to branch, and rock to rock, picking insects not ten feet from me. At the time I wished I had my camera handy, but as I look back, I am glad I could not get at it. Had I been busy with my camera, I would not have been able to grasp and fully appreciate this wonderful place, the rock garden.

As I explored the garden I was treated to several nice patches of the delicate purple-and-white showy orchis, dense clusters of deep blue and purple dwarf crested iris, foam-flower, jack-in-the-pulpit, violets, white sedum, and the dozens of other wildflowers that graced that magnificent garden. Such was my introduction to the mixed mesophytic forest, the most botanically rich forest type in North America. The images that were formed that day are still with me. It has brightened many a dull, dreary winter day to think about that place, knowing I can return next spring and it will still be there because it is a protected state nature preserve.

CUMBERLAND PLATEAU

Early pioneers called it the "Wilderness Trail." Through the Cumberland Gap, a small break in the mountainous topography, explorers and early settlers arrived in the western wilderness in a place known as Kentucky. They were following old paths trodden by Native Americans into the Bluegrass region and beyond. Permanent settlers would not arrive until a few decades latter, and most settlement would occur along the stream valleys. But as late as 1904, several families made the difficult trek up Cumberland Mountain to Hensley's Settlement, now part of Cumberland Gap National Historical Park.

Cumberland Falls (facing page) is a well-known recreational destination in Kentucky. Along Eagle Creek, in the state nature preserve, you might be treated to finding Brook's saxifrage (right), a northern species that occurs along the cool, damp banks of the creek.

Life was difficult for those early settlers. Most of them relied on small subsistence farms, harvesting the trees to provide shelter and the land to provide food for people and domestic stock. It is amazing how these rugged uplands, with their steep slopes, were grazed and farmed by those early residents. Their life-style continued until about the 1930s, when many of the fields reverted to forest. This type of disturbance to the forest ecosystem has undoubtedly impacted the forests of today in this region.

Although small-scale farming operations certainly affected these natural lands, it was not until the late 1800s that the real impact of human disturbance was felt in these forests. Large-scale logging took a heavy toll, and by the 1940s, little uncut forest remained. Add to this the loss of the American chestnut, perhaps the most dominant tree in this ecosystem, as a result of the introduced Chestnut blight. This exotic organism killed almost every tree. Couple these events with heavy grazing by livestock and repeated burning, and you begin to understand the devastation that occurred. The recovery of the forests in this region speaks volumes for their resilience.

The next onslaught on the natural communities in the Eastern Kentucky Coal Field began in the 1950s, when surface mining became the preferred method of extracting valuable coal deposits. Thousands upon thousands of acres have been altered for many future generations as a result of strip mining. I never really understood how much land was

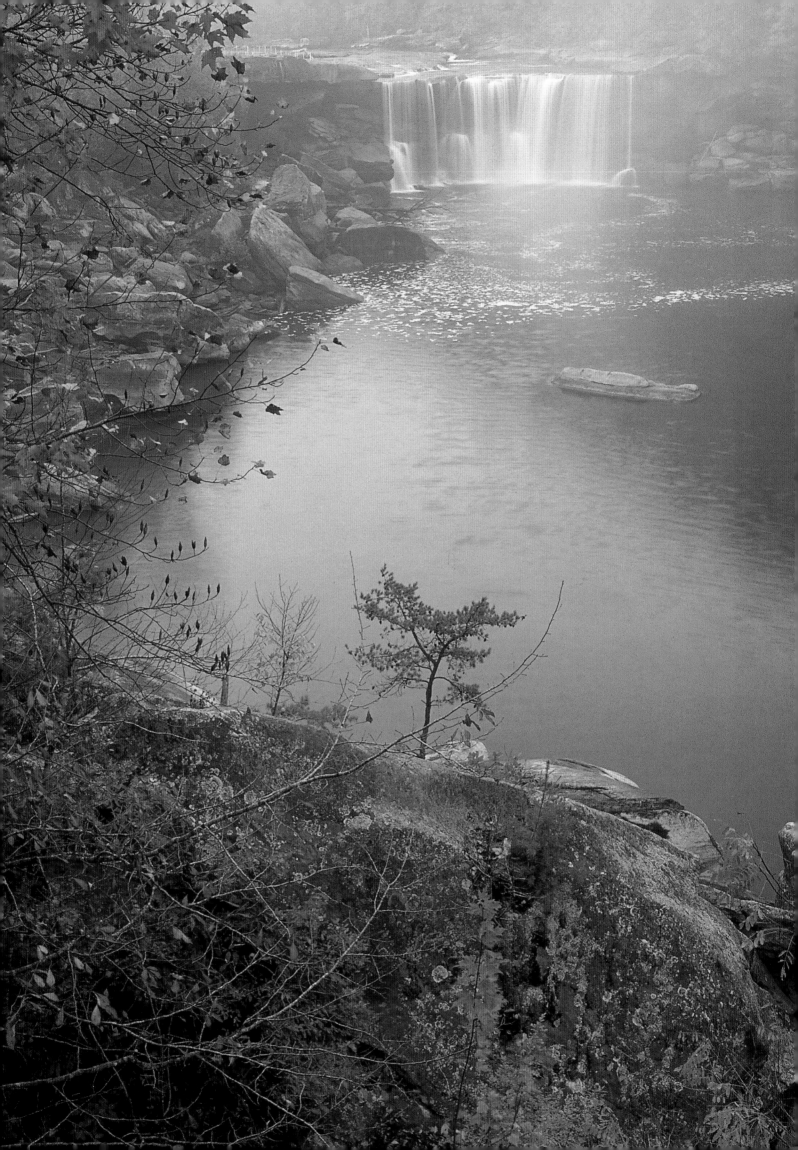

In mesic forests throughout eastern Kentucky, yellow lady's slipper orchids can be found in abundance.

affected until I flew over the area in a helicopter getting images for this book. It was depressing to see so many forested hills reduced to flat, grass-dominated moonscapes infested with exotic plants.

This industrial activity continues today, as does the devastation, such as the recent dumping of millions of gallons of coal slurry into creeks and rivers from a mine in Martin County. To say that water quality, and consequently aquatic biological diversity, has been destroyed would be an understatement. The coal industry would have us believe they are good stewards of the land and have "created" wonderful wildlife habitats. To their credit they have created habitats for many game species, such as white-tailed deer, ruffed grouse, and elk, all of them species that are abundant and in some cases overabundant. They also have created habitats for species that were not found in eastern Kentucky in years past, including coyotes and horned larks. Unfortunately, their biggest impact on wildlife has been the fragmentation of the forest habitat. The landscape is in the process of changing from a

forest to a mixed forest–grassland ecosystem. In the future, this will undoubtedly cause problems for many forest-dependent or interior bird species, such as the wood thrush.

Add to all this the impact of gas and oil extraction, sewage and other forms of pollution (including garbage dumps), the overcollecting and harvesting of ginseng and goldenseal, and the impoundment of numerous streams and rivers, and you begin to wonder if there are any Last Great Places left in the Cumberland Plateau. But despite all the disturbances over the past hundred years, the forests have shown a remarkable ability to thrive. They have regenerated and now cover most of this region. If we divide the Cumberland Plateau into three sections, the Cliff section, the Low Hills, and the Rugged Eastern section, it becomes apparent that most conservation activity has been centered in the Cliff section because these areas do not have underlying coal deposits. Exceptions to this include the University of Kentucky's Robinson Forest, Lilley Cornett Woods, the Red Bird District of the Daniel Boone National Forest, and the Kentucky Chapter's Mary Breckinridge Preserve in the Rugged Hills section.

Cliff Section

The Daniel Boone National Forest, formerly known as the Cumberland National Forest, has been described as rugged, beautiful, and biologically rich. It is a land abundant in waterfalls and natural stone arches, cliff lines and rock-shelters. Established in 1937, it was carved out of a patchwork of private lands "nobody wanted." It covers approximately seven hundred thousand acres, most of it within the Cliff section. There is no question but that habitats within the forest contain extraordinary natural diversity, with several globally unique features along its streams and creeks. Although there are significant habitat features throughout the forest, several areas are managed primarily for conservation, including the Red River Gorge and Clifty Wilderness; Cave Hollow; Horse Lick Creek; and the Rockcastle River, Rock Creek in Laurel County, Rock Creek in McCreary County, and Beaver Creek Wilderness Area. Within the Cliff section lie three additional state park treasures: Carter Caves, Natural Bridge, and Cumberland Falls. One final addition is the Big South Fork River and Recreation Area.

Let's begin our journey through the Cliff section of the Cumberland Plateau at the north and move south. Our first stop is Carter Caves State Resort Park. Bat Cave and Cascade Caverns are contained within Carter Caves State Resort Park. Bat Cave supports one of the largest wintering colonies of the federally endangered Indiana bat. It has been estimated that 10 percent of the total population of this species hibernates in Bat Cave. Fortunately, both entrances have been gated to protect this species from human disturbance. In addition to the extensive cave system that supports Indiana and other bat species, the park also supports populations of several rare plants, including mountain lover. This small evergreen shrub grows atop the cliffs, and these plants are thought to be one of the only pop-

Overleaf: Carter Caves State Park and Nature Preserve, located in the northern portion of the Cumberland Plateau, is well known for, and was designed to protect, numerous limestone caves.

ulations in its entire range that actually flowers and produces seed. Several other northern relics, including the mountain maple and Canadian yew, can be found growing along the steep, north-facing slopes at Cascade caverns.

Most Kentuckians are aware of the Red River Gorge and Natural Bridge State Resort Park and Nature Preserve and the spectacular scenery. These places are true gems. Perhaps the most significant features of this landscape are geological. More than two hun- dred arches have been cataloged in the Daniel Boone National Forest, and new ones are being discovered every year. But there are also many biological treasurers associated with these geological features. Although rock climbers and campers may think they are not hav- ing an impact on biological resources, they should think again. The most sensitive habitats in the gorge area (rock-shelters and cliff lines, caves, and the river) are the very features that attract more than a million visitors to the gorge every year. Perhaps the most destructive human activity, and the one that creates the most significant impact on natural resources, is camping under or near rock-shelters and along the cliff line. Other activities that damage sensitive habitats include looting rock-shelters and other archaeological sites, entering maternity or hibernation caves for big-eared and Indiana bats, and dragging canoes over mussel beds.

Because much of the Kentucky River system has been affected by mining, forestry, and pollution, the Red River serves as one of the last, best examples of the rich aquatic life associated with the Kentucky River drainage system. More than seventy species of fish and

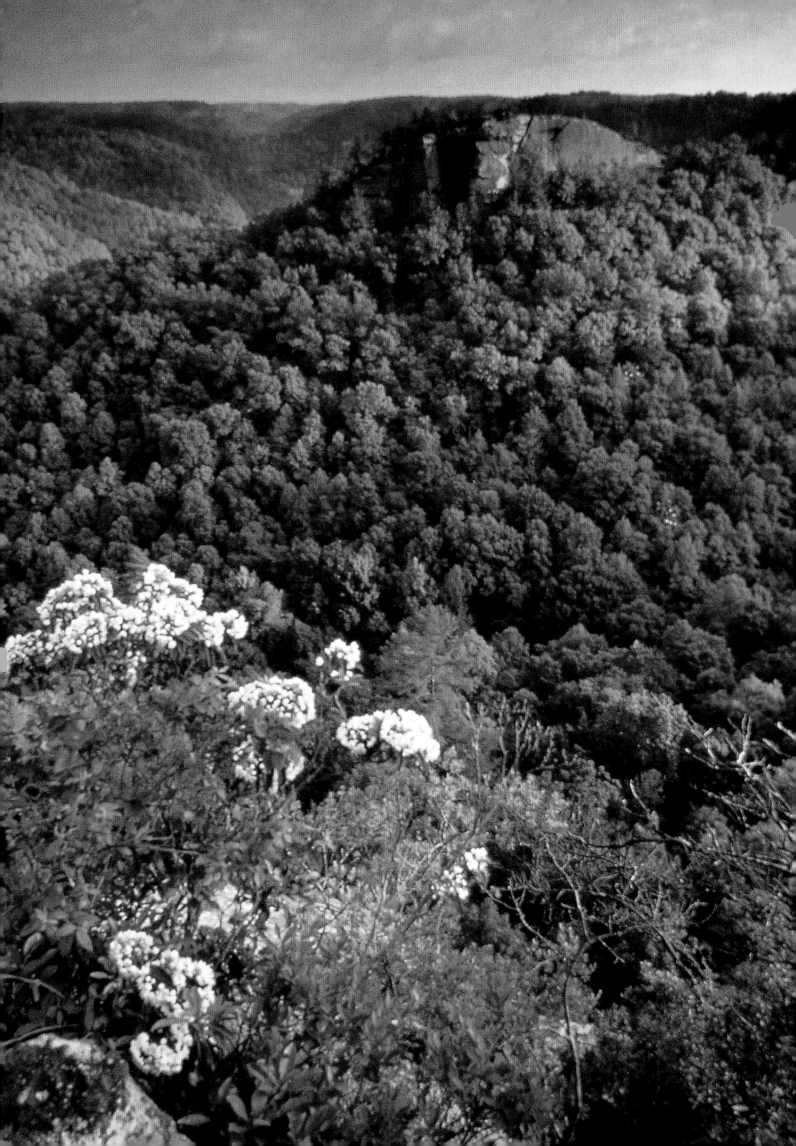

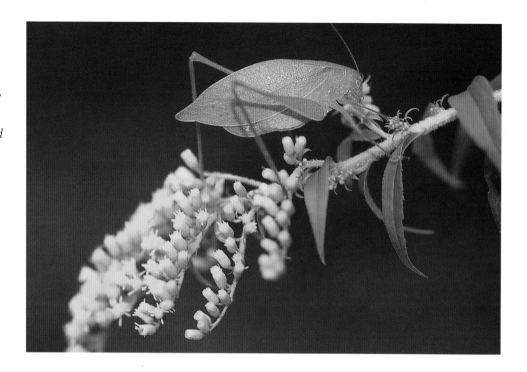

More than twelve thousand species of insects are known to occur in Kentucky. This pink katydid was feeding on early goldenrod at Robinson Forest, which is located in the rugged interior section of the Cumberland Plateau and is the state's best large, intact remnant of mature forest. Much of the original landscape in this region has been altered by strip-mining.

Some of the most significant habitat features in the Cumberland Plateau are the cliffs, rock-shelters, and caves. The rich mixed mesophytic forest provides habitat for a wide variety of spring wildflowers.

other aquatic organisms have been recorded from the Red River and its tributaries. Sensitive species include the eastern sand darter, the mountain brook lamprey, and mussels such as the snuff box, round hickory nut, and salamander. The mussel fauna here is particularly diverse; several beds may harbor nineteen or twenty different species and up to three hundred individual mussels. River weed, a submerged vascular plant that grows on rocks and looks like algae, can also be found in the cool, clear waters of the Red.

The other important river in the Kentucky River system is the South Fork, as it flows through the Red Bird District of the Daniel Boone National Forest. Ron Cicerello, aquatic specialist for the Nature Preserves, suggests that this fork rivals the Red River in its importance to the diversity of aquatic organisms. Historically, more than twenty-seven species of mussels have been found in the South Fork and twenty-two species occur there now.

Although the rivers and streams are important to aquatic diversity in the Daniel Boone National Forest, the water also moves and shapes the landscape, creating unusual terrestrial habitats. For example, along one of the Red River tributaries, Swift Camp Creek, close to the Rock Bridge area, the stream cuts a deep ravine through the rock. The resulting shaded, moist, cool conditions create a more northern type of environment. Here several northern relic wildflowers, such as dwarf ginseng, dwarf enchanter's nightshade, true wood sorrel, and Canada mayflower, can be seen growing among yellow birch and a native population of white pine. Add some hemlock and you have habitat for the only known nesting population of red-breasted nuthatches in the state. Other birds that may be declining throughout their range but appear to be doing well in the gorge include the cerulean warbler, a species under consideration for the federal threatened and endangered list.

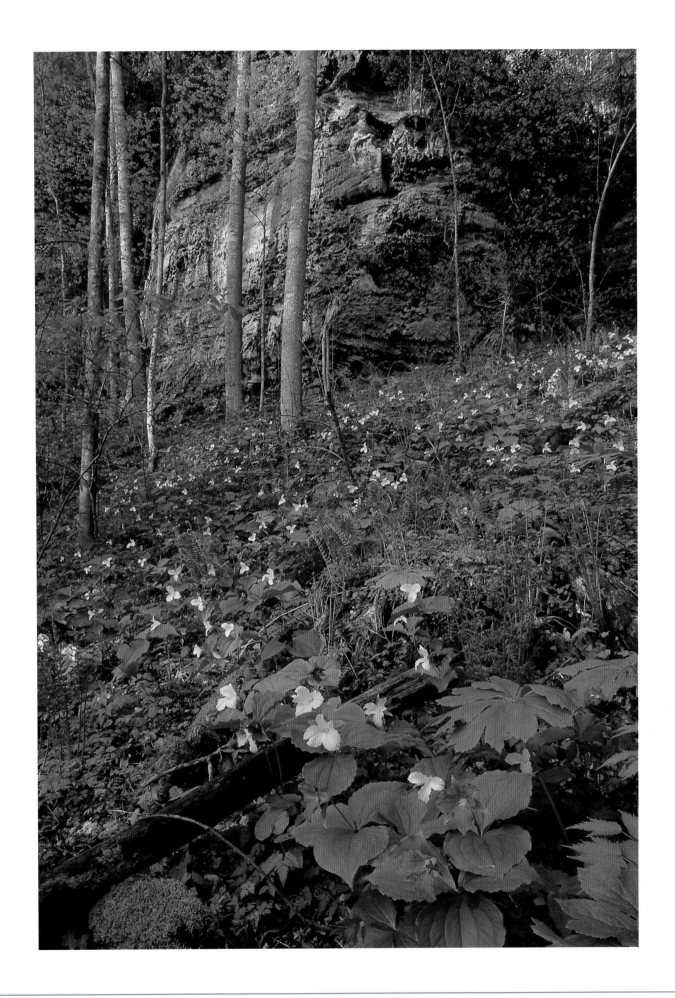

The white fringeless orchid is a rare gem found in tiny stream-head wetlands throughout the southern Cumberland Plateau. This plant was first described decades ago and was rediscovered less than fifteen years ago.

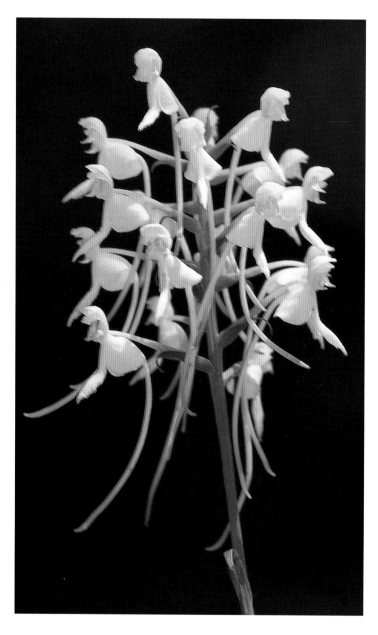

Brainard Palmer-Ball, zoologist for Nature Preserves, indicates that the best populations of the Swainson's warbler can be found in the upper Clifty Wilderness Area. The rich mesic forests found throughout the gorge area also support twenty-two species of salamanders, saw-whet owls, an isolated population of spotted skunks, black bears, and the recently reintroduced river otter.

In addition to the river and its flora and fauna, some of the most biologically significant habitats are associated with the cliffs, caves, and rock-shelters. Not far as the crow flies from the Red River Gorge lies Cave Hollow Natural Area. The Kentucky Chapter, with assistance from the Ashland Oil Conservation Fund, purchased several parcels of land that were added to the Daniel Boone National Forest holdings. These acquisitions helped protect an extensive labyrinth of caves and underground passages.

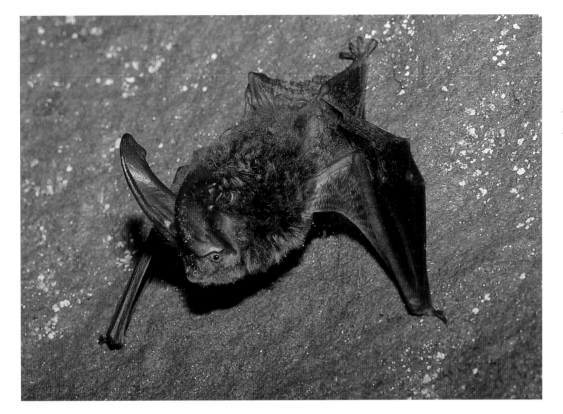

The Virginia and Rafinesque's big-eared bats (the latter shown here) use cliff and rock-shelter habitats for catching their primary food, moths. These species hibernate and have maternity colonies in the several caves found throughout the Cumberland Plateau.

The forests on the surface of Cave Hollow are not very interesting because they are fairly young. Generally speaking, the forest communities are similar to those found all across the Cumberland Plateau, ranging from mixed mesophytic in the coves to pine-oak on the uplands. The most important components of this ecosystem are the caves. Ten of Kentucky's twelve resident bat species have been found at this site, and one particular cave supports the only known wintering site for the federally endangered Virginia big-eared bat. Another nearby cave supports the majority of the breeding population of this species. Other rare bats that have been found using the site include the federally endangered gray bat and the state-listed Rafinesque's big-eared bat and southeastern bat. The rare southern cavefish also finds its home in the underground streams.

Although the big-eared bats rely on caves for hibernation and reproduction, they move about the cliffs and use rock-shelters to catch their primary prey, moths. They share this habitat with many rare critters and plants that live their life on the edge—the cliff's edge, that is. Rare plants associated with this habitat include the federally threatened white-haired goldenrod, filmy fern, Lucy Braun's snakeroot, round-leafed catchfly, and several alumroots. Some of the most interesting plant communities associated with clifflines are the unique assemblages of mosses, liverworts, and lichens. Animals that use this habitat include the Allegheny wood rat and green salamander.

Biologists continue to gather more information about cliff-line habitats. For example, Guenter Schuster, an Eastern Kentucky University professor, has described a new species of

The green salamander (top) is a species that uses cracks and crevices in cliffs extensively. The mixed mesophytic forest is known to contain a wide variety of salamander species. Cave salamanders are likely to be encountered at cave entrances, and below the cliffs you are likely to encounter one of more than a dozen species of salamanders, including northern red salamanders (bottom).

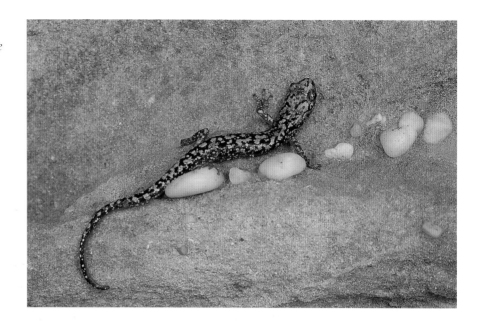

caddisfly that lives in moist seeps along the sandstone cliffs in the gorge. The larvae of this interesting species look like bison horns, and the adults are mostly terrestrial, unlike most caddisflies, which are aquatic. Dan Duorson has described a new land snail that resembles a flying saucer. Mother Nature uniquely designed this creature to move around the cliff line.

As you travel along a cliff line you often notice breaks in the continuous rock walls where some soil has accumulated. It is at the edge of these cliff-line breaks that other unique and rare plants grow. Some of the largest known populations of the state-threatened mountain lover can be found here. Other rare plants that grow in a similar habitat include a saprophytic, winter-flowering sweet pine sap, ovate catchfly, and sword moss.

One of the rare plants associated with cliff lines is the white-haired goldenrod. It is being threatened by humans who trample vegetation along cliff lines.

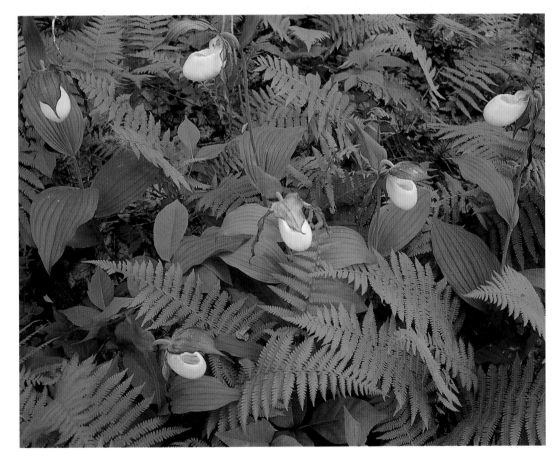

The rare Kentucky lady's slipper orchid grows in mature riparian forest habitat along creeks and rivers in the Cumberland Plateau.

*One of the more interesting
terrestrial habitats found in
the southern Cumberland
Plateau is the sandstone
glade. Numerous rare plants,
including the sandstone
fameflower, shown here, can
be found inhabiting these
small areas.*

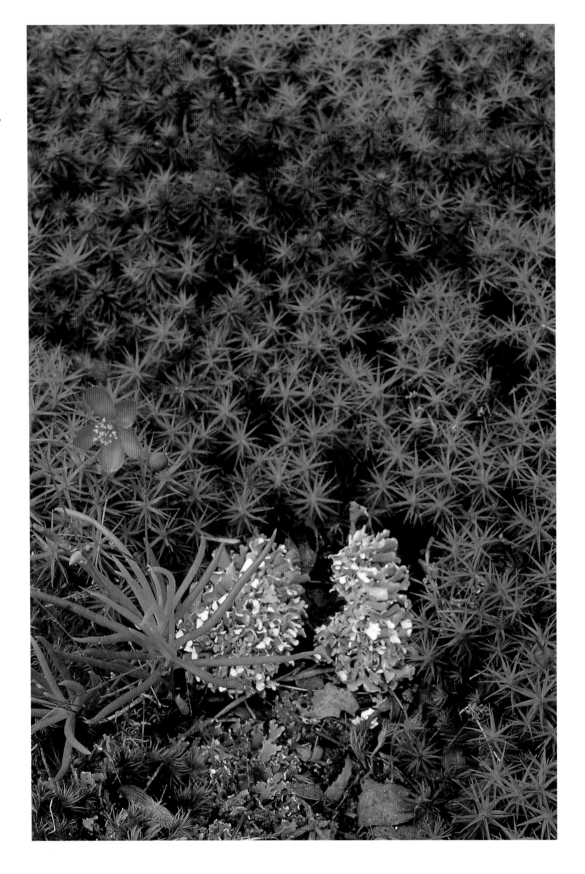

Above the cliff line and in most of the upland sandstone ridge-top communities throughout the Daniel Boone National Forest, the plant community is dominated by shortleaf, pitch, and Virginia pines, along with chestnut, scarlet, and white oak. The understory is dominated by members of the heath family and includes a number of azaleas, rhododendrons, mountain laurel, blueberries, and huckleberries. Outstanding wildflowers that occur on these sandy ridges include the pink lady's slipper orchid, dwarf iris, small-flowered bellwort, bluet, and bird's-foot violet.

On sandy ridges in the southern portion of the Daniel Boone National Forest there is a significant deviation in the plant community. The topographic relief in this region is greatly reduced and the ridges become broader. There is growing evidence that this portion of the Daniel Boone National Forest was a pine-oak barrens community before European settlement. The best places to glimpse these presettlement communities are in electric utility company power line rights-of-way. Because these areas have historically been mowed, cut, or sprayed with herbicides, they have been maintained as open, grass-dominated communities.

When it comes to unique communities and rare plant assemblages, these communities are the mother lode. At one particularly productive right-of-way you are likely to encounter a grassland community dominated by big and little bluestem and Indian grass. The wildflower component is outstanding, containing many rare plants, including wood lilies, spreading pogonia orchids, yellow-crested and yellow-fringed orchids, spiked blazing star, rattlesnake master, wild quinine, small woodland sunflowers, Virginia meadow beauty, colic root, and joe-pye-weed. It is certainly no accident that the federally endangered red-cockaded woodpecker is also found in this habitat type.

Another interesting type of plant community that occurs on the sandstone ridges in the southern part of the forest is the sandstone glade, usually found directly above the cliff line. The dominant plants on these glades are lichens and mosses. In the spring these glades look like a bouquet of white baby's breath and can be carpeted with hundreds or thousands of sandworts. Several rare, showy wildflowers, such as sandstone fame flower and small-headed blazing star, can be seen putting on an outstanding display of color in July.

Perhaps some of the rarest plant communities in Kentucky occur on or adjacent to these sandstone ridges. They are tiny in size, sometimes only a few meters square, and the plant community is usually dominated by cinnamon and royal ferns and sphagnum mosses. They are small but mighty because they pack a wallop in terms of rare plants. In one recently discovered site, more than sixty species of plants have been observed, including one of the largest populations ever discovered of the globally rare white fringeless orchid and the state-listed yellow-fringed orchid.

Martina Hines, a biologist with Nature Preserves, described finding another beautiful orchid at this site: "Weeks of uneventful field work were finally rewarded when we

stumbled upon a beautiful rare orchid, grass pink (*Calopogon tuberosus*), which is currently known from only one other location in Kentucky. . . . Nearly all the local bog orchids flower in late July; it would therefore have been logical to schedule a visit there. But here is where the luck came in . . . [as we chose to] visit the site in late June. We noticed several unidentifiable orchid leaves, but just as we were leaving, we literally stumbled upon a flowering grass pink. This beautiful pink orchid flowers for only a few days. During all other times, its narrow leaves make it nearly indistinguishable from the surrounding grassy vegetation."

As you travel farther south along the Cumberland Plateau you enter the Cumberland River drainage, where, at the uppermost reaches of the watershed, the Rockcastle River and its tributaries become another Last Great Place. This drainage basin is recognized for having one of the largest number of mussel species found in any of the world's river systems. Unfortunately, a great deal of that diversity has been destroyed as a result of impoundment and pollution. As Julian Cambell writes, "In the Cumberland River, the following endemic mussels became globally extinct in the 1950s because of Lake Cumberland—Sugarspoon (*Epioblasma arcaeformis*), Angled Riffleshell (*E. biemarginata*), Acornshell (*E. haysiana*), Forkshell (*E. lewisii*) and Cumberland Leafshell (*E. stewardsoni*). This litany of the dead is perhaps the saddest part of our recent natural history of Kentucky." Because of its outstanding scenic, biological, cultural, and recreational resources, the Rockcastle has been designated a state wild river corridor.

At the upper end of the Rockcastle River you enter the Horse Lick Creek Bioreserve in Jackson and Rockcastle Counties. This sixty-two-square-mile watershed (forty thousand acres) feeds Horse Lick Creek, which is home to more than twenty species of mussels, several of them federally endangered. The terrestrial habitats found in the bioreserve are similar to the plant communities found elsewhere in the Cumberland Plateau, with mixed

*More than twenty
species of freshwater
clams, or mussels, are
found in the Rockcas-
tle River and its tribu-
taries. The Cumber-
land bean is a federally
endangered species.*

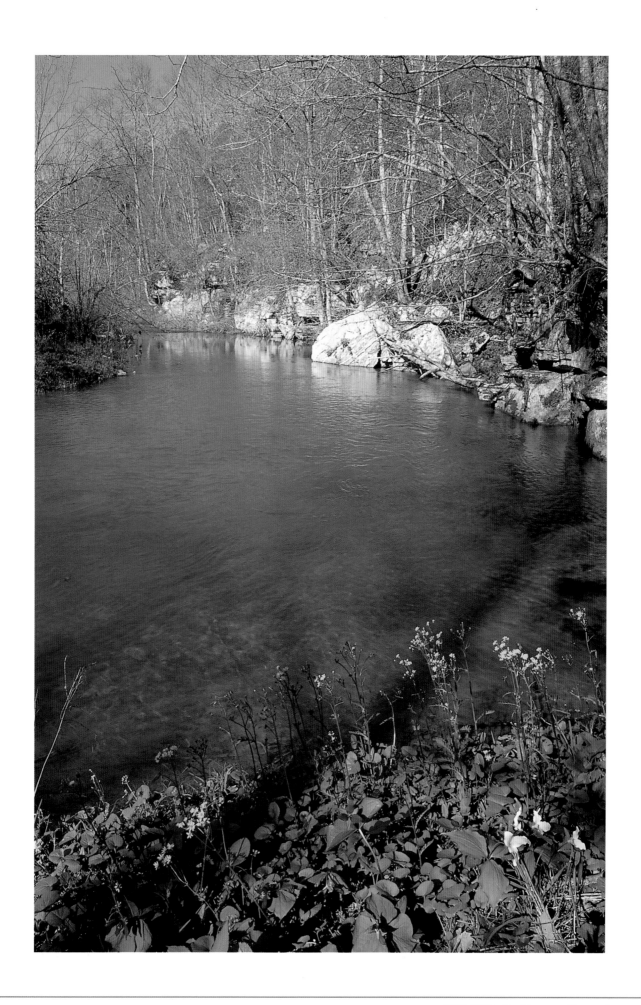

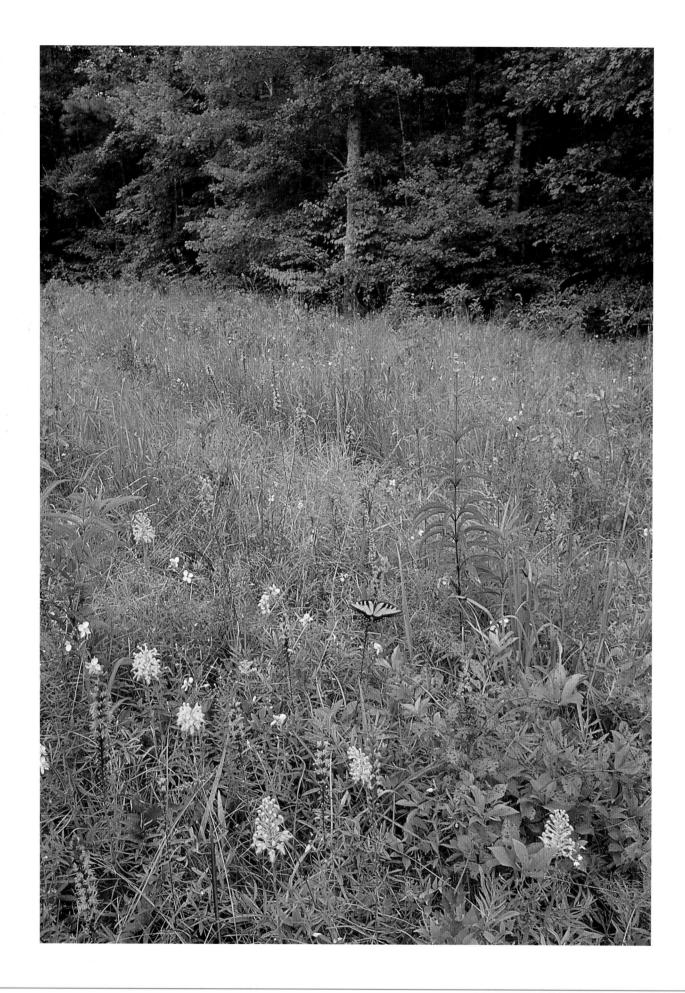

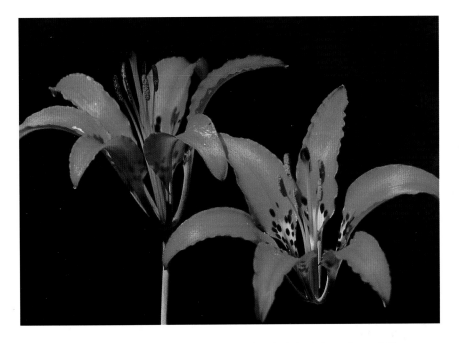

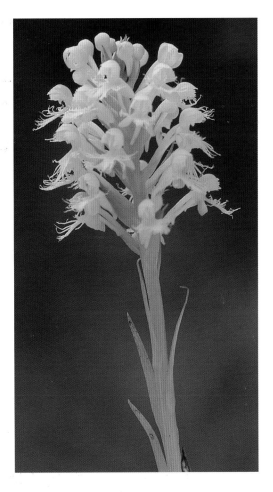

Many rare plants, including the yellow-crested orchid (right) and wood lily (above), are found inhabiting these grassland or savanna habitats.

mesophytic forests in the coves, oak-hickory forests on the south slopes, and pine-oak forests on the uplands. As in other sections of the Daniel Boone National Forest, which owns fifteen thousand acres in the bioreserve, cliff lines and caves harbor a variety of rare bats, including federally endangered Indiana bats. The other primary rare organisms in these habitats are several cave invertebrates.

The Rockcastle River and its tributaries support an incredible diversity of aquatic organisms. At least sixty-four fish species have been recorded, including several that are rare. This river has perhaps the best populations of the ashy darter found anywhere in the United States. State-endangered olive darters, found only in the Rockcastle and the Big South Fork, also maintain healthy populations in the river. Another rare fish that occurs in at least one tributary of the Rockcastle is the federally endangered blackside dace.

The relatively clean, well-oxygenated water in the upper reaches contains freshwater mussel species found only in the southern Appalachian Mountains and Cumberland Plateau. At one time more than forty species of mussels could be found in the waters of the Rockcastle. This number has declined today to about thirty, including seven that are on federal or state endangered or threatened lists. Of particular interest are the federally endangered Cumberland bean and little-wing pearly mussel. The state-endangered Cumberlandian

At one time, much of the southern Cumberland Plateau ridgetops may have been in pine-oak savannas. Utility companies have artificially recreated these open grassland habitats under power line rights-of-way.

The Rockcastle River flows through the Daniel Boone National Forest (facing page). Unique gravel-bar prairie communities can be found along the boulder-strewn edges of the river. The community is dominated by big bluestem, but other unique species that occur here include a rare grapevine, the state-endangered tussock sedge, a rare Ceanothus, *and the blue false indigo. Other plants, such as the endangered Virginia spirea and Rockcastle aster, recently described to science grow along its borders.*

combshell, the state-threatened elktoe and fluted kidneyshell, and the rare little spectacle case mussel all hang on in the river.

The diversity of the Rockcastle River site is not limited to aquatic species. The associated habitats support the globally threatened Rockcastle aster and the federally endangered Virginia spirea. The Rockcastle aster was unknown to science before the biologists' survey of the river. Most of the uplands associated with the river are owned and managed

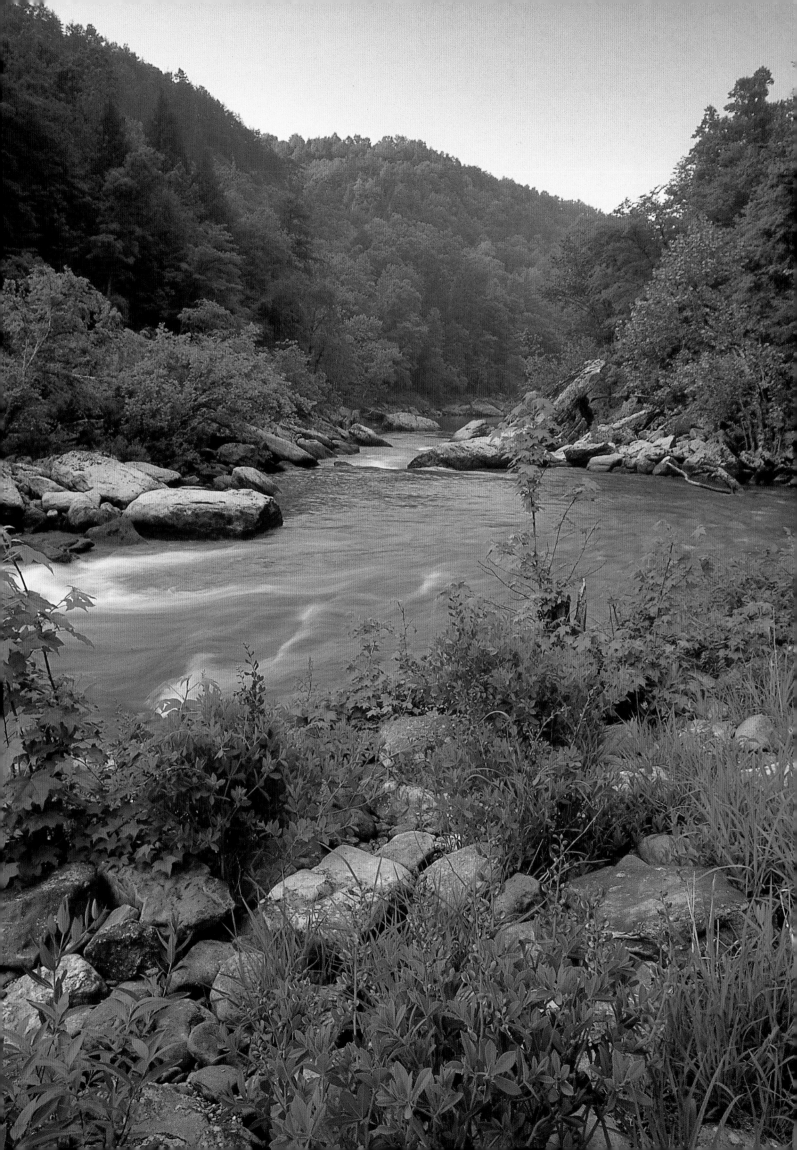

by the Daniel Boone National Forest, but the Kentucky Chapter owns the Mrs. Baylor O. Hickman Memorial Preserve along the Rockcastle, which harbors a huge population of the rare Kentucky lady's slipper orchid.

Although I have visited the Rockcastle several times, my most memorable experience was a hike to the narrows with Julian Campbell to photograph blue false indigo. As we began our adventure from the Bee Creek Campground early one June morning, we walked through a rich mesic forest that was approaching old growth. Numerous large hemlocks and tulip poplars graced the trail just below the extensive cliff line and above the scenic river. We stopped to look at some dwarf ginseng and then walked for what seemed like miles until we heard the sound of roaring water. We dropped down to the boulder-strewn river and found silky dogwood, fringe tree, and sweet azalea, all in bloom and creating an unforgettable fragrance. Julian also pointed out a rare, nondescript-looking grapevine. It is along these boulder-strewn stretches of the river that the rare onyx rock snail makes its last stand.

After poking around the rocks for a while we got back on the trail and walked until we reached a big bend in the river. At this point we crawled through a small opening in the forest and slid on our derrieres down the bank to the edge of a large gravel-cobble bar that supports a unique gravel wash prairie. It was perhaps the most pristine environment I had ever seen. No exotics were to be found. This condition is probably maintained by spring floods that scour the riverbank and keep the community open, preventing the establishment of dense, woody vegetation. Another factor that may prevent the invasion of exotic plants is the location, far from roads, homes, and other disturbance factors.

As we walked around the cobble bar, I was impressed by the dominance of big bluestem and by the amount of blue false indigo growing among the rocks in the sandy, silty, loamy soil. At one location we found some golden alexanders blooming, and Julian pointed out a rare species of New Jersey tea. The state-endangered tussock sedge is also characteristic of these cobble-gravel bars. Julian told me that similar communities occur along the Big South Fork of the Cumberland in the national recreation area.

The next important Last Great Place on the Cumberland Plateau is Cumberland Falls State Resort Park and Nature Preserve. Located along the western cliff face of the Cumberland River lies Eagle Falls. The hike to Eagle Falls provides several excellent views of Cumberland Falls, known mostly for its moonbow. This strange phenomenon, a white, arching bow, appears in the mist on nights with a full moon, a result of moonlight refracting off the rising mist. Although these waterfalls are the primary natural attractions, the real biodiversity is found in the Cumberland River, where several rare mussels have been found, along the banks of Eagle Creek, where Brook's saxifrage occurs, and in the sandy river soils, where a beautiful and rare peavine occurs. The preserve also protects cliff-line habitat. Allegheny wood rats and green salamanders have been found on the preserve.

The final Last Great Place in the Cliff section of the Cumberland Plateau is the Big South Fork National River and Recreation Area. This area, a B1 macrosite, has numerous rare organisms residing in various aquatic and terrestrial habitats. Much like the Rockcastle, there are several gravel- and cobble-bar habitats that support similar vegetation. I had the opportunity to visit one site with Deborah White, botanist with Nature Preserves, and several other biologists. It was a pretty morning in early June, and our group hiked down an old road to a horse trail. We then took a right on the trail and followed it for about a mile or more until we crossed a small creek. After a few yards we took a hard left and scrambled down the hill until we reached the river. Even then, getting to the cobble bar was no easy task. There were huge boulders and a tangle of mountain laurel and other shrubs that seemed almost impenetrable. We finally reached the bar, which appeared different from the one I had visited on the Rockcastle with Julian. It was situated higher above the stream. Similar plants, including goat's rue, blue false indigo, and big bluestem, were here in addition to the Cumberland rosemary. For half an hour we tried to locate this federally threatened, diminutive, and highly fragrant evergreen shrub. Deb finally found one plant still in flower growing in sand near a rock. After some photos and discussion about

The Cumberland sandwort is an endangered plant that occurs at the back of the drip line of some rock-shelters in the Big South Fork National River and Recreation Area.

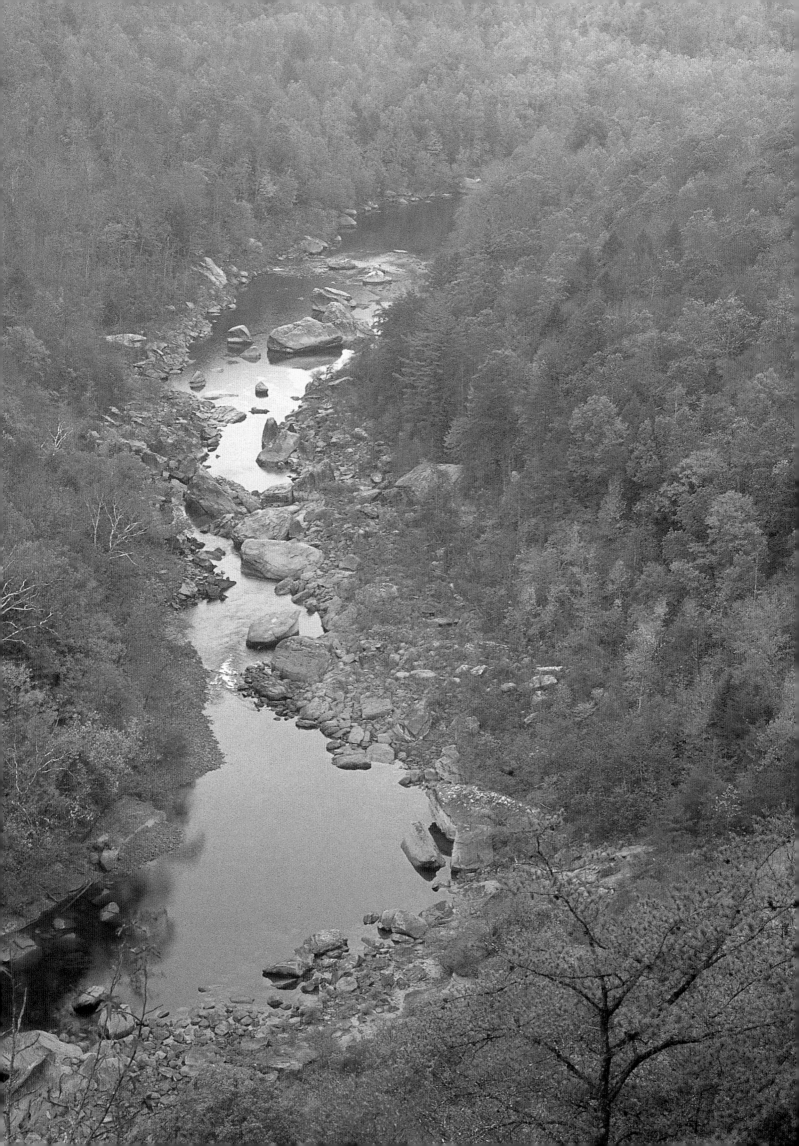

the gravel bars along the river, we headed back. On the return trip we noticed how rich the woods were, and I saw sweet shrub growing in the wild for the first time.

In addition to these unique gravel-bar communities, the river itself supports numerous rare organisms. The upper portion of the stream has been negatively impacted by coal mining, and the lower portion by the impoundment of Lake Cumberland. Below Bear Creek, however, the stream hosts several rare aquatic organisms, including the olive darter and the federally endangered duskytail darter. The duskytail is known only from the Big South Fork and three other locations, two in Tennessee and one in Virginia. More than seventy-five species of fish have been recorded from the stream. Historically, about thirty-seven freshwater mussel species could be found, but that number has decreased to twenty-eight today, including five federally endangered species: the Cumberland elktoe, Cumberlandian combshell, oyster mussel, little-wing pearly mussel, and Cumberland bean.

High above the river and the forests lie the cliffs. As in much of the Cliff section farther north, many rare organisms can be found utilizing cliff-line habitat. One of the rarest

Lilley Cornett Woods is the best example of an old-growth forest in the Cumberland Plateau. It is managed by Eastern Kentucky University and serves as an educational and research forest.

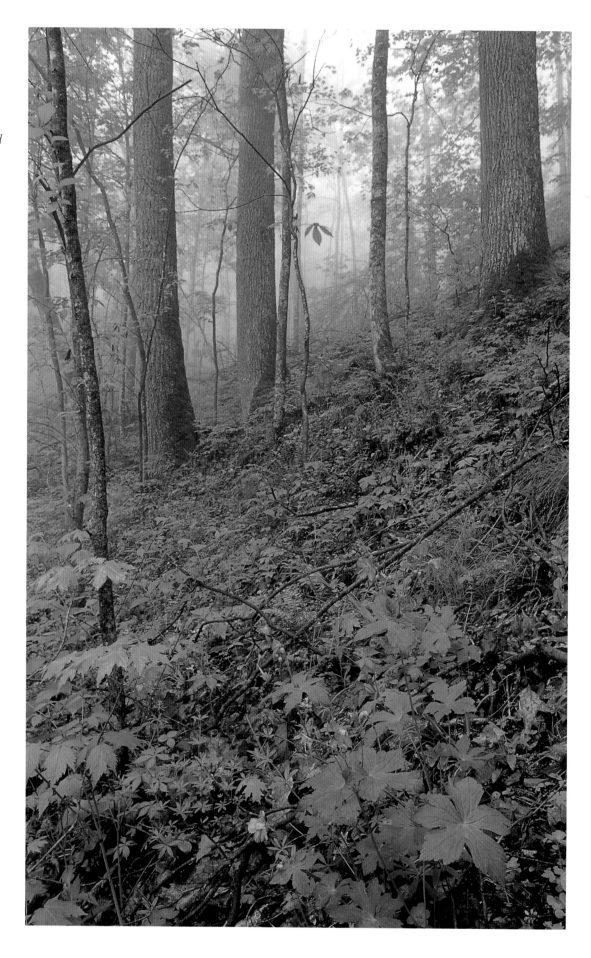

of these is the Cumberland sandwort. This diminutive, relatively nonshowy perennial is unique because it lives in deep shade under sandstone rockhouses and along moist, cavelike areas of undercut rock along cliff lines. It is unique also because it flowers in late June and July, much later than other members of its genus.

Rugged Hills Section

As you move farther east, away from the Cliff section, you enter the Rugged Hills section of the Cumberland Plateau. Unfortunately, there are few Last Great Places here because of significant habitat destruction, primarily from coal mining and forestry. The three areas worth mentioning are the University of Kentucky's Robinson Forest, Lilley Cornett Woods, and the Kentucky Chapter's Mary Breckinridge Preserve. These remnant parcels do not support much in the way of unique flora or fauna, but they provide an excellent example of the mixed mesophytic forest that once dominated the forest landscape.

Lilley Cornett Woods is 554 acres of old-growth forest. Within a relatively small area, more than nine biological communities have been recognized and more than seventy species of trees have been recorded. Like most old-growth forests, it does not provide an incredible display of spring wildflowers because the canopy is dense. But wherever a tree has fallen and created a gap in the canopy, you find large concentrations of trilliums, wild geraniums, and other showy flowers blooming. The Mary Breckinridge Preserve is similar to Lilley Cornett Woods, but the trees are mature, not old growth. This particular preserve protects a newly discovered goldenrod.

Perhaps the best large-acreage example of the Rugged Hills section is the main block of Robinson Forest. This ten thousand–acre research and education forest has received little disturbance since it was logged around the turn of the century. Most of the forest is now mature, ranging from seventy to one hundred years of age. Except for its size, there is nothing particularly unique about the forest. This is probably the only ten thousand acres of this forest type left in this region of Kentucky. From that standpoint it serves as an important refuge for forest interior wildlife species, particularly songbirds. The only rare organisms known from the forest include a colony of Rafinesque's big-eared bats and a goldenrod that has not yet been given a scientific name.

CUMBERLAND MOUNTAINS

The Cumberlands extend for 120 miles from Jellico, Tennessee, to the "Breaks" of the Big Sandy River at the Virginia border. The only true upthrust mountains in Kentucky, the Cumberlands are only ten to fifteen miles wide. Most lie within Bell, Harlan, and Letcher Counties. They occur in three distinct regions: Pine Mountain borders the Cumberland Plateau on the southeast, Big and Little Black Mountains are in the middle of the range,

One of the largest populations of Turk's-cap lily can be found atop Big Black Mountain, Kentucky's highest peak. The pipe-vine swallowtail can often be seen nectaring on this beautiful plant.

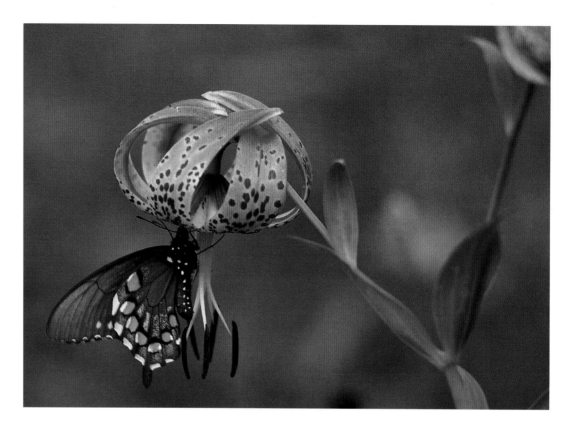

The showy blooms of Catawba rhododendron and pink lady's slipper can be found on the Yellow Rocks area of Stone Mountain. This spectacular property was purchased with money from the Heritage Land Conservation Fund. A county-owned preserve, this area will help link other important natural areas on Stone and Cumberland Mountain, including the Cranks Creek Wildlife Management Area and Cumberland Gap National Historic Park.

and Cumberland (or Stone) Mountain border those two on the southeast. The main interior mountains range in elevation from 3,000 to more than 4,000 feet and include the highest point in Kentucky, Big Black Mountain, 4,139 feet above sea level.

Though occupying only a relatively small area of Kentucky, these ancient mountains have long held an attraction for anyone interested in nature. Because of this longstanding interest, a significant number of sites have been protected on Pine and Stone Mountains. Pine Mountain preserves include Bad Branch, Blanton Forest, Kingdom Come State Park, Hi-Lewis Pine Barrens, Pine Mountain State Resort Park, Mullins and Primroy Creek Preserves, Kentucky Ridge and Kentenia State Forests, Pine Mountain Wildlife Management Area, Breaks Interstate Park, and Boone Wildlife and Recreation Area. Protected sites on Stone Mountain include Cumberland Gap National Historical Park, Shillalah Creek Wildlife Management Area, Cranks Creek Wildlife Management Area, Stone Mountain Recreation Area, and Martin's Fork Wild River. Until recently there were no protected lands on Big or Little Black Mountain, but in 2000 the state reached an agreement to purchase the mineral and timber rights for the highest elevation habitat on Big Black Mountain, providing some level of protection until surface rights can be purchased.

As you might surmise, most of the biodiversity found in the Cumberland Plateau is also found in the Cumberland Mountains, although the elevations are higher than anywhere else in Kentucky. On Big Black Mountain alone, more than forty species listed by the Nature Preserves have been documented, including the federally endangered Indiana

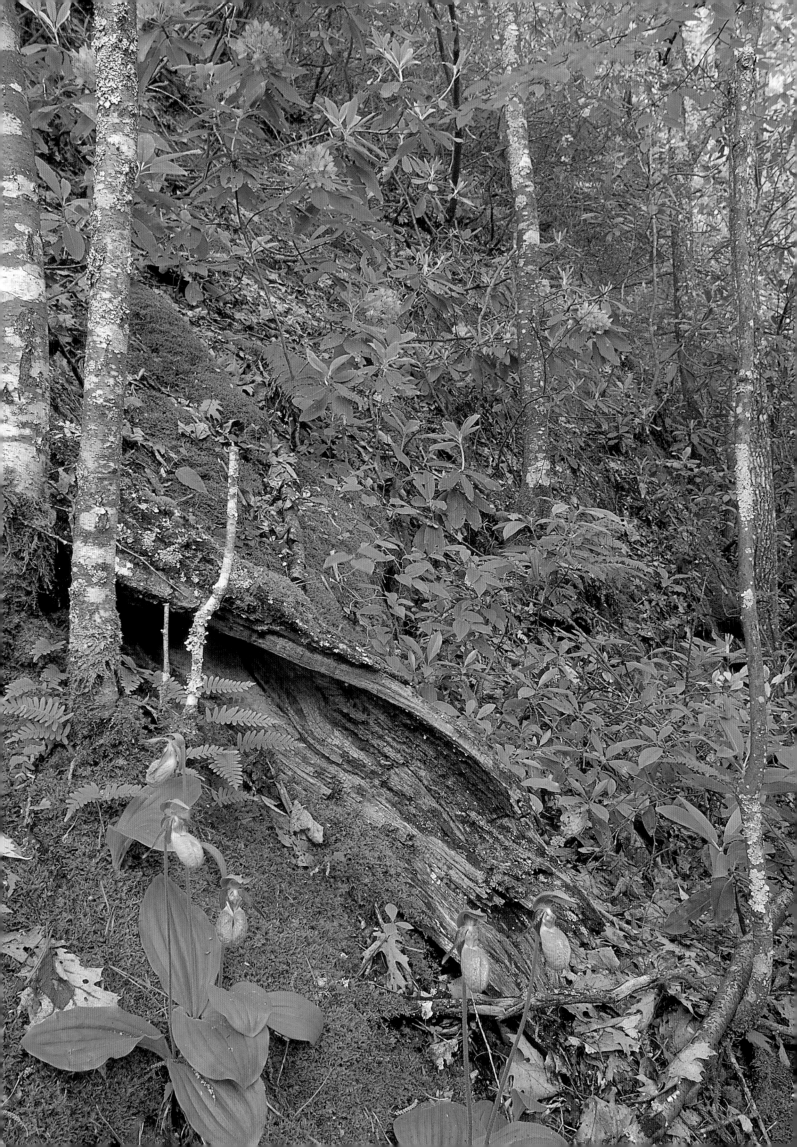

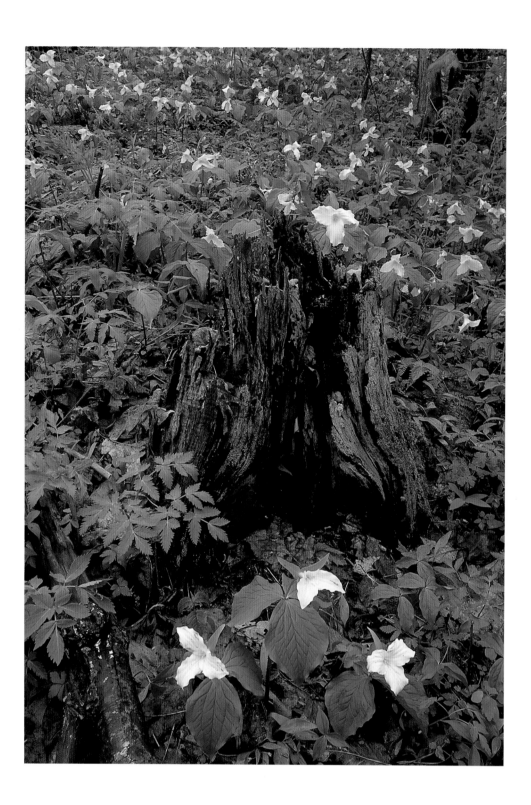

bat. At least twelve listed species are found nowhere else in Kentucky, and the best populations of another fifteen species occur on the mountain. There has been little inventory work on Big Black, but in one survey during 1998 two new plants, both high-elevation Appalachian species, were discovered, the hobblebush and Roan sedge.

Although much of Black Mountain would be considered mixed mesophytic forest, the higher elevations support a northern hardwood forest dominated by yellow birch and

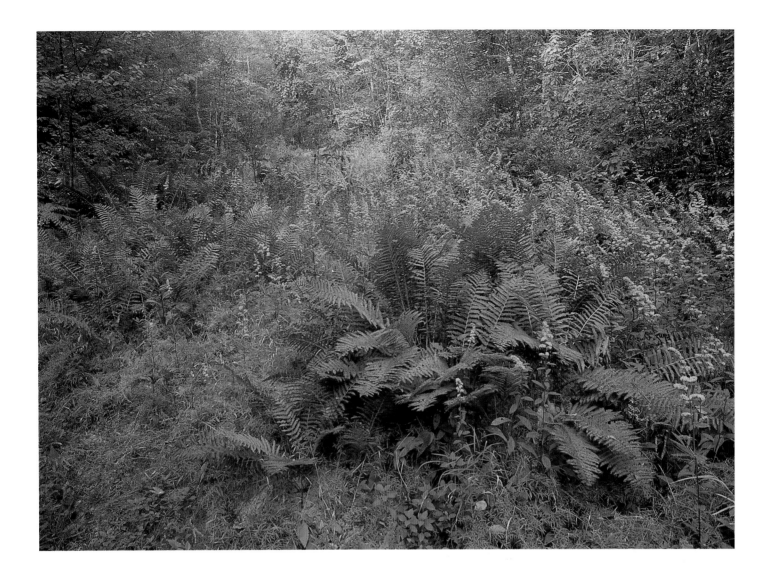

black cherry. More than a dozen rare plant species are known to occur here, including the rosy twisted stalk, painted trillium, Allegheny Mountain crowfoot, Roan Mountain goldenrod, small purple-fringed orchid, red-berried elder, Canada mayflower, filmy angelica, blunt-lobed grape fern, spotted joe-pye-weed, cow parsnip, tall hairy groovebur, finely-nerved sedge, eastern waterleaf, Curtis' goldenrod, and the spectacular Turk's-cap lily. Seven northern bird species that nest on the mountain include the least flycatcher, blackburnian, black-throated blue, and chestnut-sided warblers, dark-eyed Junco, blue-headed vireo, and rose-breasted grosbeak. Rare mammals include the masked shrew, an endemic vole (the Cumberland red-backed vole), the cloudland deer mouse, and the woodland jumping mouse. In addition, nine different beetle species, several snail species, and more than forty species of moths occur here and nowhere else in Kentucky.

Although Black Mountain harbors numerous rare species, other organisms that occupy different habitats are found on Pine and Stone Mountains. Throughout these mountains at least 128 species of listed plants and animals are known to occur: 76 plants, 23

Kentenia Bog is representative of several small, boglike wetlands in the Cumberland Mountains. This is one of three stream-head wetlands that occur on Blanton Forest State Nature Preserve. Each wetland is floristically different, but most are dominated by cinnamon and royal ferns and sphagnum moss.

invertebrates, 12 birds, 9 mammals, 4 reptiles, and 4 fish. Some Pine Mountain specialties include Allegheny vine, quinate jack-in-the-pulpit, annual yellow foxglove, yellow wild indigo, matricary grape fern, pale corydalis, thyme-leaved bluets, fetterbush, bog clubmoss, golden club, rose pogonia orchid, Michaux's saxifrage, meadow sweet, Appalachian cliff fern, and several different filmy ferns.

Three different preserves show the incredible diversity of life found on Pine Mountain: Blanton Forest, Hi-Lewis Pine Barrens, and Bad Branch. During a natural-areas inventory in 1992, Nature Preserves ecologist Marc Evans discovered two significant areas on Pine Mountain. The first was Blanton Forest, a relatively large parcel of old-growth forest, and the second was Hi-Lewis Pine Barrens, the only known pine-oak barrens on the top of the mountain.

Blanton Forest is the largest old-growth forest in Kentucky. Ultimately, 6,700 acres on the south slope of Pine Mountain will be protected, including 2,350 acres of old-growth forest. It is the thirteenth largest old-growth forest in the eastern United States. The trees that tower one hundred feet above the forest floor are the same ones the settlers saw as they came through the Cumberland Gap and moved westward into Kentucky. More than four hundred species of plants have been recorded from the preserve, including painted trillium and showy gentian. The rare blackside dace has been found in the cool, clear water of Watt's Creek at the base of the preserve.

On my first trip to Blanton Forest, Marc Evans led a field trip to Knobby Rock to showcase the splendor of this special place. I remember tramping through "rhodo hells"

and hemlock forests on our way up the slope. We stopped at one location to view a large hemlock, then climbed until we reached Sand Cave. Several eight-thousand-year-old spear points have been found near the entrance to the cave. As we made our way up to Knobby Rock, many of us were surprised by the lack of huge trees. Marc explained that many of the trees in this area would not be large because the soil was poor and we were on the south slope of the mountain. After enjoying the view from Knobby Rock and finding much mountain laurel and some Catawba rhododendron still in bloom, we took the quick way down, straight down an old Boy Scout path, to the camp.

My next trip was with Bryce Fields, a Harlan County native and Nature Preserves biologist who did the floristic inventory of Blanton Forest as a student at Eastern Kentucky University. We went to visit "the bogs" in late August, when the orchids should be blooming. These are not true mountain bogs but stream-head acid seeps, and they are real biological treasurers. We made our visit in late July in hope of catching the cardinal flower and joe-pye-weed in bloom. Sadly, we were a bit late, but we found a nice patch of Canada lily on our way to the bogs. We saw a good many large chestnut oaks and stopped to photograph one with a large mushroom growing at its base. As we arrived at the bog, a sweet fragrance tickled our noses. The bog was lined with sweet mountain pepperbush, which was flowering profusely. We hit paydirt at the edge of the bog with dozens of small clubbed orchids in peak flower.

As with most of the mountain bogs, and like those found on the plateau, the plant community was dominated by cinnamon and royal ferns. There were also dense mats of sphagnum moss with some white turtlehead blooming. I was not surprised when Bryce said that Brainard Palmer-Ball, terrestrial zoologist for Nature Preserves, had discovered Baltimore butterflies here. Their host plant, turtlehead, was sitting right in front of me. There was some cardinal flower and joe-pye weed, but the best show of color at this bog would be in the fall.

At this point Bryce asked if we wanted to see a really big white oak. Heck yes! We walked for what seemed like miles, and just past the second of three stream-head bogs was the largest white oak I have ever seen in the woods. It took three grown men, arms outstretched, to reach around that monolith. On the way out we stopped to photograph a wood frog, but we spent most of our time simply enjoying our hike in an ancient forest. I would return in October with Kyle Napier, Pine Mountain Preserve steward, to photograph this bog.

The other unique plant community Marc found in 1992 was Hi-Lewis Pine Barrens. The most interesting botanical discovery at this preserve was a rare frostweed that had been "lost" for about a hundred years. Marc found it growing around some rock outcroppings, and in June a group of dedicated professionals, including Dave Skinner, Joyce Bender, Kyle Napier of Nature Preserves, Rob Paratley, herbarium curator at University of Kentucky,

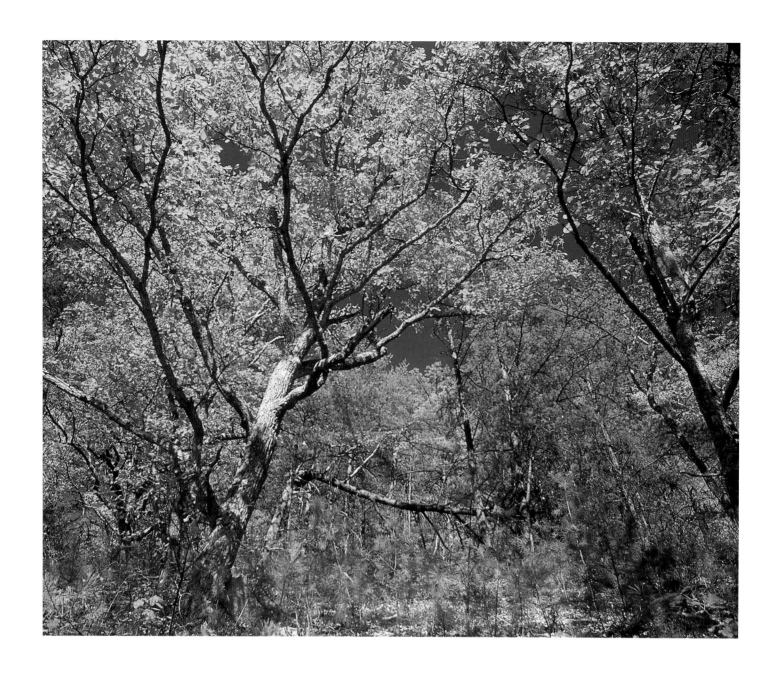

Hi-Lewis Barrens is an example of a pine-oak savanna on the crest of Pine Mountain. This ecosystem is maintained by periodic fires.

Marc, and myself, descended from the Little Shepherd Trail to the approximate location of the frostweed. I say approximate because they knew only the general vicinity where the plant could be found. We could not have picked a better day: hot and humid, humid, humid. After a sweat-drenching walk we reached the approximate location and began searching. After a few minutes someone yelled "I found it," and we all came running. There it was. One lonely plant, all by itself. Well, at least I could get a photo for Joyce, I thought. Think again. Dave made the mistake of touching a petal, and to everyone's amazement, all the petals came floating to the ground. Dave probably still gets a ribbing to this day. No big deal, we all thought, we will find another. Encouraged and reinvigorated, we all began searching among the little bluestem and Indian grass. But it was not to be. We never found another plant.

*Numerous prairie grasses
and wildflowers are found in
the Hi-Lewis Barrens
savanna, including the rare
frostweed (left) and yellow
false indigo (right).*

Since the Nature Preserves biologists had work to do, Rob and I indicated we would try to find more of the openings in hope of getting some photographs of the community. We began the slow and arduous task of hiking up the mountain across country. We hiked through some dense woody thickets until I started to feel faint and realized my blood sugar was low. Rob thought I was going to die. He lent me a few figs, which raised my blood sugar, and off we went, back to the trail.

As we got back on the trail and began the slow ascent to the top, we stopped for a break. I was definitely worn out. As we sat there for a few minutes I saw a neat little yellow flower. I called Rob over and we looked at it. It looked like the frostweed we had seen earlier, so I took a lot of photos. We notified Joyce that we thought we had found it. Alas, we had not. The beautiful plant with the little yellow flower was a common flax. I am surprised Kyle ever asked me back to photograph anything, but he did, and I managed to photograph the frostweed the following year in a power-line cut where hundreds had been discovered by Allan Risk, a Morehead State University professor.

Hi-Lewis Barrens, named for the stream that drains the area, protects an extremely rare community dominated by pitch pine and chestnut oak on the steep, south-facing slope of Pine Mountain, beginning about half way up the slope and extending to the upper reaches. This unique community, the only known example in Kentucky, supports a number of rare plants, including the diminutive screwstem, frostweed, and the largest

One of the most outstanding nature preserves in Kentucky is Bad Branch, located near the crest of Pine Mountain. It is an excellent example of a northern forest above the falls and harbors numerous biological treasures, including the painted trillium, pink lady's slipper orchids, and ground pine, all three shown here.

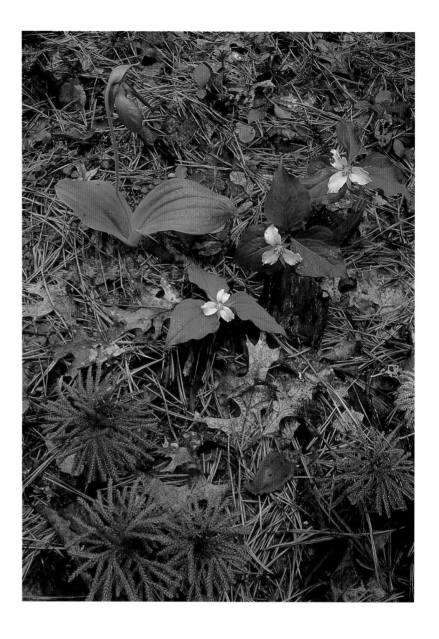

known population of yellow wild indigo in the state. The open areas feature an unusual mix of plants typically considered prairie species, such as little bluestem and Indian grass, in addition to drought-tolerant plants such as low-bush blueberries. Rising one thousand feet in elevation from the base of the mountain to the ridge crest, the area also features numerous sandstone outcrops and cliffs.

Last, but certainly not least, is Bad Branch. This was perhaps the first "gem" of the Nature Preserves system. The Kentucky Chapter purchased the original 435 acres in the lower gorge and subsequently sold it to Nature Preserves. Since that time an additional 1,850 acres have been purchased, including the gorge above the sixty-foot waterfall. Some of my most memorable trips to Pine Mountain have been spent hiking at Bad Branch with Kyle Napier. I took my first hike there many, many years ago, when Kyle led me to the only known site of the rose pogonia orchid. This small, delicate orchid grows in a tiny

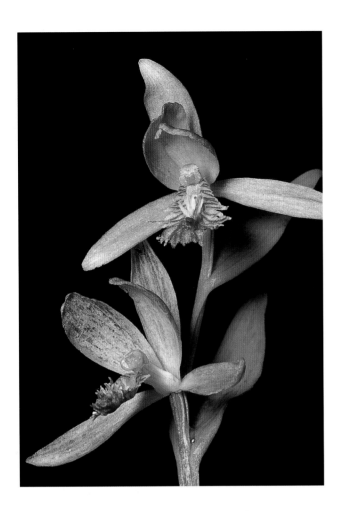

semibog wetland just as you enter the northern gorge portion of the preserve. My most recent walk with Kyle was in the fall, when we visited the preserve to find showy gentians.

Kyle is a true mountain man. Born and raised in those hills, he knows the mountains and he knows the people. And he knows about turkey hunting. On most hikes I have taken with Kyle, at some point we get around to talking turkey. We relive hunts, share secrets and frustrations, and generally enjoy the conversation about how smart those darn birds are. This day began like most others, and we ultimately did talk turkeys. Kyle found a showy gentian along the road, not one hundred yards from the truck. The plant was in good shape and I took some portraits, but I wanted some habitat shots. So we continued our walk. Our next stop was at the little wetland where the rose pogonia orchid grows. It was covered with nodding ladies' tresses orchids, and I could not resist taking a few more photographs.

We bounced along another hundred yards or so and noticed a large pile of dung right in the middle of the trail. I glanced at it, and asked Kyle why horses would still be getting into the preserve. He wasn't sure but said he would check into it. We didn't give it another thought. We continued our walk that beautiful October day, and after a mile or so we saw our first showy gentians. I set out to photograph them while Kyle looked for some additional plants.

Other plants known primarily from the Cumberland Mountains include the pink corydalis (top left), *showy gentian* (top right), *and painted trillium* (lower right).

We continued the walk up to Hi Rock, a nice rock outcropping with a great view, and then began the descent. When we reached the dung pile, Kyle was not convinced it was from horses. We looked at it more closely, and sure enough, bear poop. Kyle then told me about his encounter a few years back with a bear and cubs on that very trail. We were certainly glad that black bears were making a comeback into the eastern mountains. When we arrived back at the truck I was tired, but Kyle was just getting revved up. Flat-landers like me suck wind in these mountains. We bid farewell, knowing I would probably be back for his help again. Of course I have been, several times, and Kyle graciously puts up with me.

Bad Branch Preserve has long been noted for its outstanding natural qualities. Because the gorge is narrow with steep cliff faces, a northern forest dominated by hemlock and yellow and sweet birch has developed in much of it. Other species include basswood, yellow buckeye, tulip poplar, and American beech. Among the rare plants found here are several northern relic species, such as matricary grape fern, Fraser's sedge, and American burnet. Other rare species include Michaux's saxifrage and painted trillium. Rare animals include the state-endangered long-tailed shrew and an endemic fish, the arrow darter.

Black bears are making a comeback in eastern Kentucky.

Lastly, we arrive at Cumberland or Stone Mountain and the Cumberland Gap National Historical Park. Three things at Cumberland Gap National Historical Park are biologically important. First and perhaps foremost is that this is the only large, unfragmented, largely wilderness forest left in eastern Kentucky. It is a treat to see this park from the air—no roads, no mines, and no huge clearcuts, a wonderful place for interior forest wildlife such as our neo-tropical woodland birds. The second is an area of rock outcroppings and associated dry open forest called White Rocks, located at the crest of the mountain. Several rare plants can be found here, including American cowwheat, fly-poison, Porter's reed grass, crinkled hair grass, Appalachian sandwort, silverling, and Epling's hedge nettle.

Finally, perhaps the largest known stream-head wetland in Kentucky is located in the park. Like most of these mountain acid seeps, the plant community is dominated by cinnamon and royal ferns. But this was the first location where several true bog wetland species were documented, including cotton grass, red sphagnum moss, and the white-fringed orchid. When the joe-pye-weed is in bloom, huge numbers of Diana fritillary butterflies float above the bog.

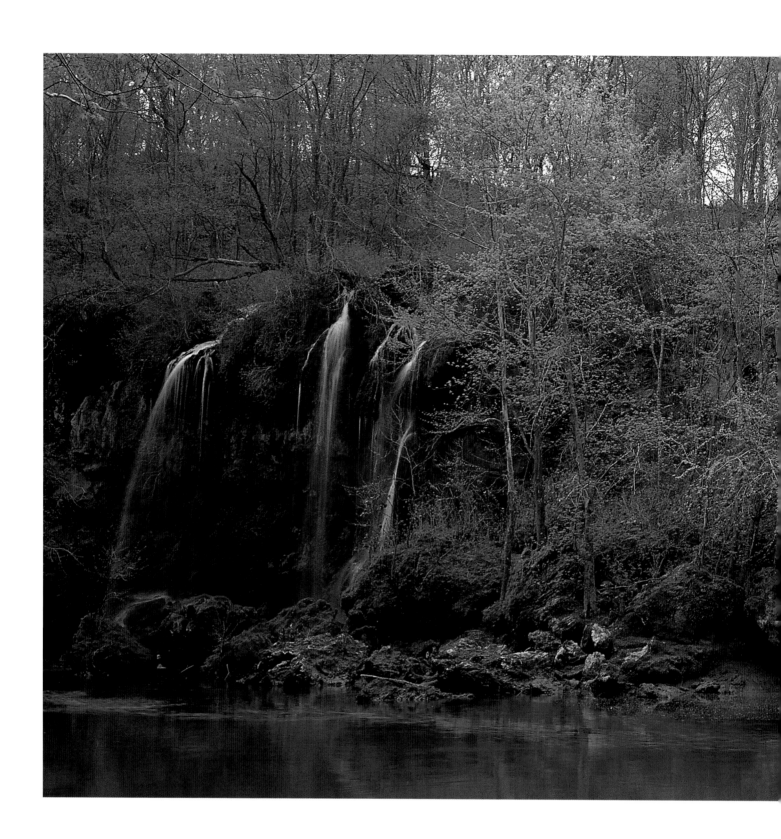

6

THE PENNYROYAL

The Pennyroyal region has been highlighted in earth science textbooks as "the classic example of karst processes and landscapes." Technically called the Mississippian Plateaus, this is a diverse region of rolling hills, caves, sinkholes, and disappearing streams. Some of the commonwealth's most fertile soils, mostly limestone-dominated and often with a red clay appearance, occur here. Hence, agriculture is the dominant industry in the region. The productivity of these soils was quickly realized and exploited by European settlers, leading to the rapid conversion of native grasslands to the point where virtually no deep-soil prairies remain. Most of the state's large artificial lakes occur in this region, resulting in the global extinction of numerous aquatic organisms. Agriculture and urban development have further complicated aquatic conservation as a result of nonpoint source pollution. Although many of the natural qualities of the area have been destroyed, there are an amazing number and diversity of high-quality sites remaining in this physiographic region. Let's begin the journey with the grasslands.

BARRENS

I like to think of the "Big Barrens" region of Kentucky as a giant jigsaw puzzle. All the pieces of tallgrass prairie are present but we do not know how they all fit together—not just yet. At one location you might find the showy prairie gentian; at another, excellent stands of rattlesnake master; at yet another, prairie dropseed grass. Unfortunately, there is no one site where all the pieces fit together. Jerry and Carol Baskin, barrens experts at the University of Kentucky, are certainly correct when they state that there are no reference

Overleaf: *Three Hundred Springs along the Green River.*

areas left from which we can decipher what the original barrens looked like, particularly the deeper-soil sites. Killebrew and others reported in 1874 that most barrens were in tilth (tilled) by the middle 1800s. Shull in 1921 reported that "the barrens are only a memory." Most of what we have left today are sites with too many rocks, shallow soils, or other factors that made them untillable.

Of all the major ecosystems known, grasslands are perhaps the most underappreciated. I'm not sure why. Perhaps because there are no colossal-sized trees. Perhaps because they are so easily plowed or grazed or developed into suburbia. Perhaps because we underestimate their age. Perhaps because we don't understand them. Whatever the reason, these communities are becoming some of the rarest biological communities in North America, and certainly in Kentucky. It has been estimated that 97 percent of the tallgrass prairie has been put under the plow to grow corn and soybeans. More than 98 percent of the midwestern oak savannas (including those found in Kentucky), 98 percent of the blackland prairies, and 98 percent of the Palouse prairies are ancient history. In Kentucky we have precious few prairies left. There are probably less than twelve hundred acres of high-quality grasslands of the more than two million acres that once graced the Pennyroyal.

Prairie gentian is perhaps the showiest gentian found in Kentucky and is known to occur only at several protected locations, including Eastview and Athey Barrens.

The gulf fritillary is considered a rare butterfly in Kentucky. I have found it most years feeding on dense blazing star on a small prairie remnant near Bowling Green.

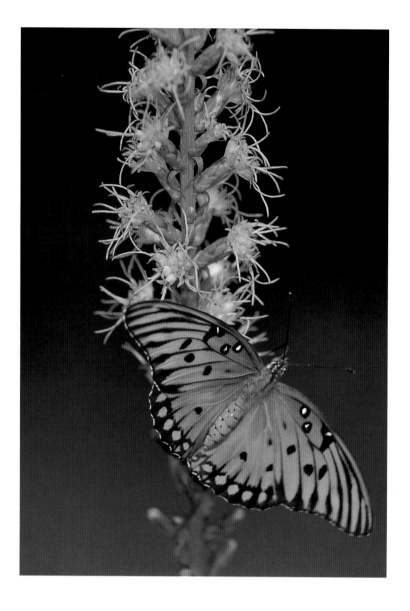

Prairies hold a special place in my heart, for I grew up on the prairies of eastern South Dakota. For some Kentuckians, used to residing in a forested state, grasslands may not appear boldly scenic. They do not have spectacular spring floral displays or picture-postcard images like those associated with Cumberland Falls. In my opinion, however, you have to experience the prairie closeup to really appreciate it. Perhaps William H. Elder expressed it more eloquently when he wrote in *Needs and Problems of Grassland Preservation*, "Every American has the right as part of his cultural heritage to stand in grass as high as his head in order to feel some small measure of history coursing his veins and personally establish an aesthetic bond with the past."

Unfortunately, most of the remaining openings are too small to be useful to most grassland wildlife species such as upland sandpipers or bobolinks. The prairie chicken once thrived in the large expanse of grassland. They are now extinct. Although grassland specialists may not use isolated grasslands in a sea of agriculture, they are no doubt used

extensively by wildlife, including white-tailed deer, wild turkey, and cottontail rabbits. Perhaps insects, butterflies in particular, make the greatest use of glasslands. Many of the flowers that occur on these prairies are highly attractive to butterflies. Over a period of two hours one hot July afternoon, I recorded a plethora of colorful flying flowers as they gathered nectar. There were big swallowtails, including black, tiger, and spicebush; there were viceroys, monarchs, buckeyes, and a gulf fritillary. There were numerous species of skippers. I even photographed a preying mantis choking down a silver-spotted skipper. Clouded and cloudless sulphurs, hummingbird moths, and cloudy-wings were fluttering everywhere.

Perhaps the most striking thing reinforced in my mind that day was that although each piece of grassland habitat in Kentucky is unique, they all look like prairie. I began to wonder what a prairie is. Are the Kentucky barrens prairie? Are the Baskins correct when they state that the Big Barrens region was not a component of the tallgrass prairie? Prairie or barrens, what to call them? My own perspective is that the question is one of semantics and something academicians can argue about for centuries. I believe they are prairies because John C. Curtis (1959) in *Vegetation of Wisconsin* defines a prairie as "an open community dominated by grass and having less than one tree per acre." John Sawhill writes, "The namesake grasses, of course, are there in abundance—Big bluestem, Indian grass, cord grass, but interspersed thickly amid these majestic grasses are hundreds of other plants, such species as the little bluestem, prairie dropseed, needlegrass, side oats grama, and the compass plant, as tasty as ice cream for a hungry cow or bison." John Weaver writes in the classic *Prairie Plants and Their Environment* that of the ten grasses that compose more than 95 percent of the grass population, big bluestem, Indian grass, prairie cord grass, switchgrass, and Canada wild rye are found in the lowlands, and little bluestem, needlegrass, prairie dropseed, side oats grama, and June grass are found in the uplands.

André Michaux wrote in his journal in 1796, "The 12th passed through a Country covered with grass and Oaks which no longer exist as forests, having been burned every year. These lands are called Barrens lands although not really sterile. The grasses predominate. . . . The *Salix pumila* that grows there in abundance is the same as that which is very common in the Illinois prairies." Davidson in 1840 wrote, "This tract extending over several counties was originally styled the barrens. Not from any sterility of soil . . . but because it was a kind of rolling prairie." In 1876 Huffy wrote, "It is well understood that the aborigines of this country were accustomed to burn over the surface of the prairies but for what purpose it does not seem to be perfectly understood. . . . The habit of firing the prairies must have exerted a wide influence on the characters and distribution of plants in the parts of our country where prairie existed." So let's call them prairie barrens.

Raymond Athey State Nature Preserve was the first prairie barrens protected in Kentucky. Shallow limestone soils support this grassland community dominated by Indian

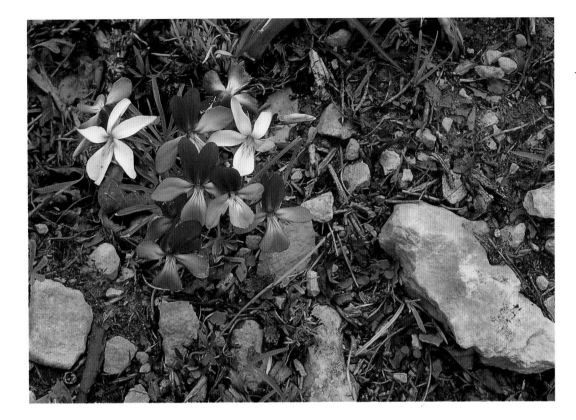

grass, little bluestem, broom sedge bluestem, and tall dropseed. There are some patches of deeper soil that support a few patches of big bluestem, and there are numerous glades interspersed throughout the post oak–dominated woodlands. Four state-endangered plants, the prairie and yellow gentians, Carolina larkspur, and hairy fimbristylus, occur on the preserve.

I have visited the preserve often, conducting research on several old fields near the back of the preserve. On one occasion I was surprised to see bird's-foot violet, hoary puccoon, and violet wood sorrel blooming several weeks after a prescribed burn. On another occasion I went to photograph showy evening primrose and was treated to a clump of prairie phlox and sundrops growing together. Scaly blazing star and white prairie clover are two of the most abundant wildflowers found here. Other prairie wildflowers include cutleaf prairie dock and gray-headed coneflower.

During one visit I noticed an olive hairstreak butterfly zooming around the early goldenrod flowers. I took a break from sampling, got my camera gear out, and began chasing after this tiny yet beautiful insect. Several of them were floating here and there, but before I could get near enough to photograph one of them, it would flit to another plant. Finally, after half an hour of frustration I found one that appeared to tolerate my presence. I took a few documentary-type photos and then sat down and spent some time with this little critter. Picture 2:00 P.M. on a typical August day. Now add heat and humidity and you have the perfect conditions for butterfly photography! This was one cooperative little insect. I worked him for more than two hours. After an hour it began to sprinkle, then rain,

Eastview Barrens after a spring burn that killed many woody stems and rejuvenated the prairie.

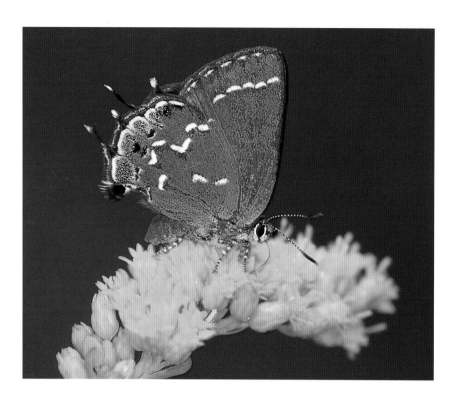

but he did not move, so I continued to photograph him. I watched him move under the stem of the flower and wait out the rain. After the rain, he moved back onto the flower and began nectaring again. When I finally felt I had enough photos, I went back to collecting data. It wasn't until several days later that I felt the full impact of that photo session. I had chigger bites on places you are not supposed to have chigger bites. Hundreds of them.

Olive hairstreak butterflies are common at Athey Barrens because their larval host plant, red cedar, is abundant.

On the western edge of the province two small but significant glades, Aimee Rosenfield Memorial Preserve and Crittenden Springs Glade, protect our most western populations of many prairie plants. Prairie dropseed, great plains ladies' tresses orchid, fringed nut rush, the sedge (*Fimbristylis puberula*), grooved yellow flax, Buckley's goldenrod (a plant normally restricted to the Ozarks and Shawnee Hills regions) all grow here. I was impressed in my visit to Aimee Rosenfield by the abundance of narrow-leafed coneflower, scaly blazing star, gray-headed coneflower, mountain mint, false white indigo, and cut-leaf prairie dock. Once fire management is initiated on these sixty-nine acres it will be a prairie showcase for the citizens of western Kentucky.

HIGHLAND RIM WET BARRENS

Nestled in the eastern Highland Rim, tucked in between small woodlots, cornfields, and fescue pastures, is probably one of the rarest plant communities in the entire state of Kentucky. I call it wet prairie. The Conservancy's term is more sophisticated and sounds better: Highland Rim Wet Barrens. Whatever name you give it, this place is a biological gem. In some sense it is part wetland and part grassland. The dominant plants in the community are various grasses and sedges, but there are also many showy wildflowers that can tolerate damp soils and the full sun. The late-summer orchids, including the nodding and slender ladies' tresses and the large, bright orange-yellow crested orchid, can be spectacular.

I have visited the preserve only a few times, but each time I have had a memorable experience. My instructions from Julian Campbell were to park at the church, cross the road, follow an old logging road, then look for the "racetracks" in the grass. There you will find the sundew. I had observed this unique carnivorous plant several times in the past.

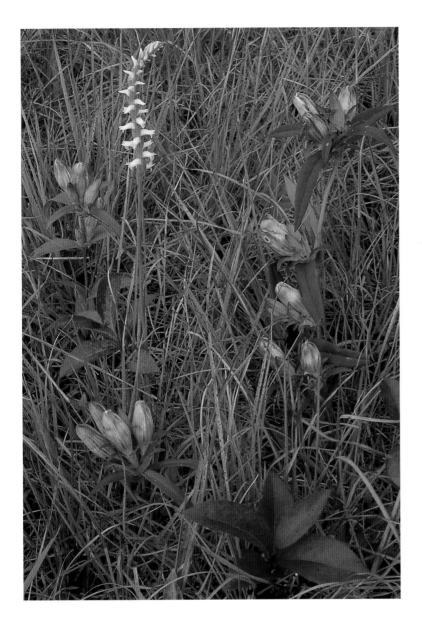

These soapwort gentians and nodding ladies' tresses orchids are fall-blooming wet prairie plants.

Once I saw tiny specimens, and once I was surprised to find specimens the size of a silver dollar. So I was really unsure of what I was searching for; I only knew I wanted a photo.

I had no problem finding the place, and as I drove up that afternoon I noticed a Kentucky Chapter truck parked at the preserve. Great luck, I thought, as I loaded up the camera gear and trekked in. After wandering through the woods, feeling rather clumsy and discombobulated, I stumbled into the opening. (Let's face it, you can't really get lost in thirty-two acres, can you?) There to my surprise were two Conservancy interns who looked as if they had been to the proverbial "warm" place and back.

Sweat was flowing profusely from their brows. There were wood chips all over their clothing, as if they had been "busy as beavers" cutting down giant trees. They looked exhausted and obviously needed a break, and I felt it was my obligation to be the source of their rest and relaxation from whatever horrendous task they had undertaken. Actually, I

was probably more self-serving because I hoped they could take me to those sundews! They had been cutting down and herbicide-treating stumps of red maple and sweetgum trees that frequently invade this unique and unusual wet grassland. The amount of woody material lying on the ground was a testament to their hard work that day. These two young ladies had the strength of Hercules.

I introduced myself, and my introduction was met with, "Oh, I've heard of you!" I am not always sure if that is good or bad, but I assumed it was good because they didn't attack me with their chain saw or herbicide bottle. After chatting a while, I asked if they knew where the sundews were located, and they quickly informed me they had no idea. I bid them farewell and went off in search of the sundew. I rambled around that thirty-two acres, hunched over, my head close to the ground, carrying forty pounds of camera gear. I must have looked like some humpbacked mastodon complete with a unique appendage (my tripod). I didn't find the sundews that day but did find some nice gentians and nodding ladies' tresses orchids. I shot some frames of these species that evening, just before sunset.

My next trip was much more successful because Julian accompanied me to the site. Once I found the sundews (they were much smaller then I had remembered), Julian pointed out a group of other rare plants, including St. Peter's wort, hairy water primrose, long-leaved panic grass, and beard grass. Perhaps the best impression I came away with was the large number of rare species that occur at this one location. The only other comparable place I know is Flat Rock Glade in Simpson County, one of the best examples of a true cedar glade in the state.

CEDAR GLADES

Flat Rock Glade is the best example of a "true" cedar glade that occurs only in the Nashville Basin. There are distinctive vegetation zones based on soil depth in these glades, as shown by the pink flowered widow's cross seen here.

Dag nab it, this place was hot! I was sitting in the middle of a giant limestone rock in Flat Rock Glade, it was ninety-five degrees, the sun was bright, and I had to wait another half hour before the limestone fameflower would open. What to do? Sit and sweat. I wondered what the temperature on the top of the rock was. But I was determined to get a photo of this spectacular tiny flower, even if I lost ten pounds doing it. My patience was finally rewarded, as one by one the tiny purple-petaled flowers opened, right on time, at 3:00 P.M. No wonder this little gem is called flower-of-an- hour; it opens at 3:00 and closes at 6:00 P.M. The photography was difficult because the wind was blowing and bees were all over the flowers, but what a sight, watching a bee about twice as large as the flower trying to get some nectar.

This is a unique place. Massive, flat-bedded limestone rocks are surrounded by a thin, gravelly soil that eventually grades into typical shallow-soil open woods. Flat Rock Glade is undoubtedly the highest quality, least disturbed limestone cedar glade in Kentucky. There are several smaller glades that contain other unusual plants, but at Flat Rock all the pieces

Flower-of-the-hour is just one of numerous rare plants that can be found on cedar glades.

of the puzzle are present. Historically, the only known cedar glades were in the Nashville Basin in Tennessee. Because the geology is similar in this part of the Pennyroyal, it was only a matter of time before a high-quality glade was found in Kentucky, and in 1990 Nature Preserves purchased these sixty-five acres from the Kentucky Chapter.

When it comes to a rough environment for organisms, cedar glades are it. During much of the growing season they are hot and dry! Although the exposed bedrock and thin soils dry out quickly, during the spring growing season or during heavy rains in the summer the soils at the edge of the rock become saturated. These strange growing conditions make for interesting plant communities. You are likely to find prickly pear cactus growing close to Butler's quillwort, a state-endangered wetland plant. Perhaps the feature that determines which plants grow where is soil depth. In the very thin soils you are likely to find widow's cross, the quillwort, fameflower, necklace glade cress, and the stemless evening primrose. All but widow's cross are very rare in Kentucky, and by midsummer the only plant alive is the fameflower. Thicker soils yield the state-endangered false hispid mallow and lots of shooting stars in the spring. As you leave the rock and proceed into the forest, you are likely to find the threatened upland privet bush, lots of red cedar trees (hence the name cedar glade), Carolina buckthorn, winged elm, persimmon, and redbuds. The surrounding forest is somewhat unusual in that is has a great deal of post oak and blackjack oak.

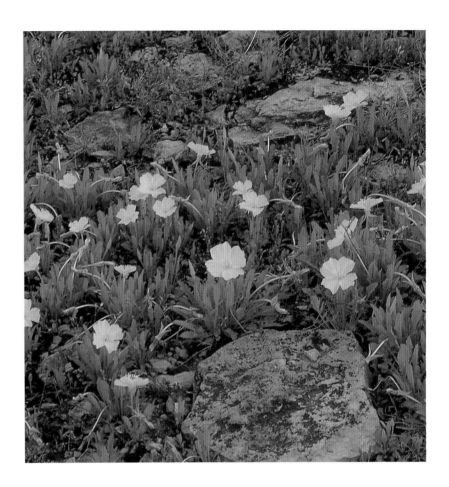

Some of the rarest plants found on cedar glades are Gattinger's lobelia (top left), the stemless evening primrose (top right), and the hispid false mallow (lower right).

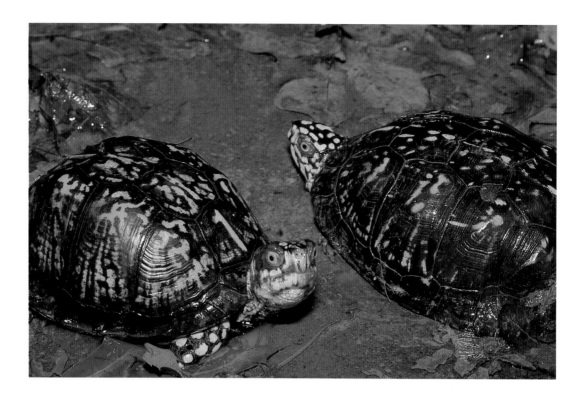

I photographed these box turtles at Flat Rock Glade. Box turtles appear to be abundant at this preserve.

The bottlebrush crayfish is endemic to the Green River.

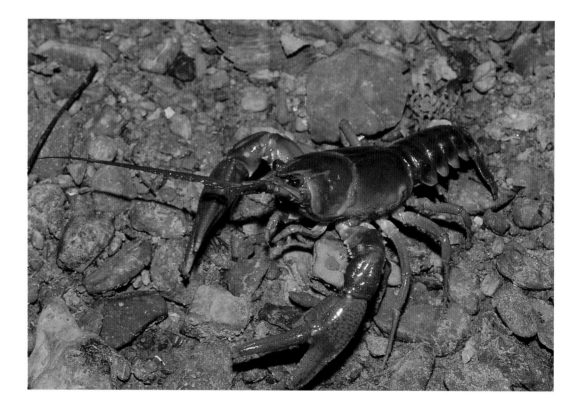

I am fortunate to have visited this site many times and have always cherished the companionship of Rick Remington, Nature Preserves' western preserve manager. The first time I visited Flat Rock I got lost and could not find the openings. That was before Rick was hired. With his guidance I have been able to find all of the rare plants on the preserve.

GREEN RIVER BIORESERVE

With all this focus on terrestrial ecosystems it is perhaps time to shift focus to one of the most challenging conservation projects in the state, protecting the Green River watershed. This enormous task can only be accomplished by working with a variety of both governmental and nongovernmental agencies. The project has been initiated in an effort to both protect important natural resources and allow people to maintain a high quality of life. So just how important is the Green River? Follow me on a little journey.

I met the Nature Preserves aquatic biologist, Ron Cicerello, at Horse Cave early one September morning. Ron was my guide in an effort to get photographs of rare mussels found in the Green River system. I loaded my camera gear into his truck, and off we drove. I could feel in my heart that it was going to be a fine adventure. As we traveled, we talked about the importance of the Green River. In North America our most imperiled organisms are freshwater clams or mussels. Ron noted that 71 of the state's 103 mussel species (out of 300 North American) are known to occur in the Green. In addition, 151 fish species, or 19 percent of the United States freshwater fish fauna, call the Green home. This system supports our state's only endemic mussel; several federally endangered mussels, including the fanshell, ring pink, clubshell, and rough pigtoe; an endemic crayfish, the bottlebrush; and an endemic fish, the Kentucky snubnose darter. Furthermore, Ron noted that Mammoth Cave National Park (which lies within the adjacent Shawnee Hills physiographic region) probably hosts the highest biological diversity of any national park because it harbors rare cave organisms, including a blind crayfish, a blind fish, and the Kentucky cave shrimp, another federally endangered species. Add to that list both the Indiana and gray bats and I quickly realized he wasn't just blowing smoke. This place was a hotbed of biological diversity.

When we arrived at our preselected location, I filled my vest with gear, we put on old shoes, and off we walked, right into the river. We waded across thigh-deep water to the opposite bank and hiked about a mile down the river to a shoals of sorts. I couldn't tell it was a shoals, but Ron knew the location well. At that point he instructed me on the finer points of finding mussels. First, prepare to get wet. Second, insert the hand all the way to the bottom of the river. Third, move your hand across the gravel until you feel something sticking up. Fourth, check to see if it is a mussel. This was more fun than playing in the mud, and we were getting paid to do it. Ron was an expert at finding mussels. He found some of the more common species, then brought up one the size of a football. I had never seen a freshwater clam that big. And it was heavy. It must have weighed five pounds. Ron told me how much the commercial mussel harvesters would get for that one shell, but it escapes me now. The only thing I do remember is that it would have been very valuable.

We searched for over an hour for at least one federally endangered mussel and finally found one, a rough pigtoe. Mission accomplished. After getting some photos of the rough

Overleaf: *The Green River is the fourth most important stream in the United States for freshwater mussels.*

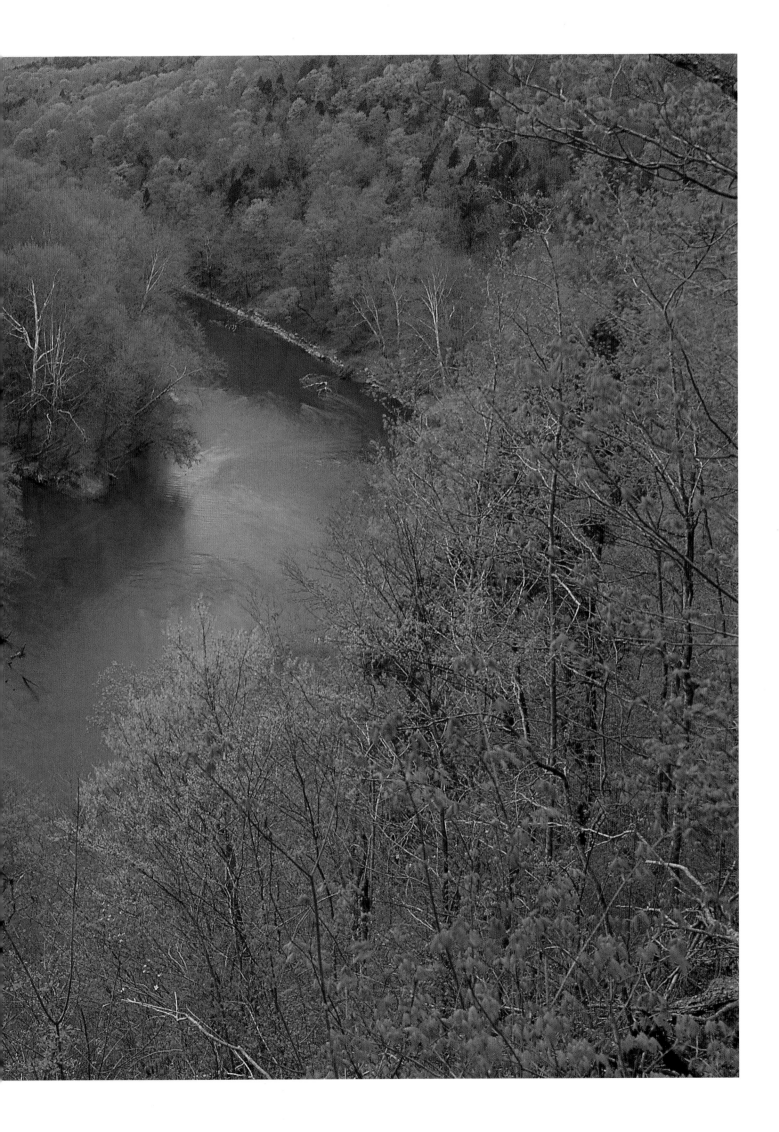

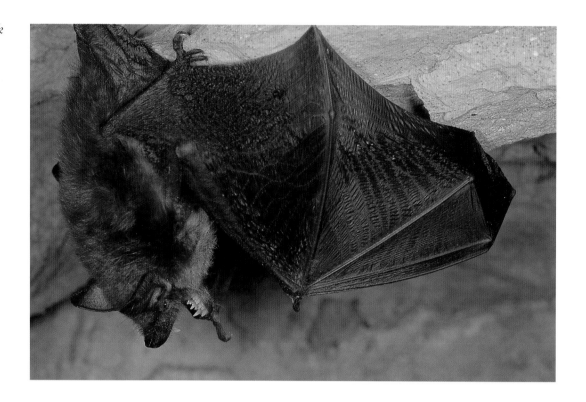

Caves throughout this karsk country support numerous cave-dwelling creatures, including cave crickets and numerous bats, such as the big brown.

pigtoe, we searched the banks and found numerous muskrat middens. Ron identified the various types of mussels, including another rough pigtoe, and explained that muskrats are not particular about which species they eat. I photographed the midden and we determined it had been a good day.

As we approached the dock on the return trip, Ron wanted to try to find a bottle-brush crayfish for me to photograph. We stopped at various riffles along the way with no luck. We had one last chance, the boat ramp. We crossed the river for the final time and stood on the bank contemplating whether or not we would be successful. Apparently the gods were smiling on us that day, because under the very first rock was a brilliant male bottlebrush crayfish. Ron grabbed it and placed it on the shore, and I attempted to get some photos. It was difficult because this guy was fast and had strong pinchers. We worked at getting photos for a while, being marginally successful, and then it happened. The doggone thing got Ron good and pinched his finger, drawing blood. I conceded the battle and Ron put him back.

We ended that fine day by going to another small stream looking for additional mussel species, but none were to be found. In this shallow tributary of the Green I learned a new sampling technique for mussels: the five-gallon pail with a clear bottom. We walked up and down this small stream for an hour or so but never found another rare mussel. On the way back to my car Ron and I talked about why the Green was so important and what factors caused fish and mussels to become extinct. We discussed the usual culprits—sedimentation and pollution from agriculture and urban sprawl, impoundment of the streams for hydro-

electric power or flood control, direct pollution as the stream travels through karst topography, and the impact of exotic organisms, particularly exotic mussels such as the zebra.

What I found most interesting was a tidbit about how exotic trout, released by Fish and Wildlife into the Nolin River Dam tailwaters, had moved up the Green into the Mammoth Cave system. Divers had actually witnessed this exotic fish eating a federally endangered species, the Kentucky cave shrimp. I was appalled that a natural resource agency would continue a practice when it was known to be harming a rare species, but the more I thought about it, the less surprising it was, because state resource agencies still focus on perpetuating game species, often to the detriment of wild plants and animals that cannot be killed for sport or recreation.

In 1998, the Conservancy published a national assessment of conservation "hot spots" for imperiled fishes and mussels titled *Rivers of Life: Critical Watersheds for Protecting Freshwater Biodiversity*. The upper Green River ranked fourth, behind the upper Clinch, Duck, and Powell Rivers in Tennessee and Virginia. This river is the most biologically rich branch remaining in the Ohio River system. Obviously the upper Green watershed is a national treasure and should be protected. But how do you protect water quality in a stream? You can't purchase or get conservation easements on all the land that feeds it. It takes a true ecosystem approach toward management to save something of this magnitude. Consequently, the Kentucky Chapter created its second bioreserve.

Karst topography is characterized by a gently rolling landscape dotted with sinkhole plains, sinking streams, and numerous springs. The world's largest underground cave system

lies underneath much of the Green River landscape. The Green's quiet waters flow through this soluble, Mississippian-age limestone. As water moves freely though the system, the minerals dissolve, giving rise to the high levels of productivity and diversity of aquatic life. Among the Green's many natural attractions is Three Hundred Springs. Water in three separate waterfalls gently cascades from the springs down an eighty-five-foot bluff in front of the globally endangered southern maidenhair fern to the river.

I have had the pleasure of visiting this spring twice, once in the spring when there was a tremendous amount of water flowing over the falls, and once in the fall when there was just a trickle. In the fall you could clearly see the deep green of the southern maidenhair fern contrasting with the bright orange of the sugar maples in the forest above. As you round the bend in the boat and the waterfalls come into sight, you feel as if you are in Costa Rica. Other spectacular springs in the region include Buckner, Rin, and Lynn Camp Creek.

Mammoth Cave National Park is situated along the eastern edge of the Shawnee Hills physiographic region but is included in this discussion of the Green River for the sake of continuity. The park is not only a state treasure but a national and international treasure. Its fifty-three thousand surface acres were named a world heritage site in 1981 and became the core area of an international biosphere reserve in 1990. The cave system, with more than 350 miles of surveyed passageways, is the largest in the world. More miles are being discovered every year. The system, which contains few of the spectacular stalagmites and stalactites of other wet caves, supports at least 130 different organisms.

There also is substantial diversity within the terrestrial biological communities. Most of the land was farmed prior to park formation between 1926 and 1941, and thus most of the forests are fairly young. There is one exception: Big Woods, a three-hundred-acre old-growth tract in the northeastern corner of the park. It is hard to imagine what the original, pre-European landscape looked like; however, much of the forest was probably restricted to mesic and bottomland sites, and the dry uplands were probably dominated by oak savanna and barrens. There is some evidence to support this concept because four globally rare plants—Eggert's sunflower, giant wood lettuce, pinnate (or cut-leaf) prairie dock, and buffalo clover—are associated with forest edge and openings. Furthermore, of the additional twenty-four state-listed species, seventeen are largely restricted to open rocky glades, grasslands, or wet areas. There are only three species, small enchanter's nightshade, filmy fern, and false hellebore, that are typical of undisturbed, closed forests.

The original upland forests were probably dominated by post, blackjack, southern red, white, black, and cherry-bark oaks. Mesic sites were probably dominated by beech, northern red oak, sugar maple, and tulip poplar. The bottomland forests associated with creeks and rivers would have been dominated by various species of oaks, sweetgum, and red maple. Julian Cambell writes, "There appears to have been little change in dominant

species within mesic or subxeric . . . forest types. . . . In . . . forest types associated with fire, it appears that post oak . . . and especially blackjack oak have declined greatly." There is one substantial deviation from this general pattern. Near sandy outcrops of the Pottsville escarpment and at some seeps or swamp margins, several Appalachian species are found, including hemlock, yellow birch, and big-leaf magnolia trees. The globally rare French's shooting star can be found under these sandstone cliffs in the northern portion of the park, and Allegheny wood rats and corn snakes have disjunct populations along the escarpment.

As the Green winds its way through the Pennyroyal, it passes through mostly agricultural fields. The only significant tracks of forest remaining in the watershed are associated with the river or its major drainages, such as the Barren River. Historically, most of this region would have been considered a part of the Big Barrens prairie region. Significant mature or old-growth forest holdings within this region include Brigadoon in Barren County and Middleton Woods, a private tract in Hart County. Land Between the Lakes is the other significant forest found within this physiographic province.

Brigadoon consists of about ninety-five acres of mostly old-growth forest with one meadow and a mid-1800s farmstead. The forest is dominated by exceptionally large tulip poplars and beech. During the mid-1970s a large chunk of the old growth was destroyed by a tornado. Mesic sites are dominated by northern red oak, ash, walnut, maples, and hack–

The corn snake is only known in Kentucky from the area around Mammoth Cave and the Red River Gorge in eastern Kentucky.

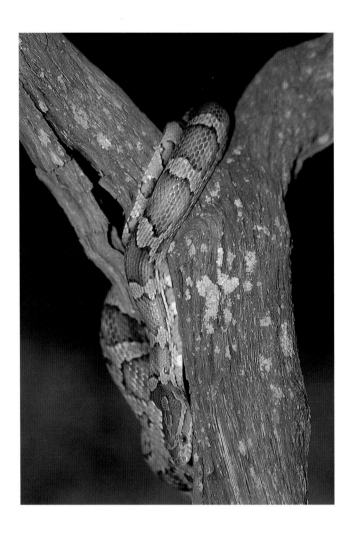

berry. The forest is dominated by oaks and hickories on the bluffs overlooking Barren River Reservoir. This small preserve is literally an island in a sea of agriculture and suburban sprawl.

My walk through Middleton Woods with owner Cap Middleton and Julian Campbell was on one of those days when I actually learned something. We met at Cap's place, which is located along the Green River at Buckner Springs. Cap provided an interesting history of the springs. He noted that a retired Civil War general did some intensive engineering of the spring and devised a mechanism whereby spring water was pumped more than one hundred feet up the cliff to the top of the ridge and into Kentucky's first man-made swimming pool—a big hole in the ground lined with limestone rocks. Parts of the swimming pool and waterworks still exist. The forest surrounding Cap's home was impressive in and of itself. It is a mesic forest dominated by exceptionally large sycamores along the bottom. On another visit during the spring wildflower season, the slopes were literally covered with synandra and blue phlox.

We hopped into Cap's truck and drove a short distance to the edge of the woods. I did not bring my camera, and I was glad of it by the time we finished hiking. We opened

Wild hydrangea colonized a canopy gap in the old-growth Brigadoon State Nature Preserve.

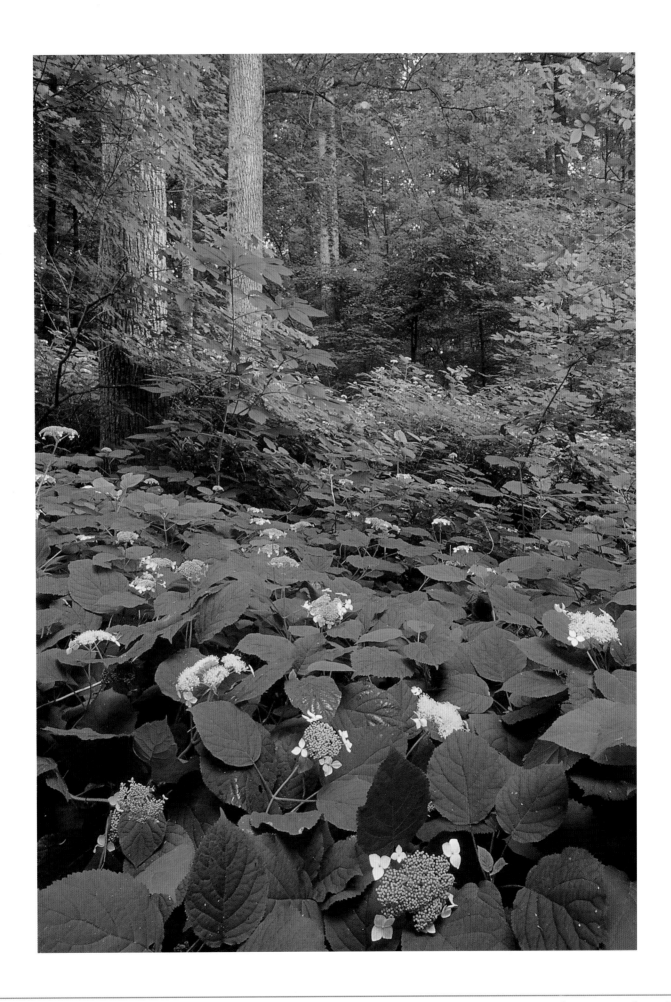

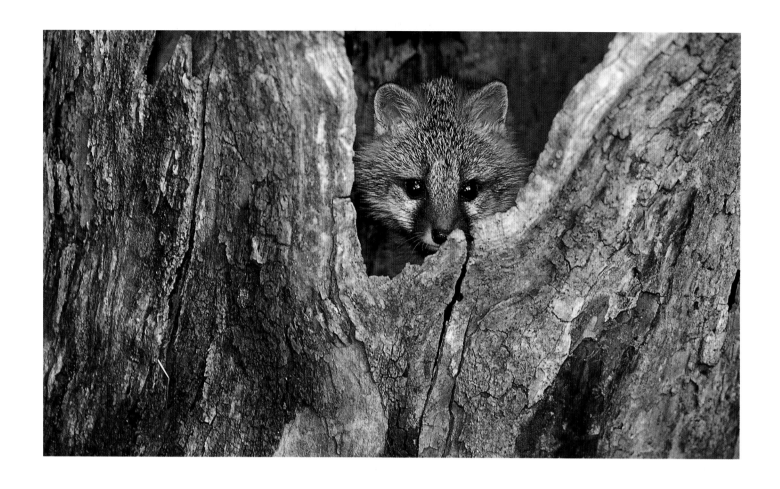

Gray foxes are abundant throughout Kentucky.

the gate and took a relatively short walk down a gentle slope through big trees to see a state champion pignut hickory tree. We then got off the trail and followed the drainage uphill for quite some time. When I thought we were close to the top, the woods became very open, with red cedar mixed in with scrubby oaks. But we were not even close to the top yet. We surmised this particular patch of woods may have been a glade or opening in times past but had grown into a scrubby forest habitat.

The most fascinating part of the walk was yet to come. After a short break we climbed a bit more, then leveled off. I was completely lost and had virtually no idea of where we had come from or where we were going. The walking was a bit easier now that we were on a saddle. We soon came to huge dead chestnut tree that had fallen across our path; its size was incredible, reaching up to my chest. I struggled over the top of the trunk and noticed the surrounding tree species had changed. It appeared we were in eastern Kentucky, complete with mountain laurel and chestnut oaks. Whoa, Nellie! Those species are not supposed to be here. During my "education" about the forests of Kentucky I had heard there were unique and isolated sandstone caps on some of the hills in this region. Now I had proof they existed.

The gravel-wash oak-hickory forests that occur in the western Pennyroyal are well represented in Land Between the Lakes. Here, one small remnant barrens near Golden

Pond has been protected and partially restored, and the area has been stocked with American bison and the Manitoban subspecies of the Rocky Mountain elk. As you travel the roads of Land Between the Lakes you notice there are several other potential barrens restoration possibilities, particularly near the nature station. The evidence is clearly present in the roadside ditches and pull-offs, where you find numerous prairie species, including the rare cream false indigo.

At the base of some of the gravel hills, acid seeps occur, and several unusual southern plants, such as southern bog club moss and Carolina yellow-eyed grass can be found. Several rare southern shrubs also can be found in these habitats, including the swamp azalea, swamp blueberry, and possum haw.

The final unique community type that has been protected in the Pennyroyal is the sinkhole lake or wetland. These "transient" lakes are not so important for rare plants but are protected for their value as wildlife habitat, particularly for birds. Chaney Lake is located on a karst window in Ste. Genevieve limestone. When fall and winter rains fill underground basins, small channels in the bedrock permit seasonal flooding, but during the summer and in exceptionally dry years, little water can be found in the basin.

How important is Chaney Lake for migrating birds? In a single year more than sixty different species of waterbirds have been observed using the lake. More than twenty different species of ducks have been observed, and some other species, such as the pied-billed grebe, American coot, and hooded merganser, are breeding there. As the water recedes in the spring, the large mud flats provide excellent habitat for migrating shorebirds.

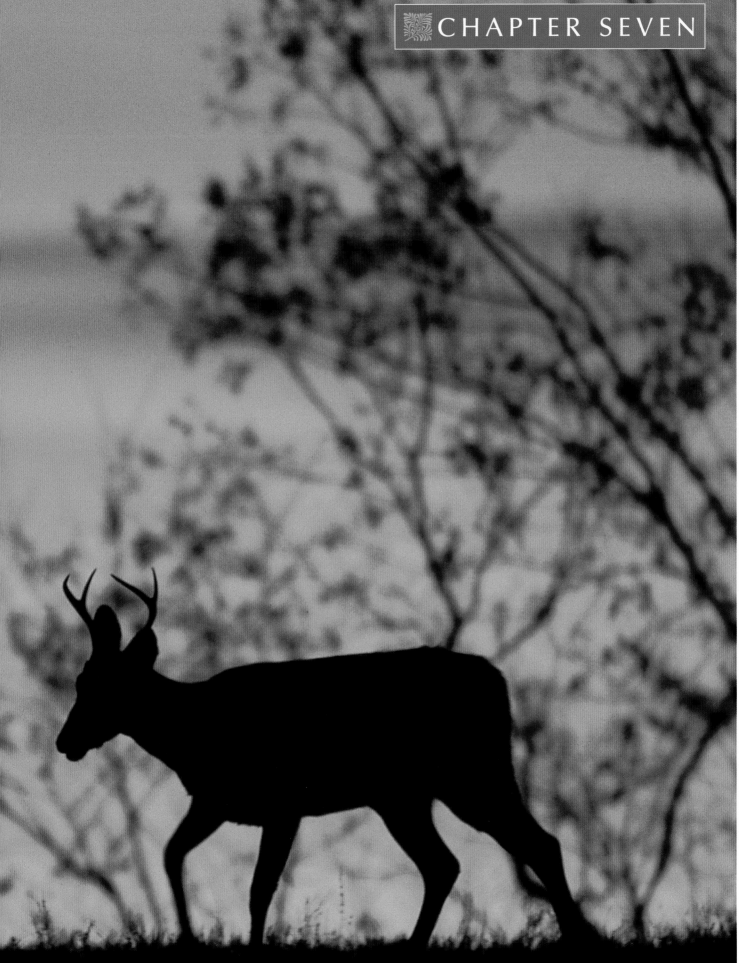

THE SHAWNEE HILLS

It seems to take forever to get from Leitchfield to Dawson Springs on the Western Kentucky Parkway. There is not much to look at along the way, unless you like giant strip-mining equipment on rolling fescue pastures or ponds colored red from acid mine runoff. From the standpoint of biodiversity you could say this physiographic region is not very interesting either. But you would be wrong. Julian Campbell writes of "The Shawnee Hills: Home-sweet-home for the Mammoth Cave Shrimp and Copperbelly Water Snake." Mammoth Cave National Park (discussed in chapter 6) is certainly the most significant site within this region.

Most Kentuckians call this province the Western Coal Field. It is similar to the Eastern Coal Field (Cumberland Plateau) in that the underlying bedrock is mostly sandstones, shales, and, of course, coal. But unlike the rugged Cumberland Plateau, the Western Coal Field topography has broader bottomlands and smaller, rolling hills. It also has more wind-blown soil (called loess), which increases the fertility of the uplands. If you were to divide the region into two sections, the inner low hills and swamps and the karst and escarpments, you would find very few protected areas in the inner region, where mining activity has been concentrated over the years. Most of the protected areas lie at the perimeter, along the Ohio River. They include Canoe Creek, John James Audubon State Park, Sloughs Wildlife Management Area, and Cypress Creek in Muhlenberg County. In contrast, there are several significant sites in the escarpments and karst section. These include Eastview, Baumberger, Lapland, and Sunset Barrens, Big Clifty, Hunter Bluff and Jones-Keeney Wildlife Management Areas, and Mantle Rock.

Overleaf: *White-tailed deer at sunset.*

All along Dripping Springs Hills there is substantial interest in the rare remnants of native grasslands and open woodlands. These remnants are mostly on limestone, but there are also a few on sandy soils, with some particularly rare plants, such as frostweed and beard grass. On the northern portion of the escarpment in Breckingridge, Meade, and Hardin Counties, I have had the great fortune to visit three prairie sites, Lapland and Eastview Barrens and the Big Clifty Roadside prairies. Several additional high-quality glades can be found on the southern edge, including several glades in Mammoth Cave National Park and Sunset Barrens.

I had been told of the great prairie area called Lapland Barrens in Breckinridge and Meade Counties. Rumor had it that there was a tremendous stand of spiked blazing star that would be in spectacular color in late July. Naturally, I was thinking of great photographs. In no time I was on the phone with Steve McMillen, a wildlife biologist with Fish and Wildlife, in an attempt to schedule a reconnaissance trip to the site in early July. We visited a while, talked business and photography (Steve is an excellent photographer in his own right), and then agreed to meet at Battletown on July 7.

My alarm went off at 5:00 A.M. I packed my photography gear, not really expecting to use it much, and headed out the door. As I ate a quick breakfast in my truck, the radio DJ said there was a 40 percent chance of showers, maybe heavy, with an occasional thunderstorm. I could live with that. Weather forecasters are usually wrong, anyway. Not long

before I crossed the Ohio River, traveling on Highway 228, I began to notice the road ditches. They looked like tiny prairie remnants. Just then I spotted a large, bright orange flower. After a quick look in the mirror, I hit the brakes hard, tires squealing, and my truck lurched to a stop. I turned that beast of a vehicle around and popped out to look at this beautiful flower. It was a lily. I had seen both Turk's-cap and Canada lilies in eastern Kentucky about this time of year, so it made sense to find native lilies in bloom. But when I looked at the flower, it just did not look like either of those species. It must be Michigan lily, the wet prairie species, I thought. A little checking and a quick confirmation. Yes, it was *Lilium michiganense.* Onward to Battletown.

I was a bit early, so I grabbed a cup of coffee at the Battletown store and waited for Steve on the porch. The sky began to look ominous. Oh, stop worrying, I told myself. Steve arrived soon and we hopped into his vehicle for the trip to the barrens. I am not going to take my camera, I thought; it is just a discovery trip. As fate would have it, that turned out to be a wise decision. Off we went on our adventure. We headed out of Battletown, traveled through another small community, and turned off onto a gravel road. Steve stopped the vehicle and we got out to examine a prairie remnant on private land. What a beautiful limestone slope prairie! The deep soils were dominated by big bluestem and Indian grass. Little bluestem dominated the upper slopes. Prairie flowers, including blazing star, rattlesnake master, and American agave, were scattered everywhere. Steve was quick to inform me that there were many small areas like this in the general vicinity. By now I was wishing I had brought my camera gear.

We jumped back into the vehicle and Steve drove down this dusty lane then that dusty lane, then onto a dirt road that led to Lapland Barrens. Pulling off the road, Steve stopped the vehicle and said, "From this point on we'll walk down this logging road to the bottom. We will then walk up the creek for a ways and finally climb the slope to the blazing star site." Okay. Neither of us had packed rain gear; the thought never occurred to us. You know how biologists are. We start talking nature, business, photography—and it never occurs to us to look at the sky or listen to the radio.

Off we went. We talked about creating prairie, hunting, fishing, and a variety of other topics as we meandered down the steep slope, ultimately reaching the creek. A quick left brought us into a beautiful clearing. There I gazed at Michigan lilies at the meadow's edge, butterfly milkweed in the open, and a grass community dominated by big bluestem and Indian grass. The opening had been invaded by cedars and lots of sweet clover, but it was an excellent example of a restorable deep-soil barrens. A few sounds of booming thunder in the distance and a few hundred yards up the creek, I noticed a purple coneflower in full bloom. That was odd. The narrow-leafed or pale purple type of coneflower blooms in June. What is this thing doing flowering now? I wondered. After another hundred yards, I turned to Steve and said, "I have to go back and look at that." I was thinking that maybe

this was the true purple coneflower, which bloomed in July. So we retraced our steps and I looked at the leaf. Sure enough, it was purple coneflower—the first time I had ever seen this classic prairie plant in Kentucky. Here was another piece of the prairie puzzle. We continued our walk up the dry branch and observed gray-headed coneflower, a phlox of some sort, and eastern grama grass. This was the easternmost population of that species I had seen in Kentucky.

Then it began. Just a few drops at first. "Oh, it will just pass us over. Don't worry," I said. Then a few sounds of thunder and a few more drops. A few more steps and the good Lord showed his sense of humor by opening up the spigot. It began to rain so hard it appeared that someone had just turned a bucket of water over our heads. We jumped out of the creek and landed under the largest sycamore we could find.

We waited and waited. I sarcastically said to Steve, "Great guide service. Really love it!" After about an hour it finally let up, and I was amazed that there was no water in the creek. No wonder they called it Dry Branch. Of course, we were soaked to the gills. We decided to cut the trip short and head straight up the hill to the barrens and blazing stars, and then retreat to the comforts of civilization. Through the woods we bushwhacked, past an old homesite, then through the open forest so typical of areas surrounding these limestone prairies. About three-quarters of the way up the slope the forest opened up, and in a power-line right-of-way we saw lots of prairie dock. Finally, we reached the top and ended up in the field with the blazing star. Or rather, where the blazing star had been. There were very few of the flowers; the forest had encroached, and the grass had taken over the field. It needed a burn in a big way.

Price's potato bean is a federally threatened plant that grows in this region.

By now I was beginning to question the knowledge and authority of my guide. Good thing he was a friend. Down, down we went, only to be greeted by a sound that I recognized as a waterfall. Something was wrong with this picture. As we approached the creek all we could hear was the sound of rushing water. It quickly became apparent that this was no longer Dry Branch. It was also apparent that we were not crossing it, because in it flowed six or seven feet of chalky red water rushing toward the Ohio River. I did not want to end up as fish food. A dilemma. Do we go right or left? Steve was confused because this could not be the same creek we had just walked up. We decided to go downstream. We walked and talked until finally Steve said, "This isn't right." We turned around. We walked and talked some more, not really getting any drier because the grass was amazingly wet. I was beginning to wonder if I was ever going to get out of there and started to doubt my guide again—a little more seriously this time. But Steve persevered, and we ended up at Dry Branch, right where we had entered the creek, and began the slow trek up the steep slope to the truck. Did I mention slow? That wonderful logging road we had come down was now a gumbo-clay nightmare. Each step up the slippery slope added an additional pound of mud to our boots. By the time I reached the top, after several breath-catching stops, I could have qualified to be a sumo wrestler, with the fifty pounds of mud I had acquired on each foot. I looked at my jeans, white in the knees from soap that never came clean in the rinse, and we laughed. We must have looked like, well, who knows what? Steve joked about putting this in the book, and I responded, "You can guarantee this story will make it!"

I could tell dozens of stories about my trips to Kentucky prairies because I am so drawn to them. Perhaps it is my heritage calling to me. Perhaps it is a reminder that prairie represents the "breadbasket" of America. Perhaps it reminds me of the frontier and frontier life. Or perhaps I am simply drawn to the inexorable color and beauty of the flowers, butterflies, and birds. Whatever the reason, I truly believe what William A. Quayle wrote in *The Prairie and the Sea*: "You must not be in the prairie; but the prairie must be in you."

Unlike deciduous forests, prairies must be managed. In the past, two forces kept the trees away from the grasslands: fire and grazing by bison and/or elk. If we are to maintain our prairie preserves we must employ the same management techniques that Mother Nature has used for thousands of years. Fire is the most frequently employed method that Nature Preserves and the Kentucky Chapter use for rejuvenating prairie. Why? John Madson explains it best in *Where the Sky Began*: "A grassland holocaust, by and large, is easily endured by native prairie. Grasses are highly fire-tolerant. . . . Their life processes are largely underground, out of reach of flames, and the fiercest blazes of early spring and autumn were fed by dead, dry plant parts during times when the vital processes of the prairie were safely dormant in roots, rhizomes, and underground parts that are shielded by a heavy sod."

One final story about prairie and the use of fire to manage these sites. Eastview Barrens is one of the finest examples, if not the finest, of both midwestern savanna and prairie

A luna moth perches on a sandstone rock.

barrens left in Kentucky. (The other outstanding example would be Raymond Athey in Logan County.) Eastview has both sandstone and limestone barrens intermixed with a post oak–blackjack oak–southern red oak savanna. This 120-plus acre site harbors many rare and endangered plants, including Eggert's sunflower, western silky aster, broad-leaf bear grass, and plains frostweed. Other typical prairie flowers that occur in abundance are rattlesnake master and the ever-so-showy prairie gentian. Over the past decade parts of the area have received several prescribed burns, the objective being to kill woody species encroaching into the grasslands and to stimulate two of the spectacular prairie wildflowers, rattlesnake master and prairie gentian.

My usual trek to the barrens is in early October, when the prairie gentian is in peak form. Over the years I have been fascinated by the response of the gentians to fire. On my first visit I counted twelve stems, a pretty good number for a rare plant. The following year, after a good fire in the spring, I went back in my usual pilgrimage and quit counting when I reached one hundred. What a difference a year and a single fire can make!

So I continued my annual October pilgrimage, but with one modification. Last year I went in June *and* October. I had been wondering if the western or eastern fringed orchid (rarest of the rare in the prairie) could occur here. This would be the only logical place, in

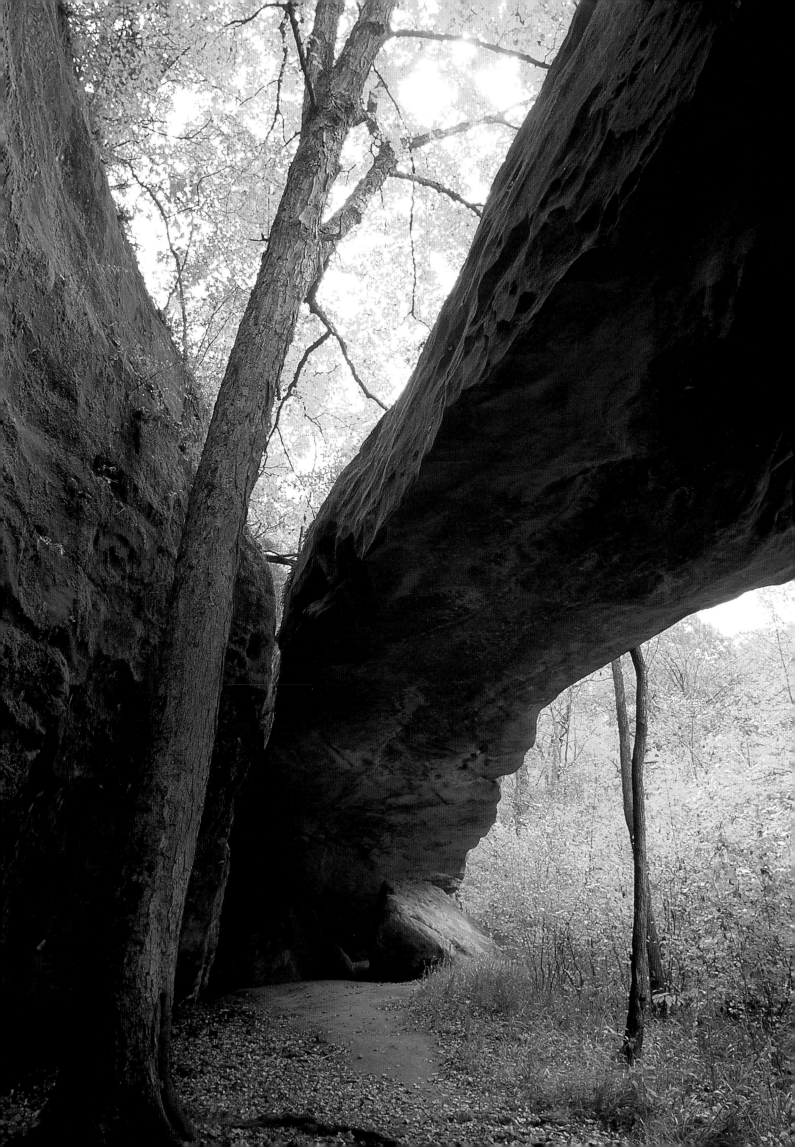

the moist, deep-soil prairies near the back of the preserve. I also reasoned that rattlesnake master might be in good form as well in mid-June.

This was another of those early morning visits. I left home at 4:30 a.m. and arrived at the barrens about 6:30, right at sunrise. It seemed like a perfect morning: no wind, a light overcast sky, and the air thick with moisture. As I trekked through the grass I felt the wetness seeping through my jeans. It seemed spiders had spun webs between every tree and every stem of dried tallgrass. Within minutes I was in a big patch of rattlesnake master. They were several weeks away from flowering, but at least I could look for the orchids.

A black-eyed Susan caught my attention because a spider web, covered with dew, was attached to one of the ray flowers and a stalk of Indian grass. As I crept around on the ground photographing that spider web, I began to look more closely at my surroundings. In the not-too-far distance was something white and orchidlike. I rushed over, thinking I had found the mother lode. There it was, the rare western fringed orchid. Or so it looked. It was definitely a fringed orchid, and it was kind of white, but it was also a little green. It didn't look as robust as the orchids I had observed in Wisconsin the preceding year, but that, I thought, could be a result of site variation. I set up the camera equipment and shot film like crazy. When I got home, I called Marc Evans at Nature Preserves in great excitement. I asked if I could have found the real McCoy. Yes, it was possible, was his response, but not probable. They had done a very intensive floristic study and that species had not shown up. So when the film came back I looked at it and compared it to the images from Wisconsin. It turned out to be a ragged fringed orchid. I was heartbroken.

On my return trip in October I ventured back to the gentians and counted the stems. I was hoping for another spectacular year. It was not to be. Less than a dozen plants. And so it goes. One year twelve plants, another year (plus a fire) more than one hundred, and yet another year back down to about a dozen.

Sunset Barrens and the associated glades are probably the best remaining example of a sandstone barrens left in the state. Like many of the limestone barrens, this grassland community is dominated by little bluestem and Indian grass, although big bluestem also occurs on the preserve. The most conspicuous rare plant occurring on these deep, sandy soils is the blueheart. Surrounding it is a typical dry forest dominated by post, blackjack, black, and white oaks. The glades are particularly interesting because an ephemeral stream pokes its way across the exposed bedrock. In several places enough soil has accumulated to provide habitat for sphagnum moss and a rare quillwort. Other plants found in this general habitat include a rush-foil and knotweed. French's shooting star has also been discovered at this preserve.

If you move from the southern edge of the region to the western edge you arrive at Mantle Rock. Like Sunset Barrens, Mantle Rock is different from most of the barrens because it occurs on sandstone. This preserve has not only biological significance but also

Mantle Rock has not only ecological significance but also historical and geological significance. The sandstone arch served as a temporary winter quarters for the Cherokee Nation during the harsh winter of 1838–39. Many did not survive this winter.

cultural and historical significance. The prime attraction here is the thirty-foot natural sandstone arch. During the harsh winter of 1838–39 the Cherokee Nation was being removed along the "Trail of Tears." Because of the treacherous weather and high, rapidly moving water in the Ohio River, many were forced to take shelter under Mantle Rock and other nearby rockshelters. Many never saw spring arrive.

Glen Buhlig, county Extension agent for agriculture in Livingston County, and I experienced the significance this site holds firsthand. We parked and noticed a vehicle in the lot with Tennessee plates. We wondered who in Tennessee would be visiting the site. After a short walk through the woods we arrived at the arch and noticed a young Native American deep in thought at one end of the arch. She was standing still and was exceptionally quiet. I set up my camera gear, and as I began to take photographs, she moved farther into the shadows and disappeared. After I got the photos I thought I needed, she reemerged. She told us numerous of her ancestors had died here.

We then climbed to examine the biologically important community that lies on top of the arch. The very thin soils have produced a unique savanna community that thrives under these conditions. It is here that you find primary succession, from lichens colonizing rocks to the "climax" community dominated by dwarf, stunted, and gnarled post oak trees. On the top of this arch you find also Kentucky's only known population of prairie June grass. Other xeric glade species associated with this habitat include prickly pear cactus, hairy lipfern, pinweed, and poverty grass. Buckley's goldenrod and glade melic grass can be found around the edge of the rock outcroppings.

One of the most unique preserves in the interior section of the Shawnee Hills occurs in a most unusual place, an industrial development. Canoe Creek is a small area that drains into the Ohio River west of Henderson. Gulf Oil originally donated the property to the Kentucky Chapter, and the property was to be resold. During an inventory, though, a most unusual plant, the Tennessee leaf cup, was discovered. As a result, seventy-two acres were kept as a preserve in the development.

This is not a showy plant, although it does have interesting foliage and is found at only a few locations in Kentucky and Tennessee. Other than the plant's global rarity, the most interesting aspect of its ecology was discovered during a project to save a portion of the population that was going to be destroyed by additional development. It was found that individual plants had to be spaced an equal distance from one another to survive. The concept of a uniform distribution of organisms in the environment is rare.

Not far from Canoe Creek lies John James Audubon State Park, named for the famous naturalist and artist who lived in Henderson and explored the forested loess hills along the Ohio River in the early nineteenth century. Although the southern portion of the park has been developed like most of the state's resort parks, the northern portion was set aside as a bird sanctuary in honor of Audubon. It is on these 325 acres that a spectacular example of

the mature mixed hardwood forest in the loess hills, dominated by beech and sugar maple, has been protected. As you walk along the trails in the spring you notice a rich spring wild-flower display. Perhaps more important, there are numerous large trees, including several cherry-bark oaks that are among the largest I have seen in Kentucky. I haven't visited the park since the great drought of 1999. That is the only time in my life I have ever seen large soil cracks and dying woodland wildflowers on a north-facing mesic slope.

Throughout the entire Shawnee Hills region the uplands have been largely logged or cleared for farmland for a long time. Since the 1950s large strip mines have altered much of the landscape, resulting in serious water-quality problems in the rivers, streams, and large swamps and marshes. Directly and indirectly mining on these wetlands has been a unique form of human disturbance of natural communities that is largely lacking in the Eastern Coal Field. Further problems for some marshes, swamps, and sloughs has been the outright destruction from mining activities and the historic conversion to agricultural fields via drainage. As a consequence, few high-quality wetlands remain in the entire region. Those wetlands and, perhaps more important, the bottomland hardwood forests associated with the deeper water cypress and tupelo swamps are an uncommon commod-ity throughout western Kentucky. The two systems remaining in the Shawnee Hills are Cypress Creek and Sloughs Wildlife Management Area. Although many wetlands have been altered in some form, even the disturbed wetlands are important for many species of wildlife. Many southern plant and animal species are at the northernmost range of their distribution in these wetlands.

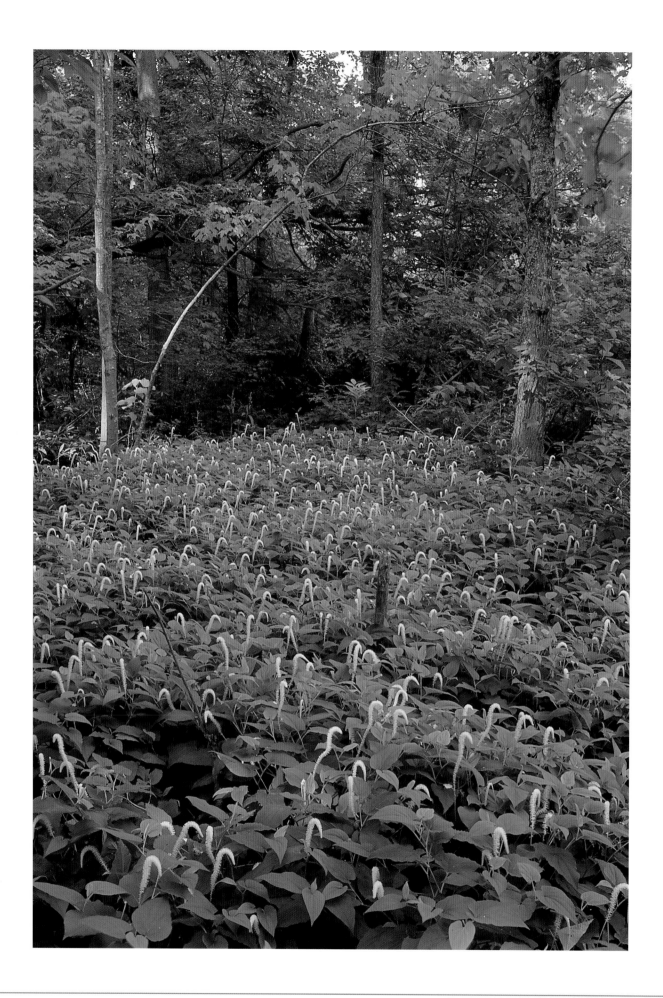

Cypress Creek is a cornerstone of the Cypress Creek wetland system. The entire wetland complex of cypress and tupelo swamps and bottomland hardwood forests covers forty-four hundred acres. Nature Preserves protects only a small parcel, ninety-seven acres. The agency would like to own more of the property, but coal lies underneath the ground and the cost of purchasing those mineral rights probably makes owning more property, without a donation, unrealistic.

The queen snake can be found around streams and ponds.

Why is Cypress Creek unique? First and foremost, this preserve protects one of the easternmost bald cypress swamps and bottomland hardwood forests found in Kentucky. These wetlands harbor many rare plants, such as southern wild rice and swamp loosestrife, some rare fishes, such as the lake chubsucker, and much unique wildlife, including disjunct populations of bird-voiced tree frogs and cottonmouth and other water snakes.

Like most streams in western Kentucky, Cypress Creek was channelized, or straightened, in the 1920s. Streams with a natural hydrologic regime like to meander here and there, creating oxbows and then abandoning them over time by creating a new channel. During the spring and fall, water spills over the banks of the stream and floods low-lying areas (cypress and tupelo swamps that retain water most of the year), abandoned channels, and old oxbows. Channelization forces the water down a straight ditch so that it moves at warp speed. Often this channelization results in the death of a freshwater marsh associated with the stream. There can be no doubt that channelization altered the tree composition of the bottomland hardwood forest. Although Cypress Creek was channelized, beavers have moved back into the stream, and this has altered the movement of water. One of the best positive results of this activity has been that in many, many places the high spoil bank has been breeched by water. Given enough time, the natural hydrology may fully restore the original bottomland forest conditions on this preserve.

The other important wetland complex in this province is Fish and Wildlife's Sloughs Wildlife Management Area. Several thousand acres of wetland habitat, including natural cypress swamps, some bottomland hardwood forest, a few open water wetlands, and numerous flooded agricultural fields and artificial shallow water management areas, are found here. This area serves as the best stronghold for the copper-belly water snake. It is also home to thousands of wintering and migrating ducks, geese, shorebirds, and other waterbirds.

Lizard tail is a typical wetland herbaceous plant found at Cypress Creek State Nature Preserve.

8

EAST GULF COASTAL PLAIN

One word describes the westernmost reaches of Kentucky: flat. The Jackson Purchase was so named because Andrew Jackson (with Isaac Shelby) negotiated its purchase by the United States from the Chickasaw Indians in 1818. Once purchased, the land was systematically surveyed following a grid pattern. Notes were kept during those surveys, allowing biologists in our time a window into understanding what ecological communities occurred here before European settlement.

This area of Kentucky is a northern extension of the coastal plain that extends from Texas to Florida. It is characterized by high plains and gently rolling hills dissected by numerous and extensive bottomlands that were associated with the Mississippi River and its main tributaries. The major ecosystems that dominate this landscape result not only from the underlying geology and soils but also from topography. For instance, oak-hickory forests dominate the gravel uplands, flatwoods occur on lower, poorly drained ground, wetlands and bottomland hardwood forests are found along the major drainages, there are deep soil prairies and barrens on the plains, and mixed hardwood forests dominate the fertile loess bluffs that form a narrow band of hills along the Mississippi River, where the wind-blown loess reaches eighty feet in depth in some places.

What is left? Not much at all. The flatwoods of Marshall County have been highly degraded by logging, fire suppression, and alteration of the natural movement of water. These open woodlands are often dominated by post oak, which is a result of extreme variations in moisture, both quantity and when in the year the area floods, in addition to frequent fires. Rare plants in such habitat include the eastern silvery aster, bearded skeleton grass, western red-disk sunflower, and rough rattlesnake root. With the recent establishment

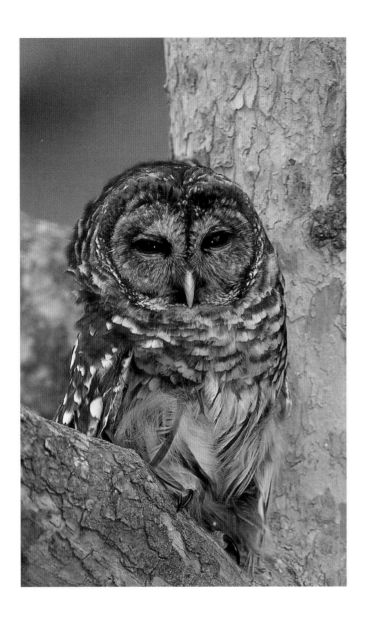

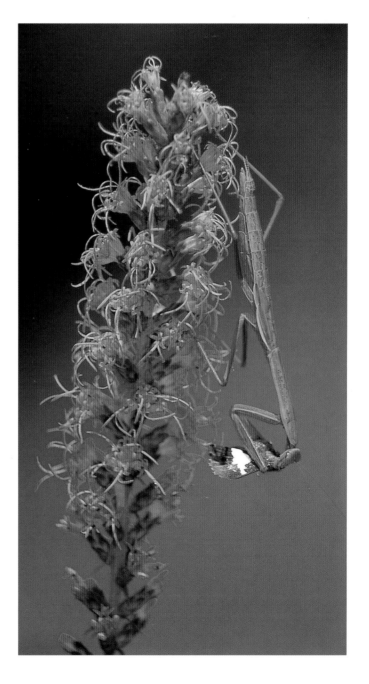

The barred owl is a common resident of bottonland hardwood forests.

This praying mantis is eating a silver-spotted skipper on a dense blazing star.

One of the remaining deep-soil prairies can be found at West Kentucky Wildlife Management Area.

of a national wildlife refuge along Clark's River, biologists hope some flatwoods can be restored.

The loess bluffs harbor small patches of unusual mesophytic plants, such as the southern sugar maple, yellowwood, and the globally rare Tennessee leaf cup. Most of these forests have been highly disturbed, however, and there are no significant conservation projects protecting any of these lands.

As for deeper-soil prairies, only two remain. One tiny remnant of unplowed wet prairie has survived at the Barkley Airport west of Paducah, and with it the only large patch of prairie cord grass and sweet Susan. The other is Fish and Wildlife's West Kentucky Wildlife Management Area, where an active burning program has allowed some of the deep-soil prairies, dominated by Indian grass and eastern grama grass, to become reestablished. Typical deep-soil prairie wildflowers found here include the rare compass plant, ashy or downy sunflower, prairie blazing star, and rattlesnake master.

The wetlands of western Kentucky support many unusual birds, such as the snowy egret (left) and great egret (right).

The ecosystem that has received the most attention in this physiographic province is the wetlands, including spectacular cypress sloughs and lakes, and the associated bottom-land hardwood forests. These swamps and other wetlands harbor many southern species that reach their northern limit of distribution here, including much bald cypress and water tupelo on the wettest ground. These sites are the favorite haunts of well-known animals, such as the cottonmouth snake, alligator snapping turtle, green tree frog, great blue heron, and great egret. Other rare animals include the federally endangered relict darter, which is endemic to Bayou de Chien drainage, and the interior least tern, which breeds on sandbars in the Mississippi River. Protected wetland habitats in this region include an Ohio River floodplain lake (Metropolis Lake), Cypress Creek Swamp Preserve, Murphy's Pond, Axe Lake, Ballard County Wildlife Management Area (including Swan Lake), Obion Creek, and Terrapin Creek.

Swamps by their very nature are designed to dry out occasionally. Many might look at the great drought of 1999 as a terrible natural disaster. Growing up around marshes and realizing that wetlands do dry up, I was not sure what to expect as I ventured into Cypress Creek Swamp Preserve, located in Marshall County, in late August of that year. One thing was certain: it was hot and the mosquitos were the size of hovercraft. Pretty typical wetland.

Overleaf: *Metropolis Lake is one of the last true Ohio River floodplain lakes in Kentucky. It is lined with exceptionally large bald cypress trees.*

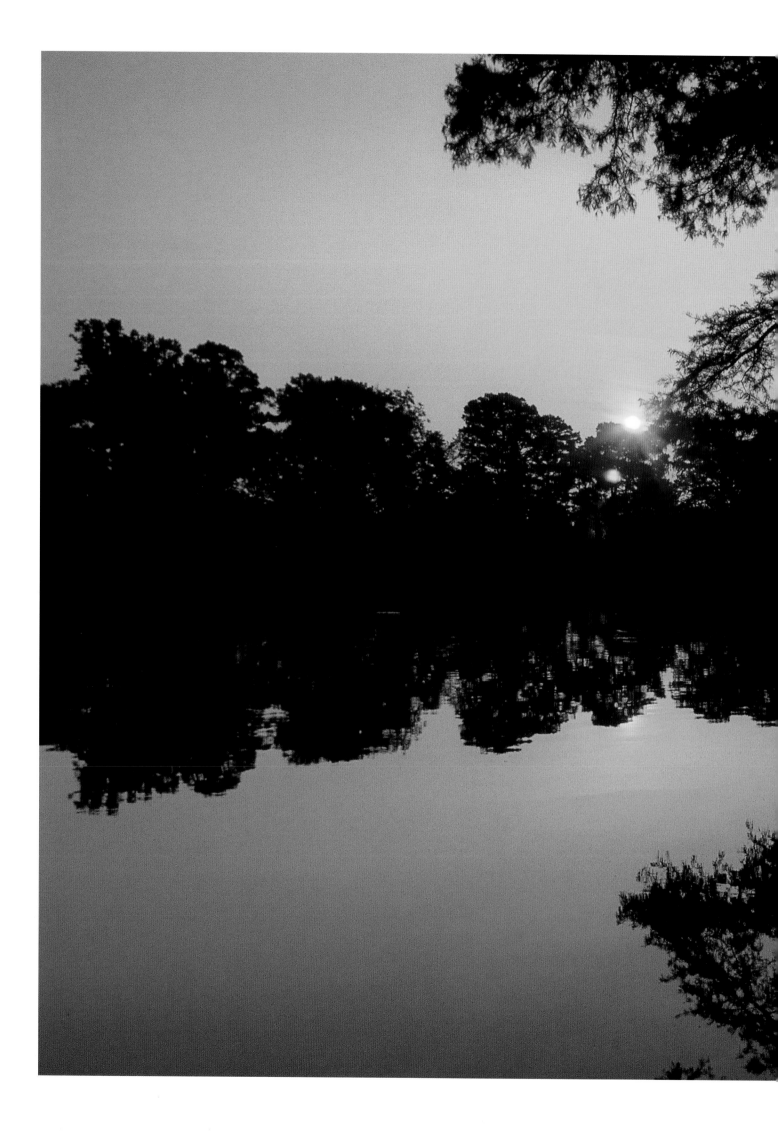

The most common type of wetland remaining in Kentucky is the cypress swamp.

There was little standing water, except in a few isolated deep pockets. Otherwise it was like walking on the uplands. As I poked around looking for the rare cypress knee sedge, I noticed hundreds of seedling cypress trees. Drought isn't all bad. These dried-out soils allowed the cypress trees to sprout and grow, something that doesn't happen under water. So although Cypress Creek Swamp in Marshall County is now dominated by water tupelo, in the future it will have a larger number of cypress trees.

Cypress Creek has been channelized, and, as with Cypress Creek in Muhlenberg County, the spoil banks have been breeched and some of the natural hydrology has returned as water moves freely through these breeches. This preserve supports the rare cypress knee sedge, which I was determined to photograph. After several hours of searching I finally located one growing at the base of a tupelo tree. As I retreated from the preserve, I was surprised to find a three-birds orchid. It was almost done flowering, but just finding that orchid, which I had never seen in the wild before, made my day.

This tupelo swamp with a purple fringeless orchid in the foreground is a part of the Cypress Creek Wetland Complex in Marshall County.

Wetlands support an incredible diversity of wildlife, and Cypress Creek is no exception. The usual players are there: raccoons, beavers, prothonotary warblers, cottonmouth and water snakes, various turtles and frogs, and many waterbirds, including great egrets and

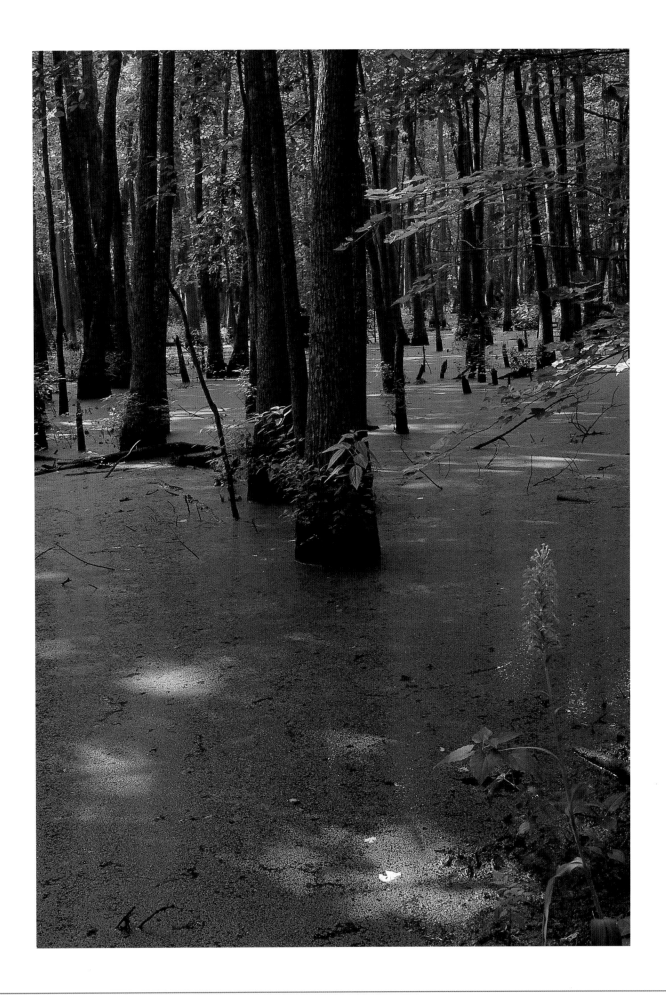

The rare cypress knee sedge is shown here growing at the base of a water tupelo tree.

green herons, with nesting wood ducks and migratory waterfowl galore. There is a large roosting colony of great blue herons near the center of the preserve. Other rare wildlife using the preserve include the eastern ribbon snake, southeastern bat, bird-voiced tree frog, and brown creeper. One rare mussel, the Texas lilliput, can also be found here.

Axe Lake Swamp, at three thousand acres, is a cornerstone wetland in the Ballard County Wetland Complex macrosite, which includes the Ballard County, Swan Lake, and Peal Wildlife Management Areas. Axe Lake Swamp lies within the Ohio River floodplain, as do the other wetlands in this complex. Dominated by bald cypress and tupelo with several natural open-water lakes, the swamp is the best remaining example of a continuous wetland system in Kentucky.

These wetlands are a crucial wintering area for thousands of geese and ducks. I try to make at least one trip annually to watch and hear the geese because it reminds me of my heritage. I guess we sometimes take things for granted, as I did growing up in eastern South Dakota, where every March and October the geese moved through on their way to the breeding or wintering grounds. The sights and sounds of thousands of snow and blue geese are forever etched in my memory. I believe this sight should be experienced by all who are interested in nature because it is truly spectacular. I will never forget the time I took a group of freshman students from the University of Kentucky on a field trip to Ballard

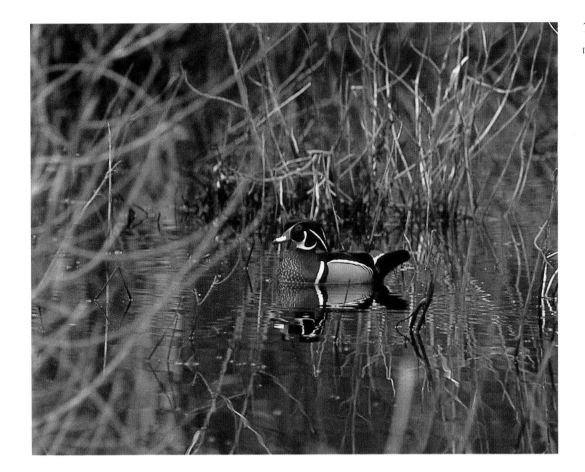

The wood duck is a common wetland resident.

Raccoons are likely to be found around wetlands habitats.

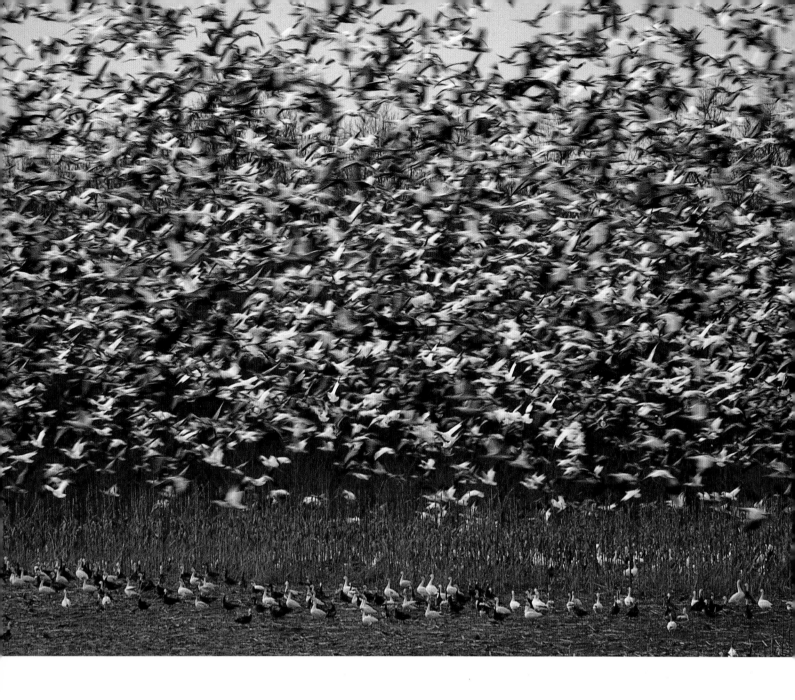

Kentucky is in the Mississippi Flyway, and thousands of geese spend the winter around Ballard County.

County Wildlife Management Area and we saw several thousand geese lift off from Mitchell Lake. As we left, one student commented that the loud racket of "goose music" made the hair on the back of his neck stand up.

Other wildlife depend on these wetlands for their existence as well. More than forty species of reptiles and amphibians, including the rare green tree frog, reside at Axe Lake. Among the rare fishes in these wetlands are the taillight shiner, chain pickerel, cypress minnow, and red-spotted sunfish. Axe Lake supports a large nesting colony of great blue herons and one of only two great egret rookeries in the state. The Jackson Purchase is the only part of the state where you are likely to find snowy egrets, little blue herons, and king rails. The bald eagle has returned to this region, and at least two pairs of the birds have successfully nested at Ballard County Wildlife Management Area over the past decade. Two uncommon bats, the southeastern bat and the evening bat, have been observed using these wetlands. The state-threatened cotton mouse, which is at the northern limit of its distribution,

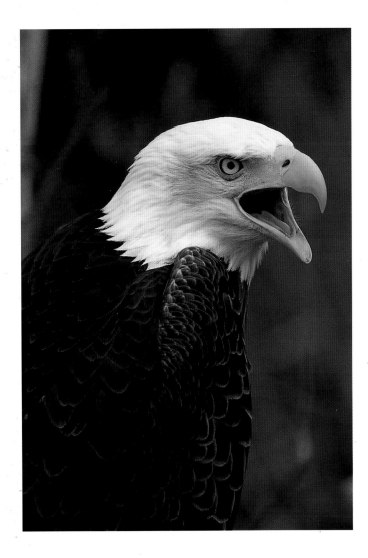

The bald eagle has made an incredible comeback and now nests in far western Kentucky.

frequents the Swan Lake area. Several rare plants, such as water hickory, Carolina fanwort, and American frog's bit, also occur at Axe Lake.

Although most protected wetlands in far western Kentucky are cypress-tupelo swamps, one of the last naturally formed floodplain lakes in Kentucky, Metropolis Lake, also has been protected. The centerpiece organisms protected at this preserve are primarily aquatic and include the state-endangered cypress minnow; two threatened species, the taillight shiner and the red-spotted sunfish; and the chain pickerel, a species listed as being of special concern. The lake is ringed by giant cypress trees. I remember one in particular—it was hollow inside and I estimated that at least four adult humans could stand comfortably within it. Several rare trees, including water hickory and common silverbell, occur on the preserve. Other rare species that can be found include a crayfish, the inland silverside, and snow melanthera.

All this brings me to the last Last Great Place in the Jackson Purchase, Obion Creek. Obion Creek is one of the most significant river ecosystems left in western Kentucky. The 1,402-acre preserve in Hickman County protects a small portion of this wetland system,

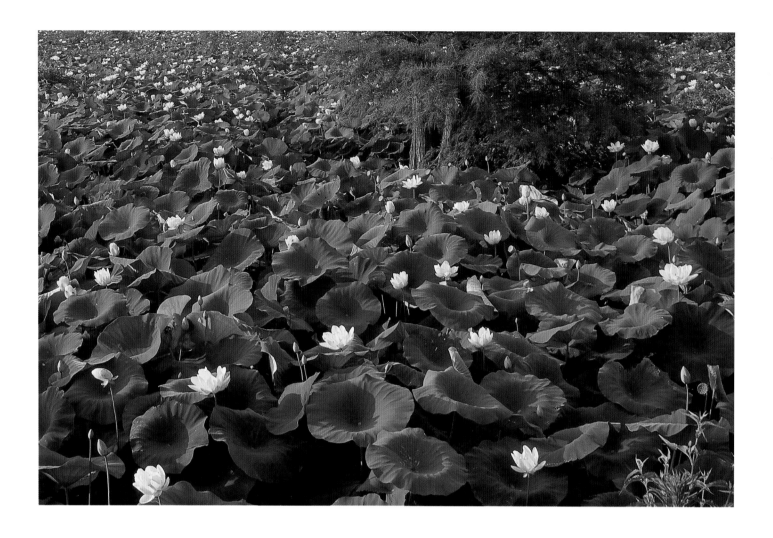

American lotus dominates this wetland at Ballard County Wildlife Management Area.

which includes not only marshes but also swamps and bottomland hardwood forests. This system provides habitat for several rare fish, such as the dollar sunfish, lake chubsucker, and chain pickerel. It is also home for the rare southern painted turtle. There are several rare plants here, as well, including an epiphytic sedge and the rough royal penny. There is no doubt that other wetland creatures, such as bird-voiced tree frogs, green tree frogs, and cottonmouth snakes, frequent these wetlands.

Near the upper reaches of the Obion Creek watershed in Graves County lies Terrapin Creek and its associated wetlands, which provide habitat for some of the rarest aquatic organisms in Kentucky. Many species, such as the gulf darter, reach their northernmost limits of distribution here. There are at least forty-one species of fishes known from Terrapin Creek, including the blacktail redhorse and bright-eye darter, that are solely restricted to this creek. At least twelve of the fish species are considered rare, and for many other species, such as the firebelly darter, this creek supports the best populations in the state. Other rare critters include the three-lined salamander, northern crawfish frog, and Kirtland's and western ribbon snakes. Only one rare plant, American frog's bit, has been discovered at this preserve.

The firebelly darter is only one of a number of rare fish species found in Terrapin Creek State Nature Preserve.

The rare green tree frog, shown here clasping the rare red or copper iris, can be found only in far western Kentucky.

Perhaps the most fascinating aspect of this preserve is the numerous springs that bubble up out of the ground. When I visited the site on a Nature Preserves field trip, I was impressed by the clarity of these unique springs. But perhaps more fascinating was my second trip six months later, when Ron Cicerello and Ellis Laudermilk graciously allowed me the opportunity to photograph some of the rare organisms associated with the creek.

It was a crisp, early morning, and Ron and Ellis were ready to go to work, seine in hand. Down the steep bank they slid and jumped right in and spread the seine. Immediately they started thrashing and kicking and creating what appeared to be havoc. Then ever so quickly the seine was lifted and we peered into the bottom. Anything good? Yes, a firebelly darter! We put the tiny fish in the aquarium and I quickly understood why they called it the firebelly darter. I don't think I have ever seen such a brilliantly colored red on any fish. Joyce Bender, stewardship preserve manager, told me that was the fish that really turned her onto protecting Terrapin Creek. In a half-dozen more seine pulls we observed at least seven or eight rare fish. I was impressed. Not only by these handsome fish but also by the incredible amount of knowledge Ron and Ellis possessed about this ecosystem and the aquatic organisms that live there. Terrapin Creek is one of those places that may not be particularly scenic, but it is a real biological treasure.

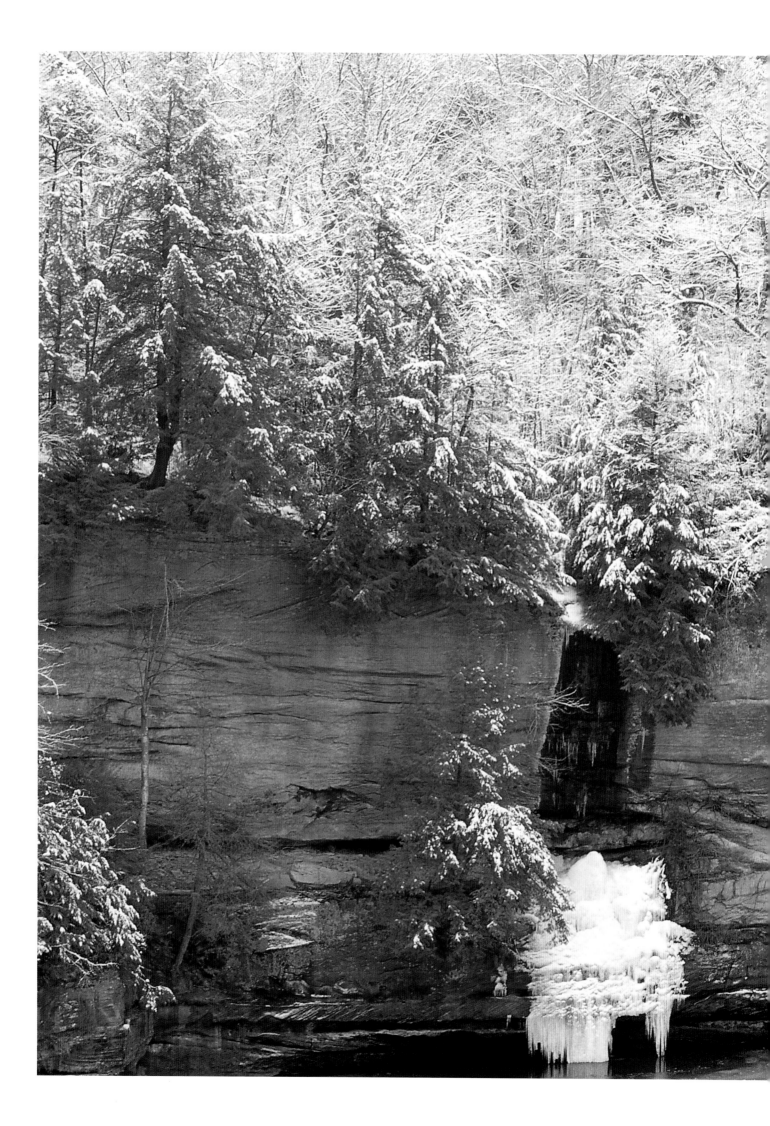

9

THE FUTURE OF PRESERVATION

The most obvious question is, Where do we go from here? And the best way to answer that is to return to the discussion in chapter 1 on the introduction of the concepts of ecosystem management and the bioreserve. Expanding on this discussion allows us to focus on where Nature Preserves and the Kentucky Chapter are headed in the future. There is no doubt each organization will continue to pursue its mission: protecting biodiversity. Nature Preserves will continue its county level–inventory, and it will continue to collect and catalog information on the rare organisms in the state. Both groups will continue to purchase ecologically significant land. At the same time, both groups are branching out into bold new arenas.

Nature Preserves and the Kentucky Chapter have come to realize that context, that is, where the biological element is placed in the landscape, is just as important as content. In other words, you must consider the surrounding land uses when attempting to conserve or protect an area for its unique ecological attributes. One method of accomplishing this task is the use of ecoregional planning, or planning on the basis of ecological systems instead of political boundaries.

It has been well documented that adjacent habitats affect one another through changes in microclimates and the transfer of nutrients, materials, seeds, and so on between communities. These changes ultimately affect ecological processes such as gene flow and species composition in each community. For example, breaking up the forest or creating openings in the forest results in drier microclimates that (1) alter species composition and favor exotic, invasive species, (2) increase the susceptibility of windthrow of existing trees, (3) exacerbate a loss of forest interior wildlife species, and (4) reduce the genetic diversity of

Overview: *Big Gimlet Creek at Grayson Lake.*

the remaining populations. Small preserves (called microsites) that are set aside for a unique or rare biological element may fail unless humans intervene with intensive, and often expensive, management. Furthermore, how do you protect the most imperiled organisms—aquatic species—which need unpolluted water? The answer lies in ecosystem management, bioreserves, community-based economic development, and watershed projects.

The ultimate goal is to provide for sustainable use of those natural resources that are renewable and to protect those that are in trouble. The ultimate end point is to provide a high quality of life for the citizens and important stakeholders in any particular region. This means that the predetermined ecological conditions or flow of benefits from the land can be maintained over time, recognizing a fundamental need to sustain high-quality soils, pure air and water, and vigorous native plant and animal populations. This new concept, which allows for human existence while making a place for things wild and free, assumes that sustainable development meets the needs of the present population without compromising the ability of future generations to meet their needs. The only way to do this is to create partnerships with both governmental and nongovernmental agencies and with an enlightened public.

Biologists with both the Kentucky Chapter and Nature Preserves estimate that at present between two hundred and three hundred microsites in the state are worthy of protection. More microsites may be added to the list as Nature Preserves continues its county-level inventories. For example, recent information from Breckinridge and Meade Counties indicates that more restorable barrens exist than had previously been discovered, which has significant implications for the Kentucky Chapter's Big Barrens project (described below). However, these microsites, in most cases, occur within larger watershed or ecosystem boundaries and can then be grouped into a larger, landscape-level project. The Kentucky Chapter estimates that there are between sixty and eighty landscape-level projects throughout Kentucky. Most of these are focused at watersheds because the majority of G1 and G2 species in Kentucky are found in aquatic systems. Currently, the Kentucky Chapter has landscape-level projects at Horse Lick Creek, the Green River, and Buck Creek. The Kentucky River Palisades will enter a new and larger phase concentrating on the area between Boonesboro and Frankfort, not just in Jessamine and Garrard Counties.

The next large project looming on the horizon is the Big Barrens project. This will be centered in Meade, Breckinridge, Hardin, Hart, and Grayson Counties, and the emphasis will be on not only protecting individual sites within the landscape but also working with private landowners and other governmental and nongovernmental agencies on restoring grasslands.

Nature Preserves is pursuing similar endeavors, including the large forest block project. The goal of this massive undertaking is to use geographic information systems to identify all the large forest acreages in the state. Data from the Natural Heritage database will be

added, as well as information from Fish and Wildlife's GAP analysis project. With this information Nature Preserves can delineate a statewide plan of protecting larger megasites and find corridors to connect these habitats.

Finally, Nature Preserves is increasing its role in environmental education. Blackacre Preserve in Jefferson County has been the outstanding leader in this area. Future plans include creating some type of environmental education program associated with Blanton Forest and examining other opportunities to become more active in environmental education.

What does the future hold? If all goes as planned, great things will happen. I am cautiously optimistic that many more Last Great Places will be added to an already growing list of outstanding natural areas. I hope and pray that both organizations succeed in achieving their goals because I desperately do not want my children's generation to be the first that has to decide which species live and which species die.

I have come to cherish Kentucky as my adopted home. The lush forests, verdant grasslands, and wonderful wetlands beckon me to explore them further. I hope you come away with the same feeling after reading about Kentucky's Last Great Places.

Heavy snowfall in Elliott County.

References

Books and Articles

Braun, E.L. 1950. *Deciduous Forests of Eastern North America.* Philadelphia: Blakiston.

Campbell, J. 1996. "The Big Picture: Ecological Regions of Kentucky." *KY News: The Nature Conservancy*, Summer, 14.

———. 1996. "The Big Picture: Ecological Regions of Kentucky: Where the Mountains Kiss the Bluegrass." *KY News: The Nature Conservancy*, Winter, 16.

———. 1996. "The Big Picture: The Bluegrass." *KY News: The Nature Conservancy*, Fall, 15.

———. 1997. "The Big Picture: Appalachian Plateaus." *KY News: The Nature Conservancy*, Spring, 18.

———. 1997. "The Big Picture: Ecological Regions of Kentucky: Kentucky's High Country." *KY News: The Nature Conservancy*, Summer, 16.

———. 1997. "The Big Picture: Ecological Regions of Kentucky: The Pennyrile." *KY News: The Nature Conservancy*, Winter, 18.

———. 1998. "The Big Picture: Ecological Regions of Kentucky: The Coastal Plain of Kentucky." *KY News: The Nature Conservancy*, Summer, 20.

———. 1998. "The Big Picture: Ecological Regions of Kentucky: The Shawnee Hills." *KY News: The Nature Conservancy*, Spring, 20.

Kentucky Biodiversity Task Force. 1995. *Kentucky Alive!* Edited by Diana J. Taylor. Frankfort, Ky.: Commonwealth of Kentucky.

Kentucky Chapter of the Nature Conservancy. 1998. *Exploring Kentucky Nature Preserves.* Lexington: Kentucky Chapter of the Nature Conservancy.

Kentucky State Nature Preserves. 1995. *Naturally Kentucky Newsletter*, vol. 16.

———. 1996. *Naturally Kentucky Newsletter*, vol. 17.

———. 1996. *Naturally Kentucky Newsletter*, vol. 18.

———. 1996. *Naturally Kentucky Newsletter*, vol. 19.

———. 1996. *Naturally Kentucky Newsletter*, vol. 20.

———. 1997. *Naturally Kentucky Newsletter*, vol. 21.

———. 1997. *Naturally Kentucky Newsletter*, vol. 22.

———. 1997. *Naturally Kentucky Newsletter*, vol. 23.

———. 1997. *Naturally Kentucky Newsletter*, vol. 24.

———. 1998. *Naturally Kentucky Newsletter*, vol. 25.

———. 1998. *Naturally Kentucky Newsletter*, vol. 26.

———. 1998. *Naturally Kentucky Newsletter*, vol. 27.

———. 1998. *Naturally Kentucky Newsletter*, vol. 28.

———. 1999. *Naturally Kentucky Newsletter*, vol. 29.

———. 1999. *Naturally Kentucky Newsletter*, vol. 30.

———. 2000. *Naturally Kentucky Newsletter*, vol. 31.

———. 2000. *Naturally Kentucky Newsletter*, vol. 32.

———. 2000. *Naturally Kentucky Newsletter*, vol. 33.

Stein, B.A., L.S. Kutner, and J.S. Adams, eds. 2000. *Precious Heritage: The Status of Biodiversity in the United States.* New York: Oxford University Press.

Wharton, M.E., and R.W. Barbour. 1991. *Bluegrass Land and Life.* Lexington: University Press of Kentucky.

Interviews with the Author

Andrews, M. 1999. Lexington, Kentucky.

Archer, H. 1999. Lexington, Kentucky.

Bryant, W. 1999. Crittenden, Kentucky.

Cicerello, R. 1999. Frankfort, Kentucky.

Dott, D. 2000. Frankfort, Kentucky.

Duorson, D. 2000. Slade, Kentucky.

Evans, M. 2000. Frankfort, Kentucky.

Harker, D. 2000. Lexington, Kentucky.

INDEX